RUTH
ASAWA

RUTH ASAWA

THROUGH LINE

Edited by Kim Conaty and Edouard Kopp

With Contributions by
Aleesa Pitchamarn Alexander
Jordan Troeller
Scout Hutchinson
Kirsten Marples
Isabel Bird

The Menil Collection, Houston
Whitney Museum of American Art,
New York

Distributed by Yale University Press,
New Haven and London

FOREWORD

A visit to Ruth Asawa's Craftsman-style house in San Francisco, her residence for more than fifty years, underscores just how thoroughly her art practice was integrated into her daily life. She wove many of her looped-wire pieces from a small hook in the doorway between the living room and kitchen; a clear view of the stove ensured that no pots boiled over as she created her sculptures. Once the family's meal was cleared, the kitchen table became her workspace, a spot where she drew daily, despite having a studio downstairs. The lush container gardens that Asawa nurtured on her front deck and the dried seedpods that she arranged among the artwork displayed in her home further demonstrate the connection between her drawing and her personal environment. The natural world inspired her both as an artist and an educator at the Alvarado School Arts Workshop, which she cofounded in the 1960s. She believed that "a child can learn something about color, about design, and about observing objects in nature. If you do that, you grow into a greater awareness of things around you. Art will make people better, more highly skilled in thinking and improving whatever business one goes into, or whatever occupation. It makes a person broader." Asawa's drawings are complex and rich, owing much to her striking creativity, her curiosity about the world around her, her cultural background as an American artist of Japanese descent, and her European-based artistic training in the Bauhaus tradition.

The Whitney Museum of American Art and the Menil Collection are honored to present *Ruth Asawa Through Line*, the first retrospective survey of her drawings. The curatorial team, led by Kim Conaty, the Steven and Ann Ames Curator of Drawings and Prints at the Whitney, and Edouard Kopp, the John R. Eckel, Jr. Foundation Chief Curator of the Menil Drawing Institute, have had the great pleasure of working closely with the Asawa-Lanier family, who have been exceptionally generous in their support of this project. We thank them for their encouragement and advocacy and for so capaciously sharing their knowledge and artwork with us. We are also grateful to Ruth Asawa's estate, represented by David Zwirner Gallery, for its commitment to the artist's legacy and enthusiasm for this project.

Several years ago, when we discovered that the Whitney and the Menil were independently exploring the idea of curating an Asawa drawings exhibition, we happily joined forces. The Whitney was an early supporter of Asawa's work, including it in three Whitney Annuals in the mid-1950s and acquiring a sculpture in 1963. More recently, the museum acquired two Asawa drawings, which inspired Kim to learn more about the artist's graphic practice. When the Menil Collection inaugurated a building to house the Menil Drawing Institute in fall 2018, it featured several works intended to challenge the traditional definition of a drawing. One was an Asawa looped-wire sculpture, which the artist

referred to as a kind of "drawing in space." After Edouard joined the Menil, he became increasingly intrigued by Asawa's drawings. Kim and Edouard, both excellent scholars, have wonderfully complemented each other's interests to create an enriching and educational experience for all involved. We thank them, along with their curatorial colleagues, Scout Hutchinson and Kirsten Marples, who have contributed to this project in meaningful ways.

Major funding for this exhibition and publication is provided by The Henry Luce Foundation; The Andy Warhol Foundation for the Visual Arts; and Christie's.

At the Whitney, we are deeply appreciative of Delta's longstanding sponsorship of the museum's curatorial programming. Judy Hart Angelo and David Bolger both recognized the importance of an exhibition devoted to Ruth Asawa's drawings at this time, and we extend our gratitude to them. Our sincere thanks goes to the Abrams Foundation; the Ellsworth Kelly Foundation; the John R. Eckel, Jr. Foundation; and the Jon and Mary Shirley Foundation for their important support. In addition, we owe a debt of gratitude to the Lipman Family Foundation, Nancy and Fred Poses, and a donor who wishes to remain anonymous. Our sincere thanks also extends to Ann Ames and Sheree and Jerry Friedman. The Whitney is grateful to its board of trustees, led by president Fern Kaye Tessler, chairman Richard M. DeMartini, as well as chairman emeritus Leonard A. Lauder, for supporting all the museum's endeavors.

At the Menil, additional support comes from The Brown Foundation, Inc./Nancy Abendshein; Clare Casademont and Michael Metz; Barbara and Michael Gamson; Dillon Kyle and Sam Lasseter; Franci Neely; Susanne and William E. Pritchard III; Ann and Mathew Wolf Drawing Exhibition Fund; Nina and Michael Zilkha; and the City of Houston through Houston Arts Alliance. Support for this exhibition catalogue is provided by the Menil Collection Publishing Fund; and Furthermore: a program of the J.M. Kaplan Fund. As always, the Menil would like to thank the board of the Menil Foundation, led by chair emerita Louisa Stude Sarofim, chair Janet Hobby, and president Doug Lawing.

A survey exhibition such as this one cannot take place without artworks from numerous public and private collections, and we are extremely grateful to the lenders for their generosity.

REBECCA RABINOW
Director
The Menil Collection

ADAM D. WEINBERG
Alice Pratt Brown Director
Whitney Museum of American Art

ACKNOWLEDGMENTS

It has been a great privilege to spend the past few years exploring Ruth Asawa's extraordinary drawing practice. To have the opportunity to dive deeply into such a remarkable and still largely unknown body of work, one that carries the artist's most intimate and expansive ruminations on the world around her—and on the materials in front of her—is nothing short of marvelous. We are grateful to our respective institutions, the Whitney Museum of American Art and the Menil Collection, for supporting us in our proposed collaboration, which has enriched our own experience of looking and also strengthened our capacity to share Asawa's work with more audiences.

This exhibition would not have been possible without the unstinting generosity of the Asawa-Lanier family, the children and grandchildren of Ruth Asawa and Albert Lanier. Aiko Cuneo, Addie Lanier, Hudson Lanier, Paul Lanier, and Xavier Lanier, along with their families, offered gracious support and shared tremendous goodwill toward our project from the start. Their profound commitment to and care for Asawa's artistic legacy is infectious, and through them her life-affirming spirit and beneficent ethos are still alive today. As president of Ruth Asawa Lanier, Inc., Henry Weverka accompanied our project every step of the way, always with enthusiasm, care, and the utmost professionalism, while Vivian Tong, arts manager and archivist, gamely answered countless research queries expeditiously and precisely.

Scout Hutchinson, curatorial fellow at the Whitney Museum of American Art, and Kirsten Marples, curatorial associate at the Menil Drawing Institute, were integral parts of the curatorial team, and we are deeply grateful for their remarkable work on all aspects of the project. From the outset, they offered not only tireless organizational support but also critical intellectual contributions, evident in their thoughtful and carefully researched texts in the present volume. Their diligence and collaborative spirit brought the project to fruition seamlessly, and they were joined at certain junctures by Isabel Bird, Menil Drawing Institute pre-doctoral fellow, who offered assistance and expertise, and made a written contribution. Clara Rojas-Sebesta, Ellsworth Kelly Conservator of Works on Paper at the Whitney, has been a key collaborator on this project as well; her material observations and technical discoveries can be found throughout this book, and works that she carefully conserved hang throughout the galleries. Jan Burandt, conservator of works of art on paper at the Menil, offered invaluable advice and expertise too.

This publication is the impeccable work of the Menil Collection's director of publishing, Joseph N. Newland, who rose to the challenge with his characteristic enthusiasm and talent for making beautiful books. We are grateful to scholars Aleesa Pitchamarn Alexander and Jordan Troeller for contributing illuminating new texts to this publication and for their thoughtful dialogues with us along the way. Book designers Miko McGinty and Julia Ma deserve much credit for their crisp, elegant, and sensitive design that gives space to new scholarship while immersing the reader in a bounty of stunning works. The superb color separations and lithography are owed to the masterly printers at Trifolio, Verona, led by Massimo Tonolli. Donna Török-Oberholtzer, the Menil's imaging services librarian, diligently secured rights for images reproduced in these pages.

We benefited immeasurably from the help of many colleagues at both institutions. At the Whitney, we are indebted to Adam D. Weinberg, Alice Pratt Brown Director, for his steadfast support of this project from its inception. For his counsel and trust throughout the planning process, we thank Scott Rothkopf, Senior Deputy Director and Nancy and Steve Crown Family Chief Curator. Numerous other colleagues in administration, advancement, finance and treasury, and strategic planning worked behind the scenes with their teams to make this exhibition and publication possible; in particular we thank I.D. Aruede, co-chief operating officer and chief financial officer; Amy Roth, co-chief operating officer; Pamela Besnard, chief advancement officer; Marilou Aquino, chief philanthropy officer; Eunice Lee, director of strategic partnerships and events; Nicky Combs, director of individual giving; Morgan Arenson, director of foundation, government, and planned giving; Galina Mardilovich, manager of foundations and government relations; Gina Im, senior manager of special events and production; Jen Leventhal, chief of staff; Lily Herzan, executive coordinator to the Alice Pratt Brown Director; and Laura Busby, coordinator, director's office.

For their role in the planning and implementation of the Whitney's presentation, we are grateful

to: Christy Putnam, associate director for exhibitions and collections management; Lynn Schatz, senior exhibitions manager; Paula Bauer, exhibitions coordinator; Emilie Sullivan, registrar, exhibitions; Joshua Rosenblatt, director, exhibition and collection preparation; Caitlin Bermingham, head preparator for exhibitions; and Kelley Loftus, paper preparator. Carol Mancusi-Ungaro, Melva Bucksbaum Associate Director for Conservation and Research, shared her team's great expertise, including that of Margo Delidow, associate conservator. Melanie Taylor, director, exhibition design, and Aseeli Coleman, associate exhibition designer, brought their usual ingenuity to the exhibition's design and layout, and helping to bring the space to life were Elissa Medina, manager, exhibition production; Abigail Hack, production and preparation assistant; Michael Gibbons, audio visual manager; Hilary Greenbaum, director of graphic design and brand creative; and Erika Wentworth, graphic design project manager.

For their support as we welcome audiences to the Whitney, we thank the respective teams of Wendy Barbee-Lowell, assistant director of visitor and member experience; Larry DeBlasio, director of security; Jennifer Heslin, director of retail operations; Brianna O'Brien Lowndes, chief marketing officer; Angela Montefinise, chief communications and content officer; Cris Scorza, Helena Rubinstein Chair of Education; and Peter Scott, chief facilities officer. And, as always, we express our gratitude to our curatorial colleagues, especially Jane Panetta, Nancy and Fred Poses Curator and Director of the Collection; Adrienne Edwards, Engell Speyer Family Curator and Director of Curatorial Affairs; and Melinda Lang, senior curatorial assistant; along with curatorial interns Paula Bauer, Ananya Goel, Jackie Huang, and Casey Li.

At the Menil, we thank Director Rebecca Rabinow for believing in our project and for supporting it despite a tight schedule. Our sincere thanks go to the following colleagues at the Menil Drawing Institute: Catherine Fitzgerald Eckels, registrar, Dominic Clay, conservation technician; Mellon Advanced Training Fellow in Paper Conservation Abby Schleicher; Patrick Yarrington, art preparator, and his Art Services colleagues; Julia Fisher, administrative associate, and Seneca Garcia, visitor/membership assistant. Museum colleagues also deserving thanks include Sarah Beth Wilson, exhibitions manager; Kent Dorn, exhibition designer, and Alex Rosas, exhibition design assistant; Amanda Thomas, senior graphic designer; Joy Bloser, assistant objects conservator; and Mina Gaber, framer; Lauren Gottlieb-Miller, director of the library and archives; Margaret McKee, digital asset manager; and Sarah Hobson, associate director of marketing and communications. The Advancement Department makes the ambitious program at the Menil possible, and thanks are due to its director, Judy Waters; Madeline Kelly, director of individual giving; Martin Schleuse, manager of foundation relations; and their colleagues. Mary Magsamen, public programs manager, and Tony Martinez, programs coordinator, as always, provided valuable expertise.

We are most grateful to the private lenders who agreed to part with important works for the duration of the exhibition, including halley k harrisburg and Michael Rosenfeld, and other lenders who prefer to remain anonymous. Jonathan Laib, senior director at David Zwirner Gallery, which represents the artist's estate, was benevolent towards the project from the outset, and facilitated certain loans with the kind help of assistant Priya Parthasarathy. We are indebted to several colleagues in the field, including Deborah LaCamera at Studio TKM Associates, Inc. and independent conservator Scott Gerson, as well as Veronica Roberts, Cara Starke, and Jason Vartikar, for their help and insights as we were developing our project.

We wish to thank our institutional lenders for their time and generosity: at the Achenbach Foundation for Graphic Arts at the Fine Arts Museums of San Francisco, Thomas P. Campbell, Karin Breuer, Sarah Mackay, Furio Rinaldi, Britta Traub; at the Josef and Anni Albers Foundation, Bethany, Connecticut, Nicholas Fox Weber, Brenda Danilowitz, Kyle Goldbach, Samuel McCune, Karis Medina, Amy Jean Porter; at the Asheville Art Museum, Pamela L. Myers, Whitney Richardson, Hilary Schroeder, Chris Whitten; at the Black Mountain College Museum + Arts Center, Asheville, Jeff Arnal, Alice Sebrell; at the Crystal Bridges Museum of American Art, Bentonville, Arkansas, Rod Bigelow, Austen Barron Bailly, Miquel Geller, Libby Hilliard, Jen Padgett; at the Fuller Craft Museum, Brockton, Massachusetts, Erin McGough, Jackie Lupica, Beth McLaughlin; at the Getty Research Institute, Los Angeles, Mary Miller, Virginia Mokslaveskas, Glenn Phillips, Naoko Takahatake; at the Glenstone Museum, Potomac, Maryland, Emily Wei Rales, Philip Batler, Annie Farrar, Julia Grasso; at the Harvard Art Museums, Cambridge, Massachusetts, Martha Tedeschi, Joachim Homann, Penley Knipe, Katie Kujala, Nicole Linderman, Lynette Roth; at the Stanford University Libraries, Robert G. Trujillo, Leif Anderson, Gurudarshan Khalsa, Tim Noakes, Kristen St.John, Aisha Wahab; and at the State Archives of North Carolina, Raleigh, Sarah E. Koonts, Cynthia Bradley, William H. Brown, Heather South. Also, we would be remiss if we did not express our sincere gratitude to the generous funders of this project.

Finally, we wish to thank our families—David, Miles, and Emmet; Frauke and Léandre—for their support and patience, and for enriching our daily lives.

<div align="center">

KIM CONATY
Steven and Ann Ames Curator of Drawings and Prints
Whitney Museum of American Art

EDOUARD KOPP
John R. Eckel, Jr. Foundation Chief Curator
Menil Drawing Institute

</div>

PREFACE

For Ruth Asawa (1926–2013), drawing marked the beginning of a lifelong interest in and commitment to art. Attesting to the significance of the medium in her practice, she started to express the desire to show her drawings in the 1950s. In a letter to the dealer John Hohnsbeen at Peridot Gallery in New York, her gallery of six years by the time she wrote in 1959, Asawa asked: "Would it be possible sometime to have a show of drawings? I have been drawing a lot and hoping to paint too and leave wire alone for a while."[1] Her idea was ultimately rejected, likely owing to her rising renown as a sculptor; she had been the subject of three exhibitions at Peridot, and her groundbreaking looped-wire sculptures were featured in three Whitney Annuals between 1955 and 1958. But Asawa continued to draw daily, referring to the act as her "greatest pleasure and the most difficult."[2] Drawing was the center of gravity for her creative journey, an indispensable and generative everyday exercise she likened to "scales for musicians."[3]

Ruth Asawa Through Line presents the artist's work through the lens of her expansive drawing practice. By drawing, Asawa explored her immediate surroundings and the boundaries of the medium itself, turning quotidian encounters into moments of profound beauty and endowing ordinary objects and subjects with new aesthetic possibilities. Her motivations to draw, beyond mere pleasure, were manifold: to see, to know, to record, to heal, and to nurture the world around her, as well as to imagine what is or might be beyond the visible.

This volume, like the eponymous exhibition it accompanies, demonstrates the breadth of Asawa's innovative practice, positioning drawings, collages, watercolors, and sketchbooks alongside stamped prints, paperfolds, copper-foil works, and a few sculptural works in the round, for as early as the 1950s Asawa saw her sculpture as "an extension of drawing . . . almost like drawing in space."[4] Highlighting the continuity of drawing in her practice is at the heart of the present investigation.

Organized thematically, the book opens with four essays, each considering a particular aspect of Asawa's multifaceted practice: her drawing as a daily discipline and lived experience; a way to weave a sense of community; her engagement with paper and its value in teaching; and, finally, her exploration of drawing materials and techniques. These texts are followed by artworks organized into thematic groupings that consider eight ways to look at Asawa's body of drawings. Each one—whether "Found and Transformed" or "Rhythms and Waves"—is a leitmotif in Asawa's work, often an approach that the artist returned to again and again over the years. Concise introductions to each grouping articulate the key ideas at play and contextualize those works within Asawa's oeuvre, always centering the artist's voice and honoring her profound sensitivity and boundless curiosity.

Asawa's exploratory and resourceful approach to materials, line, surface, and space developed from her childhood to her last years. Drawing remained a constant, providing a connective tissue across her life and work as artist, educator, and community leader. Those closest to her understood the crucial importance of this activity, even as many of her drawings were never exhibited or shared outside the home. Looking back on their memories of their mother, Asawa's daughters Aiko and Addie explained: "She sketched almost every day because it helped strengthen her ability to see."[5] *Ruth Asawa Through Line* seeks to offer us all an opportunity to see through Asawa's eyes, opening, as it were, a window into her world.

— KC AND EK

1 Ruth Asawa, letter to John Hohnsbeen, April 6, 1959, Ruth Asawa Papers, box 101, folder 7.
2 Ruth Asawa, artist statement, c. 1968–73, Ruth Asawa Papers, box 127, folder 1.
3 "I think drawing is very central. It's like scales for musicians," Ruth Asawa, quoted in Jeannette Good, "Ruth Asawa & Albert Lanier: When Creativity Sparks a Marriage," *Prime Time*, a quarterly supplement for the *San Francisco Independent*, March 1996, 3. We are grateful to Vivian Tong for sharing this reference.
4 Ruth Asawa, interview with Mary E. Harris, December 19, 1971, Ruth Asawa Papers, box 35, folder 3.
5 Aiko Cuneo and Addie Lanier, in Gwynned Vitello, "Ruth Asawa: The Poetry of Pattern." *Juxtapoz*, October 9, 2018, https://www.juxtapoz.com/news/magazine/ruth-asawa-the-poetry-of-pattern.

Ruth Asawa's archives are in the Stanford University Libraries, Department of Special Collections, accession M1585, abbreviated here throughout as "Ruth Asawa Papers."

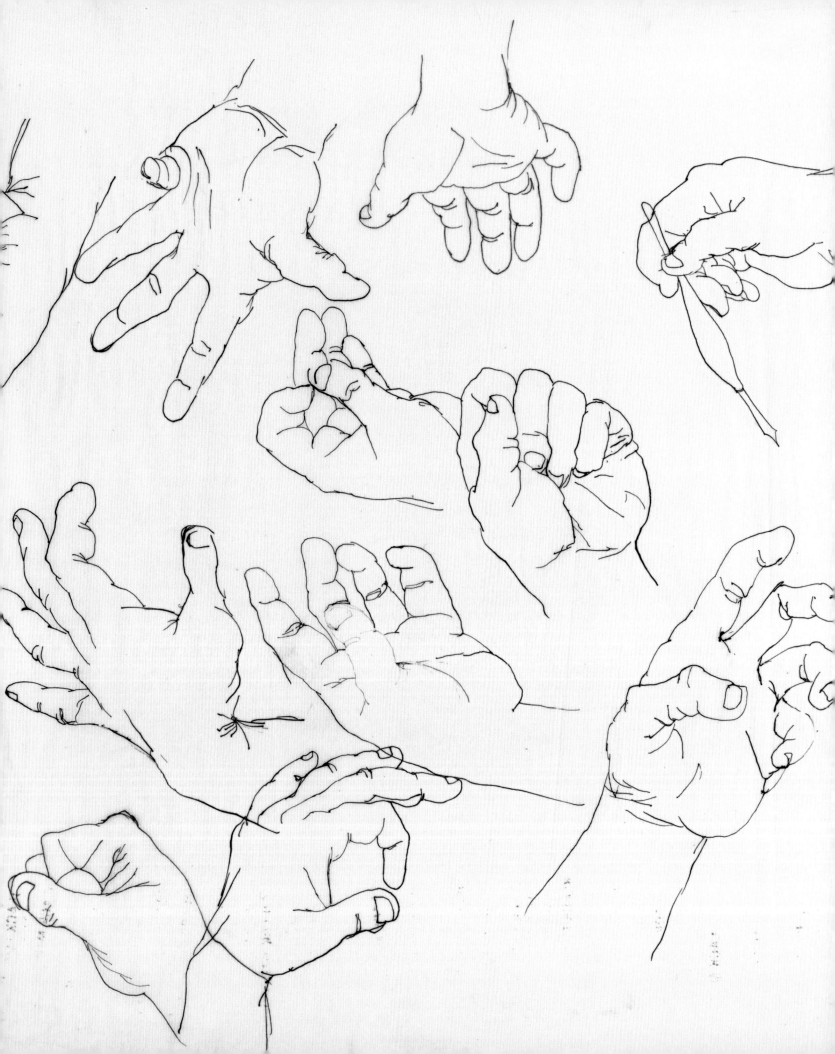

KIM CONATY

"YOUR HAND IS ALREADY FLOWING"

Ruth Asawa's Daily Practice of Drawing

Detail of *Untitled* (BMC.123, Studies of Hands and Feet), c. 1946–49, see p. 74

"Work slower, Ruth, for neatness." So implored Edith Lowe, Ruth Asawa's art teacher during her first year at Excelsior Union High School in Norwalk, California, as she evaluated her student's lettering assignment. An exercise in form, ink handling, and, of course, "good spacing," Asawa's notebook sheet shows her trying out different scripts and flourishes, as curving G's lead to looping O's, and incidental smudges and drips appear along the way (see next page). The phrase is rendered as a repeating pattern, but it also becomes a mantra; when the last of the more generously scaled letters on the fourth line falls off the edge, it does so as an inevitability of the former and perhaps an unexpected consequence of the latter.

For Asawa, neatness would never be the point. An inkblot was a natural occurrence, an inherent risk in employing an aqueous medium to turn tight corners on an absorptive support. Such material curiosity and preoccupation with process itself became a hallmark of Asawa's approach to drawing, just as her persistence with even the most repetitive manual exercises would come to define her work on paper as well as her looped- and tied-wire sculptures. In her hands, art became a process of continuous exploration and negotiation, not a means to an end. And drawing, as a daily practice, served as an active mode of seeing, recording, understanding, and participating in the world around her.

BREATHING LINES

"With art," Asawa later remarked, "your motor sense should be developed at full capacity."[1] Well before she set foot in her first art class, Asawa had acquired notable dexterity working on her family's farm. Growing up in a Japanese American household that valued both contribution to the family livelihood and participation in cultural traditions, Asawa and her six siblings were expected to help out on the family's truck farm after school, performing assigned tasks until evening on weekdays and on Sundays. Asawa chopped wood, repaired vegetable crates, and trellised beans, all independent jobs that required careful eye-hand coordination. Thinking back on her childhood home decades later, Asawa drew from memory the repeating patterns of the board-and-batten farmhouse her father had built before she was born, complete with a corrugated metal roof represented by a simple undulating line along the edge. The modest structure, rendered in graphite contours, suggests a frugal existence but one marked with care, the curtains neatly draped in the windows

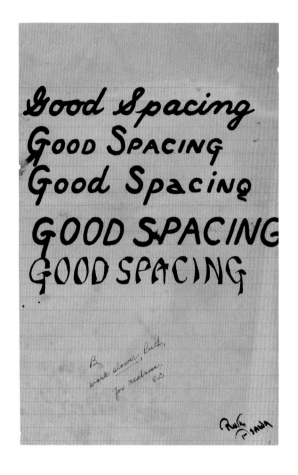

carrying it across the paper until the ink ran out, a cyclical rhythm described as a "breathing line," as one inhales when the ink is replenished, and exhales as it flows out. Though calligraphy training begins with rote exercises aimed at building a repertoire of precise strokes, true mastery of the art is achieved through a marriage of technical facility and human touch. The presence of the hand, including incidental marks or inconsistencies, grounds the activity in the natural world. In addition, calligraphy requires the ability to see the whole sheet while making marks within it. Working from top to bottom and right to left, Asawa learned to focus on the spaces around her brush: "You're watching what it isn't doing, so that you're taking care of both the negative space and the positive space."[5] This allover sensibility and constant negotiation between line and space, control and curiosity, laid the groundwork for her later training at Black Mountain College, where she would push these ideas ever further. Calligraphy grids tucked into her notes for one of Josef Albers's classes suggest that she may have returned to the art form during this time.[6]

If Asawa's childhood instilled a rigorous daily practice of handwork and hard work, the sixteen months she spent in incarceration camps after her family was forcibly removed from their home presented an unexpected rupture with routine. First at the Santa Anita Racetrack and later at Rohwer Relocation Center in Arkansas, Asawa was confronted with abject living conditions, oppressive surveillance, and, like all of the Japanese American detainees there, a lack of privacy and freedoms. Displaced and disoriented, prisoners sought to establish ways to instill the empty stretches of time with some semblance of normalcy through community activity. For the sixteen-year-old Asawa, this meant time to pursue drawing in earnest. She met a group of accomplished Walt Disney Studio animators also detained at Santa Anita, including Tom Okamoto, who offered drawing and watercolor instruction; later, at Rohwer High School, she enjoyed the support of a dedicated art teacher, Mabel Rose Jamison, who took students on sketching trips to practice drawing from nature: "This was the first time in my life," Asawa later explained, "that art was not something extra to do, but the main subject."[7]

Before this time, Asawa's free drawings comprised mostly cartoons and sketches copied from reproductions and comic strips. In the camps, she began to work from life, studying

and billows of smoke rising from the chimney. On the farm, she learned from her mother to use both hands—"she'd pick with her right and her left and her right"—and to work close to the land, observing nature and noting its changes.[2] While doing so, Asawa took advantage of the solitary time to daydream, forging a generative synergy between manual work and freeing the mind. "The seemingly endless patterns we made in the dust," she remembered, "the shapes of the flowers and the vegetation, the translucence of a dragonfly's wing when sunlight pours through it—these things have influenced my work."[3]

Weekly calligraphy lessons at a local Japanese school on Saturdays further honed Asawa's agility, as she learned to wield a brush and coax the sumi into distinct strokes. Looking back on her experience as an eight-year-old student she reflected: "It was like a dance. Lift your feet up and lift up your hands. You have to work so this round curve turns into the next stroke."[4] There was life in these lines, and she intuitively connected with it, understanding the practice as a form of choreography as much as painting and writing, with inherent possibilities in every character. The dance involved loading a flexible brush with medium and then

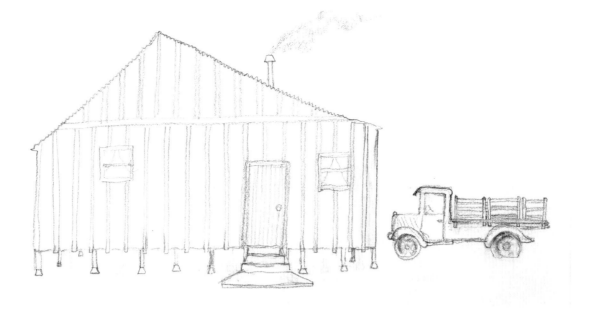

Detail of Ruth Asawa's drawing of the family home, Norwalk, California, 1985. Private collection

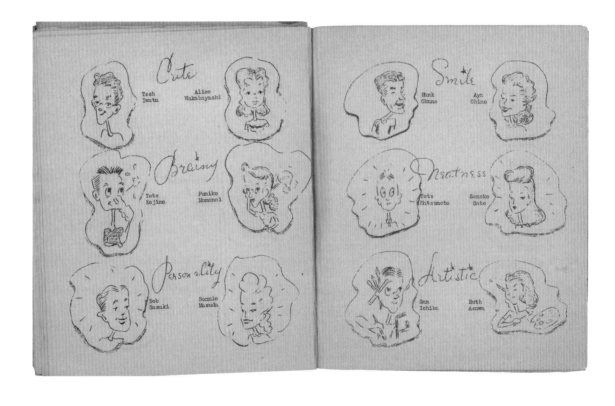

Ruth Asawa's illustrations for the *Delta Round-Up,* Rohwer High School Annual, Rohwer, Arkansas, 1943. Courtesy of the Department of Special Collections, Stanford University Libraries

the people and places around her. For her high school yearbook, the *Delta Round-Up,* for which she served as art editor, she infused her cartooning talents with her sharp observational skills to create a set of playful caricatures of schoolmates, demonstrating her keen ability to capture the personality of her subjects through line. Classmates known for their "smile," "neatness," or for being "artistic"—the accolade with which

she endowed herself—are rendered in small, lively sketches, each ensconced within a halo of amoeba-like form, whose line responds to the contours of the subjects themselves. Looking back on this experience she noted, "I think [art] did help with the anger, but I didn't know it at the time."[8] Throughout the months of imprisonment, drawing served as a salvation and a purpose, a breathing line that sustained her.

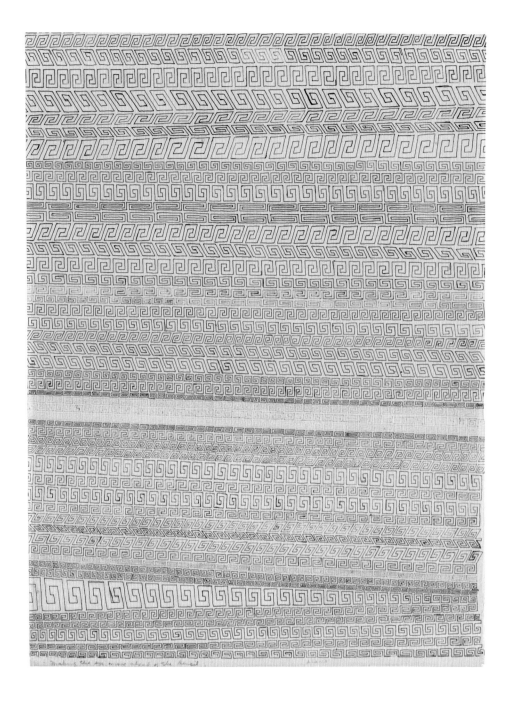

MAKING THE EYE MOVE AHEAD OF THE PENCIL

When Asawa arrived at Black Mountain College in July 1946 for the summer session, her drawing practice took on new rigor and life. She had come to the progressive North Carolina school from Milwaukee State Teachers College, where she had pursued further artistic training with the aims of becoming an educator. Ever inquisitive, Asawa had traveled with her older sister Lois during the summer of 1945 to Mexico, where she learned techniques of fresco painting, watched muralists at work, and studied with the Cuban-born furniture designer Clara Porset at the Universidad Nacional Autónoma de México

(National Autonomous University of Mexico). Porset encouraged the young artist to seek out Josef Albers at Black Mountain College, a recommendation that would be echoed in the following months by her friends and classmates Ray Johnson and Hazel-Frieda Larsen (later Hazel Larsen Archer) upon her return to Milwaukee.

Though Asawa intended to complete her teaching degree, persistent prejudice against Japanese Americans prevented her from completing the student teaching assignment required to graduate. Seeking inspiration while determining her next steps, she applied and enrolled for the 1946 summer session at Black Mountain College as an interim step.

The profoundly intensive program—which was based in a communal environment that required collaboration, shared labor, and a creative approach to materials given meager resources—embodied the values that she had already been living out of necessity; Asawa was uniquely positioned to absorb and explore all that the experimental school had to offer.[9] Of her first courses there, she recalled: "I signed up for Josef Albers' Basic Design and Color classes and another world opened up for me."[10]

Asawa spent three years at the school, with the exception of another summer trip to Mexico in 1947 that would inspire her nascent sculpture practice.[11] Above all other lessons she learned at the school during this time, Asawa credits her instructors with teaching her how to see.[12] Drawing became a crucial activity in developing this skill, not with the aim of representing the world mimetically but rather with a goal of investigating it. Through free studies, line exercises, and object lessons, Albers encouraged students to focus on process and to spend time intensely observing their subjects, whether the rhythmic, repeating curves of a Jello mold as seen from multiple angles (BMC.48 [p. 75]) or the telling creases and dynamic contortions of one's own hands and feet, (BMC.123 [p. 74]). Asawa embraced this inquisitive mode, devoting her full attention in the service of "making the eye move ahead of the pencil," an Albersian idea that Asawa jotted in her notes and inscribed at the bottom of one of her drawings that explored the Greek meander. This pattern is based in a continuous line that moves forward while also turning in on itself, again and again. With equal attention given to interior and exterior spaces, the meander opened up more possibilities to her, as she experimented with its principles in notebook pages alongside notes about yin and yang, figure

and background, and ensuring that "negative [is] taken care of as much as positive." Albers professed the importance of economies of form in the meander and in all artistic pursuits; Asawa's class notes include phrases like "do less get more," "do one get two," and "be curious."[13]

In Albers's Design and Color classes, which Asawa enrolled in several times while at Black Mountain, she leaned in to her teacher's belief in continuity and the infinite—no exercise was ever finished, and ideas could and should be explored over and over, based in direct encounters, and across materials and mediums; "endlessness as method," as the art historian Jordan Troeller has incisively described it.[14] "In the simple process of drawing," Asawa recalled of her re-enrollment in this class and continued attention to its values, "[t]he difference between stopping at two hours and four hours and six hours or going through and starting, continuous again on the same thing, your hand is already flowing like this. And I think this has great value."[15] Asawa's description of this sustained drawing practice resonates with the idea of a flow state, an experience of absorption and focus in which senses operate in optimal form and the mind and body are wholly in sync. The value of being in such a state can be euphoric, or, at the least, can offer a sense of self-actualization and clarity regardless of the passage of time or distractions in the surrounding environment.

KEEPING YOUR HANDS IN IT
Continuous stretches of uninterrupted time would be harder to come by outside of the more protected environment of school. In 1949, following her time at Black Mountain, Asawa moved to San Francisco to begin the next phase of her life, with her classmate, the architect Albert Lanier. As she pursued her artwork and Lanier settled into a slew of new projects through his firm, they were also eager to begin a family; a middle child who grew up with six siblings, Asawa hoped that she would be surrounded with six children of her own. Between 1950 and 1959, she and Albert became the proud parents of Xavier, Aiko, Hudson, Adam, Addie, and Paul, all while managing an increasingly busy decade in their own work.[16] As Asawa reflected, "I couldn't go to a drawing class so I drew my children or the flowers in the garden. I kept my hands in it."[17] Indeed, she was determined to integrate her life and her work, even in these years when her

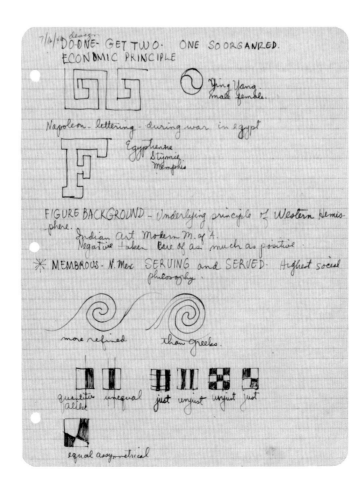

Ruth Asawa's notes on lettering and the meander from Josef Albers's Design class, Black Mountain College, July 16, 1946. Courtesy of the Department of Special Collections, Stanford University Libraries

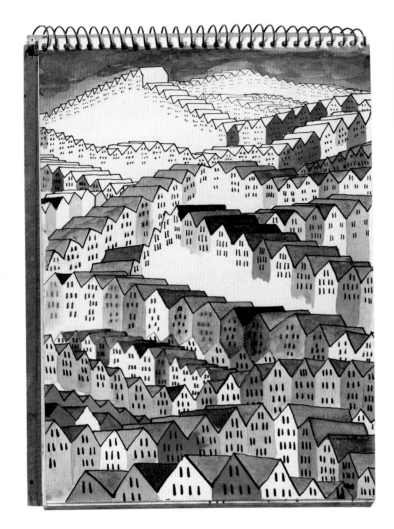
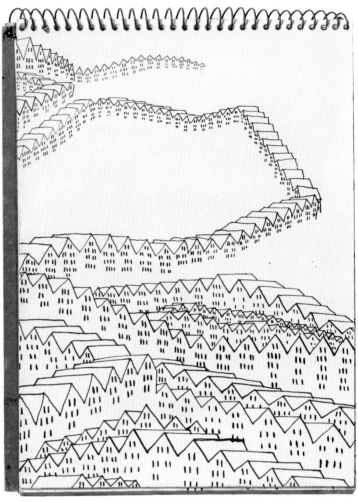

children were youngest—a dance only possible with a strong and boundlessly energetic lead.[18]

Asawa's sketchbooks from the 1950s offer a glimpse into her daily life during this time, as she kept her hand active in those infrequent "snatches of time" and in the moments when she was caring for others.[19] The contents of one small sketchbook, eight by six inches and dated 1957 through 1959, demonstrate the ways in which she took drawing exercises and concepts from Black Mountain and used them to see her surroundings anew. In two drawings—one rendered in black ink and the other with added watercolor—she transformed a view that approximated the one from her Saturn Street home into a continuous, geometric pattern, emulating the houses as they shoulder one another along the hilly cityscape. The sketches bear similarities to Asawa's earlier In and Out paintings based on Albers's paper-folding exercises, in which students explored the relationship between figure and ground by manipulating a flat sheet into

a sculptural form, and then translating the peaks and folds of the three-dimensional form back into line on paper; planes of color, as she demonstrated in works such as an untitled drawing of about 1946–49 (BMC.132 [p. 77]), added yet another dimension.[20]

A spiral-bound notebook from 1958 with a black marbled cover and translucent paper exemplifies Asawa's drawing practice during these years as a true family affair, she and her children working alongside one another, their lines bleeding into one another's. Her studies of calla lilies, likely from her garden or brought to her by friends and family, stretch across the page, the black-ink lines sweeping and elegant in their economical capture of the petals' ornamental forms. The ink seeped through the paper, allowing each subject to be visible on recto and verso, at times forging expansive, chance compositions across a full spread. A few pages later, Asawa's gentle portrait of one of the neighborhood children, Larry Woodbridge, seen obliquely

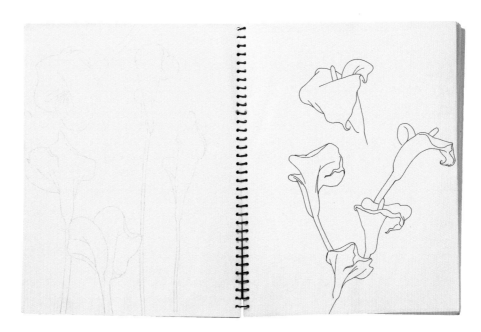

Untitled drawings of calla lilies (SB.013), 1958. Ink on paper in spiral-bound sketchbook, 11 × 8½ in. (27.9 × 21.6 cm) each. Private collection

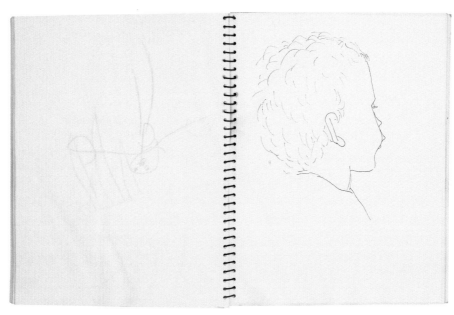

Untitled drawing of Larry Woodbridge (right), with child's drawing (left) (SB.013), 1958. Ink on paper in spiral-bound sketchbook, 11 × 8½ in. (27.9 × 21.6 cm) each. Private collection

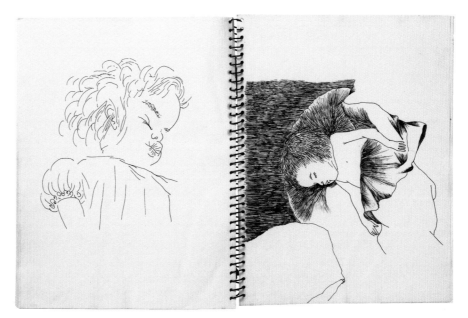

Untitled drawings of Addie Lanier sleeping (SB.013), c. 1958. Ink on paper in spiral-bound sketchbook, 11 × 8½ in. (27.9 × 21.6 cm) each. Private collection

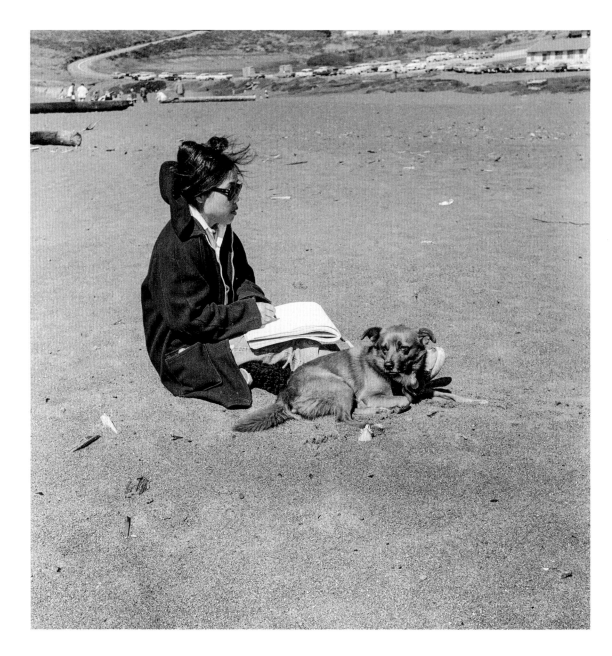

Ruth Asawa sketching on the beach at Fort Cronkhite with Henry the dog, 1967. Photograph by Imogen Cunningham

from the back, appears across from one of the younger children's lively stick-figure sketches, portraits of a different kind, seemingly prompted by their mother's line. Finally, two lovingly rendered portraits of a napping Addie show Asawa carefully taking stock of the still, small being before her, the curving lines in the sleeve of her dress echoing those that capture the tendrils of her hair, just as hatching marks on the opposite page forge a portrait through pattern.

Beginning in 1950, Asawa developed a rich and sustaining relationship with the photographer Imogen Cunningham, and the two became lifelong friends and subjects for each other.[21] Cunningham, Asawa noted, "taught

me . . . that in child rearing the artist can still create by observing what is around them, children, plants, and making images that can be savored when we are old."[22] A deep respect and sense of reciprocity underpinned Asawa's relationship with Cunningham, who became an important part of the Asawa-Lanier household. Outside of her own family members, Cunningham was one of Asawa's most frequently depicted subjects, typically represented in intimate portraits capturing the expressive contours of her face, her independent spirit, and her eccentric style. Asawa also portrayed the elder Cunningham at work. On one of their joint outings, their mutual interest in each other as

Untitled (FF.909, Seven Views of Imogen Cunningham), c. 1976. Ink on Japanese paper, 18¾ × 40 in. (47.6 × 101.6 cm). Private collection

subjects was memorialized in portraits by and of both artists. During a 1967 trip to Rodeo Beach, in the Marin County Headlands just north of San Francisco that includes Fort Cronkhite, Cunningham shot multiple photographs of Asawa and her family, but also of the artist seated alone on the sandy beach, her dog, Henry, beside her, with sketchbook in her lap and sun-shaded eyes directed toward a subject before her. Cunningham herself was a subject, pictured in multiple images across several sketchbook pages, awkwardly carrying her equipment or hunched over her Rolleiflex camera, her head buried below a dark cloth. The two appeared to see each other most fully through their chosen implements— whether the camera or the pen—guided by their equally attuned observational skills.

I DRAW MORE THAN I DOODLE

In the 1960s and particularly in the 1970s, Asawa became very active in civic responsibilities around the Bay Area, throughout California, and even with the National Endowment for the Arts in Washington, DC; her involvement with the California Arts Council, the federal Comprehensive Employment and Training Act (CETA), and other organizations grew out of her strong belief in

arts pedagogy and the need to support such opportunities for schoolchildren. "The arts are so important," she explained, "because they are teaching you how to use your body as an instrument. You learn to leap, you learn to sing, you learn to hear, you learn to see, and you learn to use your hands."[23] With these affiliations and activities, Asawa was often out of the house and spent considerable amounts of time in meetings. Her daily drawing practice never ceased though; it simply became a form of notetaking. This mode of drawing to keep the hand active while otherwise engaged is often described as "doodling," but Asawa had a strong response to that word: "I draw more than I doodle. It's a fine line between the two."[24]

Across scores of sketchbooks, Asawa captured the activities at myriad convenings and gatherings, as she watched, listened, and paid careful attention to the important—if often bureaucratic—discussions around her. In some drawings, her role as observer is emphasized, as in a sketch from May 1977, depicting a State Senate Finance Hearing in Sacramento at which she is quite literally not at the table, the backs of conference-room-style chairs forming a barrier between her and her subjects. A similar feeling of

remove and curiosity is captured in her study of four profiles of a man (or men) wearing glasses, the curves of the visages echoing one another and forming a repeating pattern that suggests a set of types as much as individuals (SB.076 [p. 217]). In many other drawings, Asawa's close relationships with committee members and advocates are made visible through her touch. In a drawing of artist and fellow California Arts Council member Noah Purifoy at a Los Angeles Board of Education meeting, Asawa offers just enough information in her pen sketch to communicate her friend's soft yet intense gaze, the creases on his forehead, how his fingers curl around the phone he holds to his ear (SB.102 [p. 216]). As she did in her drawings of Cunningham, Asawa was recording a kindred spirit engaged in activity, someone that she

knew intimately and could see fully even when he was otherwise occupied.

DRAWING ALONE

While the world around her slept, Asawa often stayed up, reveling in the open, uninterrupted stretches of time and resting her mind while drawing. She loved to watch her favorite television programs—news station interviews and musical performances, in particular—while capturing the televised subjects in her sketchbooks. As she did in many committee meetings, Asawa participated through the activity of her pen or pencil, sometimes even recording her subjects' statements alongside their depictions. One sketch from August 23, 1994, depicts television host Jane Pauley from an appearance on the talk show *Charlie Rose*, alongside a caricatured

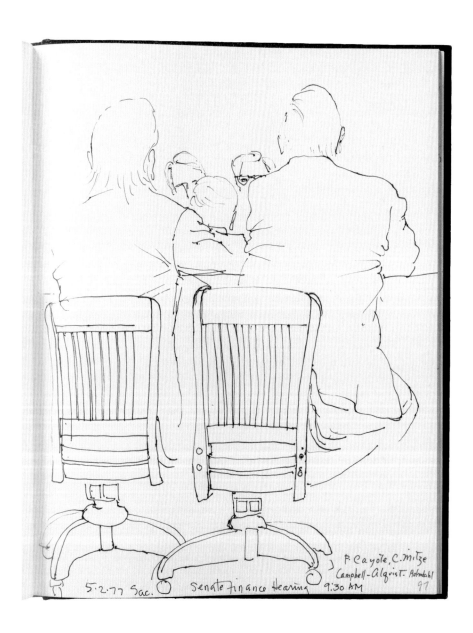

5.2.77 Sac. Senate Finance Hearing 9:30 AM P. Cayote, C. Mitze, Campbell-Alquist. Holmdahl (SB.085), 1977. Ink on paper in hardbound sketchbook, 11 × 8 in. (27.9 × 20.3 cm). Private collection

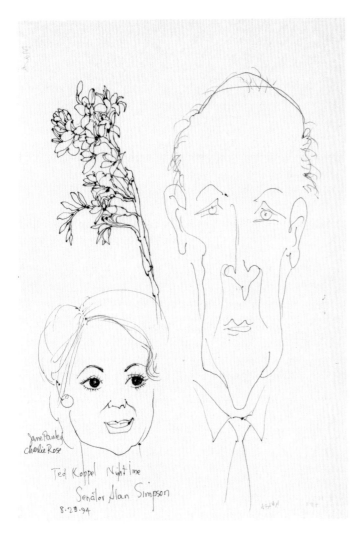

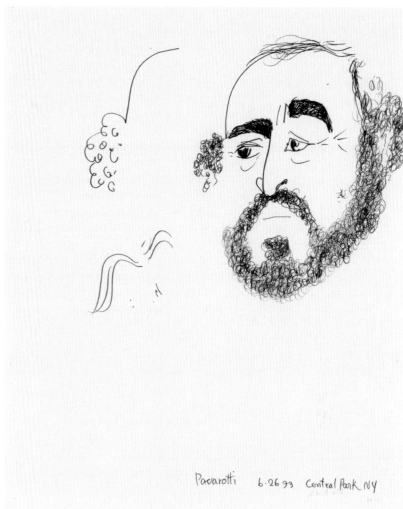

image of Wyoming Senator Alan Simpson from *Nightline* with Ted Koppel, and between them an elegant set of intertwined stems and flowers, likely positioned near her as she sketched from the screen. Another, one of many drawings of Luciano Pavarotti—a favorite of hers—captures the expressive facial movement and looping curls of the world-renowned tenor at his June 26, 1993, performance in Central Park, a program broadcast on PBS before millions, all joining this communal experience from their own homes. This was Asawa's private world, a place where she could take her time to watch, listen, see, feel, and draw.

As part of an autobiographical narrative Asawa began to write in the mid-1980s, she described the ways in which drawing had (or could have) anchored her days: "Ruth washed the dishes, made the bed, and began to draw in her sketchbook. . . . She was happy to draw for hours. . . . She had eight hours to quietly look/

study and draw a bouquet of flowers that Albert had picked up at Union Square the day before. . . . Next week it would be a different bouquet. He would find one that he thought she would like to draw."[25] This story captures the mundanity of a daily practice that is anything but banal; rather, through repetition and over time, "Ruth" opens herself to new experiences, insights, and knowledge. No flower is the same, and every arrangement offers a fresh set of forms to untangle through line. Without voices of their own, these subjects relied on Asawa moving her eye ahead of the pencil, watching them with an unwavering gaze while she worked rather than looking down at the movements of her line.

Captured in a 1990 photograph sketching the plants on the patio outside her house, Asawa appears to be fully absorbed in the act of looking, her body leaned in to her work, elbows resting comfortably on her knees, and chin tilted up just enough to take in the jungle of leaves, stems,

and petals before her. As if extensions of her engaged body, her nib pen rests comfortably in her right hand, which hovers over the paper, the ink pot settles in her left. Whether studying plant forms in her garden or staying up late into the night sketching loquat cuttings at her table, Asawa's solitary drawing practice was a critical, grounding part of her days that most people did not see. Portrayed so often by her mother while growing up, Aiko (Cuneo) turned the lens back on her mother in a photographic nocturne that captures Asawa's relentless energy and perpetual insomnia.[26]

Throughout Ruth Asawa's life, her line served as a sustaining force and, at times, a barometer. A notebook page from a debilitating bout with lupus is a testament to drawing's continued role as salvation. Three irises, sketched on a single page and annotated with the time of day in which she made them, mark her convalescence (SB.157 [p. 218]). The strokes of her pen forge the graceful, arcing stems that open and expand into lines and waves. With "hand unsteady," she continued to draw, exercising eye, mind, and body in a record and reflection of her well-being. Drawing, always, was the through line.

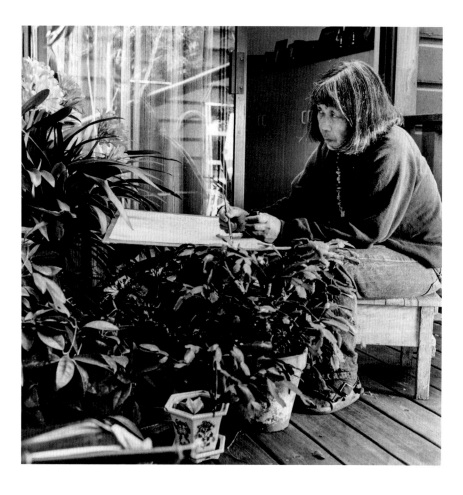

1 Ruth Asawa, lecture on Josef Albers, n.d., Ruth Asawa Papers, box 1, folder 4.
2 Ruth Asawa, "Oral History Interview with Ruth Asawa Lanier," by Taeko Joanna Iritani, April 7, 2000, Department of Special Collections and University Archives, California State University, Sacramento, https://californiarevealed.org/islandora/object /cavpp%3A22611.
3 Ruth Asawa, artist statement, c. August 14, 2001, Ruth Asawa Papers, box 107, folder 3.
4 Ruth Asawa, in Jacqueline Hoefer, "A Working Life," in The Sculpture of Ruth Asawa: Contours in the Air, Timothy Anglin Burgard and Daniell Cornell et al., rev. ed. (San Francisco: Fine Arts Museums of San Francisco; Oakland: University of California Press, 2020), 32.
5 Ruth Asawa, Art, Competence, and Citywide Cooperation for San Francisco (Berkeley, CA: Regional Oral History Office, Bancroft Library, University of California, Berkeley, 1980), 14.
6 See Black Mountain College Albers class notes, n.d., Ruth Asawa Papers, box 174, folder 6.
7 Ruth Asawa, artist statement, c. 1968, Ruth Asawa Papers, box 127, folder 1. For a fuller account of the Asawa family's time in these incarceration camps, including correspondence and the specific conditions they endured, see Marilyn Chase's extensive biography on Asawa. Marilyn Chase, Everything She Touched: The Life of Ruth Asawa (San Francisco: Chronicle Books, 2020), 22–35.
8 Ruth Asawa, in CBS Sunday Morning interview by Jerry Bowen, July 31, 1994, Ruth Asawa Papers, box 44, folder 1.
9 For a more complete discussion of Asawa's transition to Black Mountain College, see Karin Higa, "Inside and Outside at the Same Time," in The Sculpture of Ruth Asawa: Contours in the Air, Timothy Anglin Burgard and Daniell Cornell et al., rev. ed. (San Francisco: Fine Arts Museums of San Francisco; Oakland: University of California Press, 2020), 52, 62–63.
10 Ruth Asawa, artist statement, c. 1982–89, Ruth Asawa Papers, box 127, folder 5. The proper course titles were simply "Design" and "Color," and Asawa took Design twice (summer 1946 and spring 1948) and Color three times (summer 1946, summer 1948, and spring 1949). Ruth Asawa student file, Black Mountain College Records, Western Regional Archives, State Archives of North Carolina, Asheville.
11 In the summer of 1947, Asawa returned to Mexico and taught art in Toluca for the American Friends Service Committee. It was during this trip that she became interested in local crafts, especially the looped-wire baskets used to carry eggs; this would be a critical impetus in her development of the looped-wire technique in sculpture. For a succinct account of Asawa's time in Mexico, see Zoë Ryan, "There Is Design in Everything: The Shared Vision of Clara Porset, Lola Álvarez Bravo, Anni Albers, Ruth Asawa, Cynthia Sargent, and Sheila Hicks," in In a Cloud, In a Wall, In a Chair: Six Modernists in Mexico at Midcentury, ed. Zoë Ryan (Chicago: Art Institute of Chicago, 2019), 46–48.
12 In later years, Asawa often credited her Black Mountain training, and especially her courses with Josef Albers, with teaching her to see. In a letter to Albers in 1963, she noted this directly: "The San Francisco Museum of Art called me to ask if I would give a talk about you and your approach to color and design. . . . I will tell them

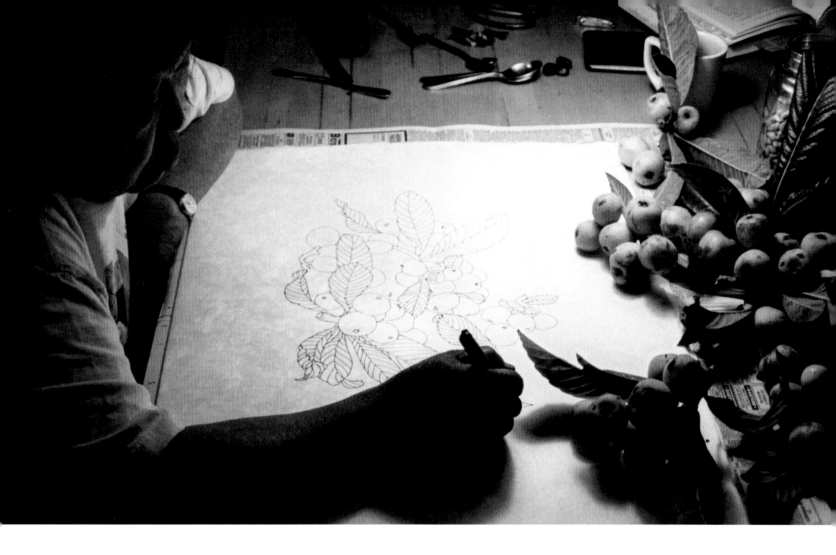

Pages 26–27:
Untitled drawings (SB.200),
1995. Spiral-bound
sketchbook, various
mediums, 17 × 14⅛ in. (43.2 ×
35.9 cm) open; 17½ × 14⅛ ×
½ in. (44.5 × 35.9 × 1.3 cm)
closed. Private collection

Pages 28–29:
Untitled drawings (SB.066),
1971. Hardbound sketchbook,
various mediums,
14 × 22 in. (35.6 × 55.9 cm)
open; 14 × 11 × ¾ in. (35.6 ×
27.9 × 1.9 cm) closed.
Private collection

how you have influenced in my seeing. I hope you do not mind." Letter from Asawa to Albers, April 26, 1963, Ruth Asawa Papers, box 1, folder 4.

13 The phrase "Do less get more" appears in Asawa, lecture on Josef Albers. "Do one get two" appears in Asawa's notes on lettering and the meander from Josef Albers's Design and Color courses, July 16, 1946, Ruth Asawa Papers, box 175, folder 9. The phrase "Be curious" appears in Asawa's notes from Albers's Design class, Ruth Asawa Papers, box 174, folder 13.

14 For a carefully researched account of Asawa's drawing instruction from Josef Albers, see Jordan Troeller, "Drawing Lessons: Ruth Asawa's Early Work on Paper," in Object Lessons: The Bauhaus and Harvard, ed. Laura Muir (Cambridge, MA: Harvard Art Museums, 2021), 149–65; quotation on 163.

15 Ruth Asawa, "Interview with Ruth Asawa and Al Lanier," by Walt Parks, June 28, 1968, Ruth Asawa Papers, box 35, folder 2.

16 The Asawa-Lanier children include Francis Xavier Lanier (b. 1950); Aiko Lanier (b. 1950); Hudson Dehn Lanier (b. 1952); Adam Lanier (1956–2003); Addie Laurie Lanier (b. 1958), and Paul Asawa Lanier (b. 1959).

17 Ruth Asawa, in The New Older Woman conference transcript, July 15–18, 1991, Ruth Asawa Papers, box 127, folder 6.

18 Addie Lanier has described her mother's "relentless energy." Addie Lanier, conversation with the author, June 23, 2021.

19 Ruth Asawa, in Cathleen Rountree, On Women Turning 70: Honoring the Voices of Wisdom (San Francisco: Jossey-Bass, 1999), 93.

20 I am indebted to Aiko Cuneo for suggesting the likely relationship between these cityscapes and Asawa's consideration of paper-folding and Black Mountain "in and out" exercises. Aiko Cuneo, in email correspondence from Vivian Tong to the author, September 26, 2022.

21 For a focused examination on the collaborative friendship of Asawa and Cunningham, see Makeda Best, "Spaces of Relation," in Ruth Asawa: All Is Possible, Helen Molesworth et al. (New York: David Zwirner Books, 2022), 92–98.

22 Ruth Asawa, lecture on Imogen Cunningham, August 15, 1993, Ruth Asawa Papers, box 6, folder 6.

23 Ruth Asawa, in Ruth Asawa: Of Forms and Growth, film by Robert Snyder (Santa Barbara, CA: Masters & Masterworks, 1978).

24 Ruth Asawa, response to Merla Zellerbach (San Francisco Chronicle), September 20, 1982: "I draw more than I doodle. It's a fine line between the two." Ruth Asawa Papers, box 100, folder 3.

25 Ruth Asawa, handwritten pages telling story of her life (her attempts at "fantasy"), March 4, 1985, Ruth Asawa Papers, box 127, folder 5.

26 Asawa's perpetual insomnia has been discussed often by her family. Recent publications that have cited this include Ruth Erickson, "Wide Awake," in Molesworth, Ruth Asawa: All Is Possible, 30.

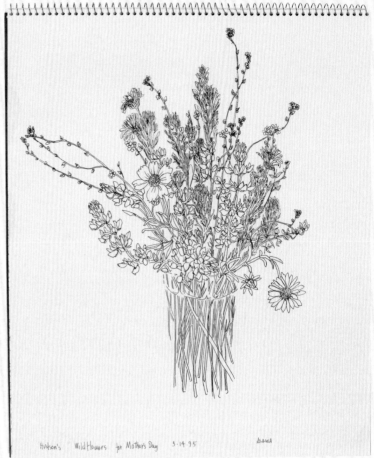

Hudson's Wild Flowers for Mother's Day 5-14-95 Asawa

Xavier Gerri orangered succulent 6.14.95 ASAWA

Barbara & Lois's Orchid 6-20-95 ASAWA

6-22-95 Nasturtiums

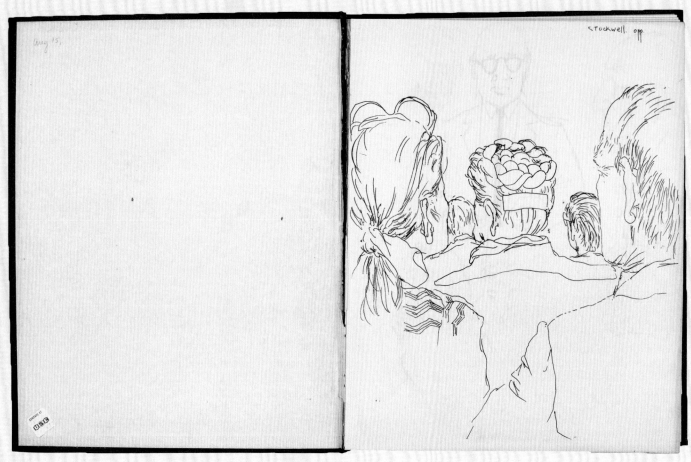

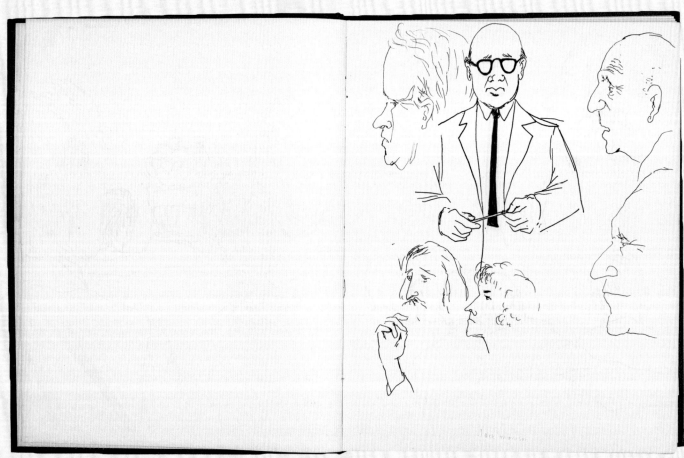

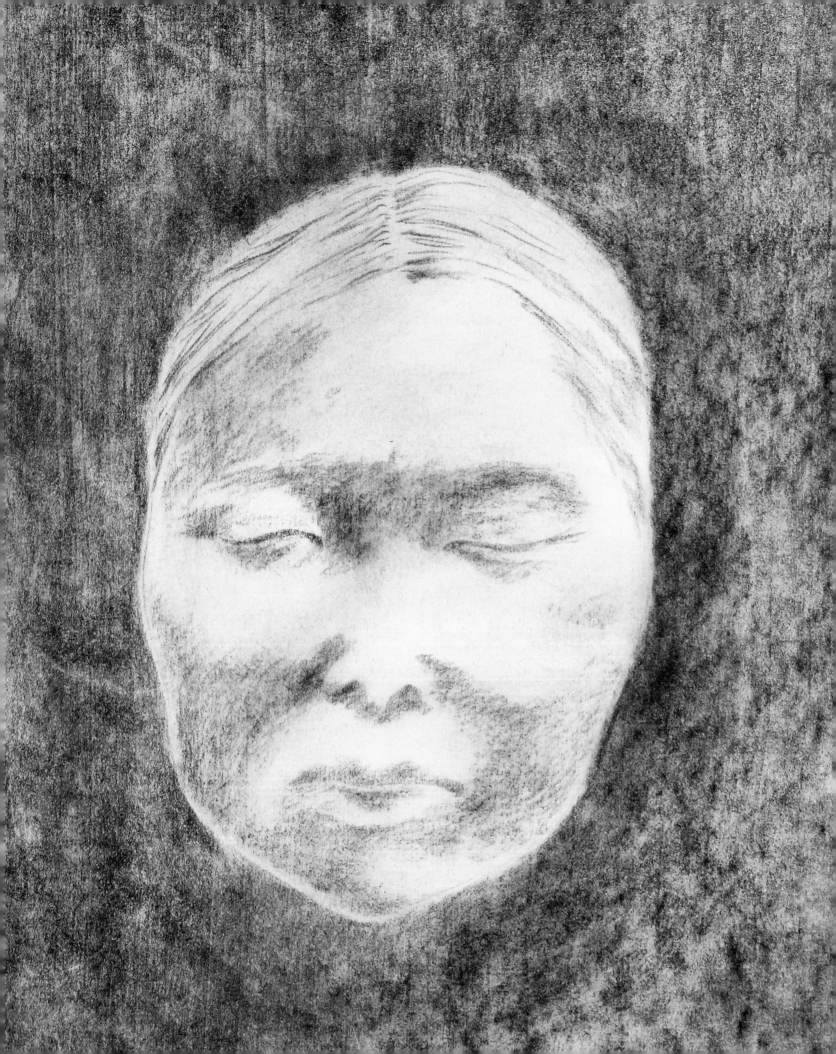

ALEESA PITCHAMARN ALEXANDER

DRAWN TOGETHER

Ruth Asawa and Community

Detail of *Untitled* (FF.016, Life Mask of Ruth Asawa), c. 1968–70s, see p. 213

Untitled (LC.012-002, Ruth Asawa Life Mask), c. mid-to-late 1960s. Ceramic, 8½ × 5½ × 2½ in. (21.6 × 14 × 6.4 cm). Cantor Arts Center, Stanford University; William Alden Campbell and Martha Campbell Art Acquisition Fund. Conservation made possible by the Robert Mondavi Family Fund at the Cantor Arts Center and the Asian American Art Initiative Fund

An untitled Ruth Asawa drawing (FF.016) presents the artist in isolation: eyes closed, her face, with its features softly rendered in reddish-brown crayon, floating on a textured ground. The image is a double self-portrait—or perhaps more accurately, a self-portrait once removed—as it is a rendering of a life mask cast from the artist's face. As does almost any entry point to Asawa's varied artistic practice, this drawing offers a suggestive link to another aspect of her life and career. Starting in the mid-1960s, Asawa cast in plaster the faces of friends, family members, and fellow artists. From these casts, she created ceramic positives that she hung on the exterior of her Noe Valley house.[1] In the life mask's original context, it existed among a constellation of other faces, creating an articulated portrait of one large community: the community of Ruth Asawa.

Owing to its geographical diversity, the San Francisco Bay Area is known for its microclimates and interconnected microcommunities, which are separated and connected by bodies of water. During Asawa's time in the region, she became a respected leader in the greater Bay Area arts ecosystem—the word *ecosystem* chosen very deliberately in this instance, as it suggests interrelations of beings, complex organizations,

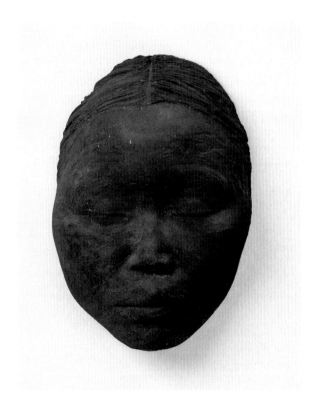

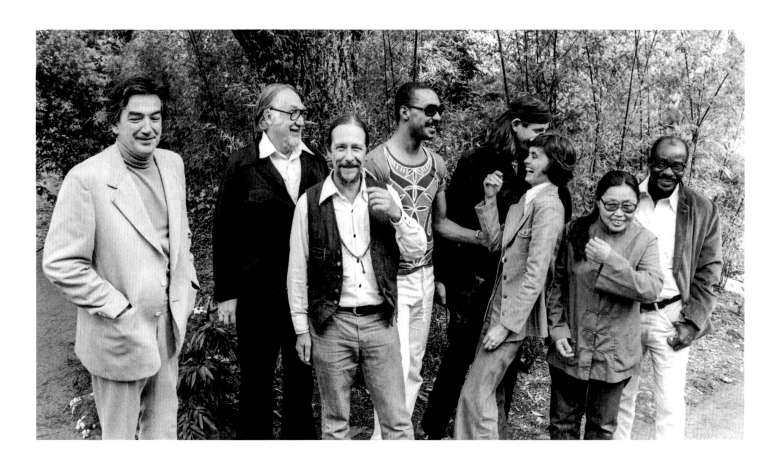

California Arts Council, 1975. Left to right: Alexander McKendrick, Clark Mitze, Gary Snyder, Duval Lewis, Peter Coyote, Julia Connors, Ruth Asawa, Noah Purifoy. Photograph by Ron Scherl

Untitled (FF.1231, Imogen Cunningham with Beads), 1975. Ink on paper, 12 × 9 in. (30.5 × 22.9 cm). Private collection

Suzanne Jackson, 2.11.77 (SB.100, detail), 1977. Ink on paper in hardbound sketchbook, 11 × 8½ in. (27.9 × 21.6 cm). Private collection

patterns of relation within an environment, and the natural world. Just as Asawa's sculptures allude to connected biological forms, her work as an arts advocate makes clear that she saw herself as an artist in the context of a larger cultural and environmental system. Like the cells that make up an organism, or one face on a wall among hundreds of others, Asawa found meaning in cocreation and coexistence.[2]

How did Asawa's diaristic drawing practice relate to her role as an arts advocate and the interethnic and intergenerational community she was part of in the Bay Area and greater California? Asawa's drawings offer manifold depictions of the human figure, as her sitters range in age, race, and class, and serve as indexes of her personal and professional relationships. Her sketchbook drawings quietly and intimately express her democratic and inclusive values in the subjects she chose, and they speak to her dedicated work as an arts leader. Asawa's drawings and paintings of plants and flowers, whether grown by herself or others, or given to her as tokens of affection, emphasize her ecological orientation toward the world. Like a garden, one's community requires cultivation—time, labor, and continued care—to survive. In choosing to draw her colleagues and family, Asawa created records of relational encounters between

herself and other California arts advocates, a community she helped sustain during her life.[3]

Following the social and cultural upheaval of the 1960s, the 1970s served as a particularly energetic period of arts-oriented community activity in the United States. This was certainly the case in San Francisco, where Asawa was an active member of many local and national arts organizations and initiatives. In 1968, Asawa joined the San Francisco Arts Commission (SFAC), which had recently begun supporting the nascent Neighborhood Arts Program (NAP), an organization that offered services for the arts, free art classes, and employment to artists.[4] Partially due to the success of SFAC and NAP, the federal Comprehensive Employment and Training Act (CETA), modeled its arts program after these organizations. Between 1974 and 1981, CETA provided full-time employment to almost 20,000 artists and cultural workers nationally, making it the most robust federal support for the arts since the Federal Art Project of the New Deal.[5] The Alvarado School Arts Workshop, which Asawa established with the architectural historian Sally Woodbridge, was perhaps the most notable CETA-supported project of the artist's life.[6] By funding artists directly, this intricate network of government administration and grassroots organizing made the Bay Area arts

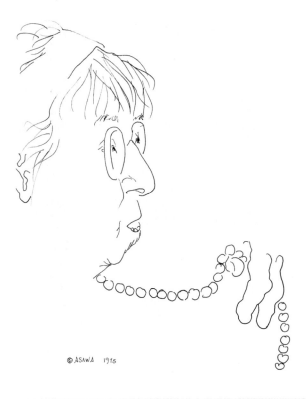

© ASAWA 1975

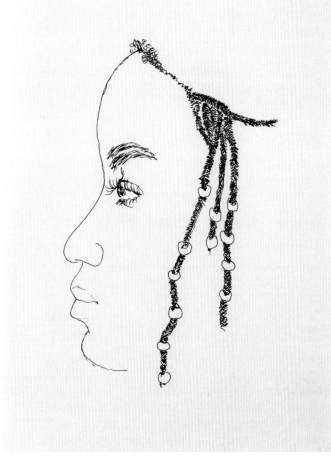

community particularly rich during this period, and Asawa was a vital part of these efforts.

Asawa encountered dozens of artists and arts community members through her work with SFAC, NAP, Alvarado, her many public art commissions, and her spouse Albert Lanier's work as an architect. An untitled 1964 brushed-ink drawing (WC.112 [p. 211]) features Andrea Jepson, who served as the model for Asawa's first major public commission, *Andrea,* a bronze fountain featuring a nursing mermaid in San Francisco's Ghirardelli Square. This contemplative drawing predates the fountain and combines Asawa's aesthetic interest in pattern and repetition—as seen in the pooled ink spots on Jepson's shirt—with her dedication to documenting important members of her artistic circle. Jepson worked with Asawa in the public schools, and their relationship lasted decades. Warner Jepson, Andrea's spouse, was also a notable composer, artist, and photographer, and at different times provided music lessons to the Asawa-Lanier children.

One of Asawa's most significant personal and professional relationships began shortly after Asawa and Lanier moved to San Francisco. The photographer Imogen Cunningham, more than forty years Asawa's senior, created iconic images of Asawa that in subsequent decades have helped shape the artist's historical reception.[7] As is characteristic of Asawa's engagement with others, the relationship was reciprocal, and she created works inspired by Cunningham's form and presence. In an untitled drawing of 1975, Asawa captured the photographer with her mouth slightly open, revealing teeth whose rounded forms are echoed in the string of beads she holds up with two disembodied fingers and a thumb. Drawn a year before Cunningham's death, this image was printed in 1982 on the program cover for the presentation of the fifth annual Imogen Cunningham Award. Administered by the San Francisco Foundation, this award was given to photographers whose work was under recognized by the mainstream art world. Like so much of Asawa's artistic practice, this drawing has indexical connections and an afterlife that speaks to the community in which she was entrenched.

As one of the eight founding members of the California Arts Council (CAC) appointed by Governor Jerry Brown in 1976, Asawa also worked with an esteemed group of creatives, including the actor Peter Coyote, playwright Luis Valdez, poet Gary Snyder, and artists Suzanne Jackson and Noah Purifoy. The CAC held

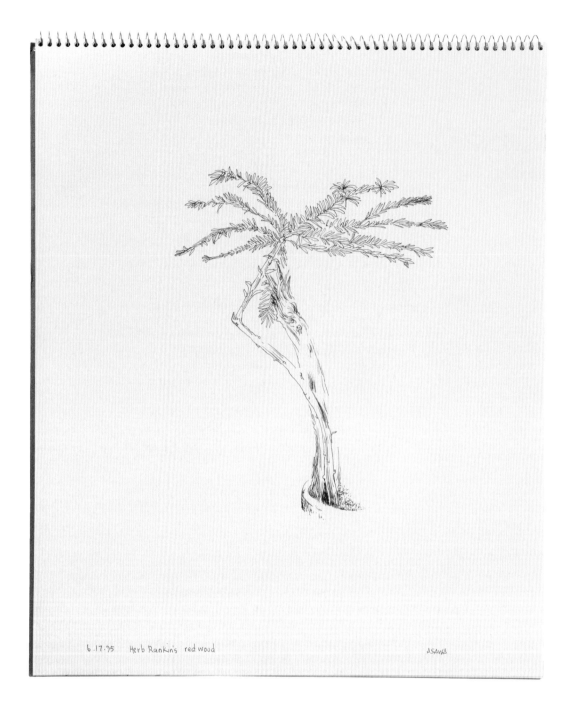

Herb Rankins' Redwood 6.17.95 (SB.200), 1995. Ink on paper in spiral-bound sketchbook, 17 × 14⅛ in. (43.2 × 35.9 cm). Private collection

6.17.95 Herb Rankin's red wood ASAWA

meetings around the state, with different areas divided into "eco-regions," according to Jackson. For the two years Asawa served on the CAC, she was measured in her verbal input during council meetings, choosing to draw in the sketchbooks she brought. "She was always drawing in these meetings," Jackson recalls, and her sketchbooks reflect the diversity of her subjects.[8] Nestled before and after a 1977 sketch of Jackson are drawings of children, plant and animal life, Gary Snyder, and Peter Rodriguez, who founded the Mexican Museum in San Francisco, to identify a few. Asawa's ink drawing *Suzanne Jackson,*

2.11.77 presents the subject in profile, with three locks of hair punctuated by beads. The repeated bead forms recall both the Cunningham drawing and Asawa's hanging looped-wire sculptures, further suggesting that to Asawa, the formal qualities of individuals—how they comport, adorn, and express themselves—possessed possibilities for her aesthetic exploration. Rather than be seen as separate from her abstract sculptures, Asawa's drawings indicate that in her universe, all is connected.

Asawa also saw value in understanding our connection to the natural world and

promoted activities that cultivate the knowing of people as beings in landscapes. Through her work in public schools, students engaged not only with the visual arts but gardening as well. In a 1995 drawing, *Herb Rankins' Redwood, 6.17.95*, a redwood sapling emerges from the edge of its container. Rankins and his spouse, Susan, were parents of a child who attended the School of the Arts (later named Ruth Asawa San Francisco School of the Arts) and served as garden and school volunteers.[9] Rankins gave this sapling to Asawa (whether it was for her or a school-related garden project is unclear). In turn, Asawa chose to document this encounter between three beings. The work's title is telling: Asawa asserts the relationship between plant and human life, noting that the redwood was connected to a specific individual, one who was in relation to the artist and others in a larger community.[10] The California redwood, an iconic tree of Northern California, potentially serves as a synecdoche for the region itself—a beloved symbol of the ancient plant life that surrounds the Bay Area.[11]

Closer to home, Asawa rendered an exuberant bouquet of flowers gifted to her by her son Adam: *Adam's Ranunculus* (PF.1107 [p. 223]). An intricate tangle of forked leaves and lacy-edged petals fills the composition, and in the lower-left corner, a single snail crawls upward, leaving a delicate trail behind. This small creature reminds one that flowers are not just aesthetic objects to behold but living organisms that support other life. Since her childhood growing up on a farm in Norwalk, California, Asawa understood that she belonged to an ecology of existence dependent on relationships—human, plant, and animal—in order to survive.

For Asawa, to consider the life of a flower was an opportunity to contemplate existential stakes and states. In a 1971 interview with the historian Mary Emma Harris, Asawa described the value of teaching gardening to children:

> You can't rush a plant to bloom; you have to wait for its time to happen. And if you have a cycle of animals, you understand that it takes so many days for a chick to hatch. All of these things are important, because different things have [their] own cycle. And I think . . . the more experiences you have like this, the more you begin to understand your own cycle.[12]

To cultivate something—whether a garden, a community, or both—was nothing short of understanding the limits and possibilities of one's time on Earth.

1 In 2020 the Cantor Arts Center at Stanford University acquired the 233 masks of *Untitled* (LC.012, Wall of Masks), serving as the first major acquisition of the Asian American Art Initiative. As of July 6, 2022, the masks are part of the Cantor's long-term installation, *The Faces of Ruth Asawa.*

2 For more on the biological dimensions of Asawa's practice, see Jason Vartikar, "Ruth Asawa's Early Wire Sculpture and a Biology of Equality," *American Art* 34, no. 1 (Spring 2020): 3–19.

3 Special thanks to Addie Lanier, Aiko Cuneo, Henry Weverka, and Vivian Tong for support with this essay. Their recollections, reflections, and archival assistance provided invaluable background and context.

4 Kevin B. Chen and Jaime Cortez explored the specific impact of NAP in their exhibition *Culture Catalyst: Celebrating the Art and Legacy of the Neighborhood Arts Program* (San Francisco Arts Commission Gallery, April 27–June 9, 2018). The exhibition introductory text can be viewed under the exhibition title on Kevin B. Chen's website, https://kevinbchen.com/artwork /4428987.html. See also Roula Seikaly, "How a Grassroots Program Shaped the SF Arts Scene, 50 Years On," *KQED,* June 5, 2018, https://www.kqed.org/arts/13834231 /neighborhood-arts-program-culture-catalyst-sfac.

5 John Kriedler, conversation with the author, August 12, 2022. Kriedler started the CETA artists project for SFAC in 1974 and worked with Asawa in various capacities over the years. As Kriedler recalls, "It's hard to imagine what arts education would be today in San Francisco without Ruth Asawa."

6 For more on Asawa's dedication to public schools, see Emily Pringle, "The Artist as Lifelong Learner: Ruth Asawa and Education," in *Ruth Asawa: Citizen of the Universe,* ed. Emma Ridgway and Vibece Salthe (Oxford, UK: Modern Art Oxford; Stavanger, Norway: Stavanger Art Museum, MUST; in association with Thames & Hudson, London, 2022), 136–49.

7 Susan Ehrens explores the reciprocal nature of their relationship in "'Making it Mine as Well as Hers': Ruth Asawa and Imogen Cunningham," in *The Sculpture of Ruth Asawa: Contours in the Air*, Timothy Anglin Burgland and Daniell Cornell et al., rev. ed. (San Francisco: Fine Arts Museums of San Francisco; Oakland: University of California Press, 2020), 166–73.

8 Suzanne Jackson, conversation with the author, October 5, 2022.

9 With thanks to Aiko Cuneo (through Vivian Tong) for offering information regarding the connection between Rankins and Asawa.

10 Asawa cast the faces of Herb, Susan, and Jessica Rankins. These ceramic masks are part of *Untitled* (LC.012, Wall of Masks). One could argue that the face masks are the sculptural analogue to her drawings of people, and many of the subjects represented on the wall also appear in her sketchbooks—either as portraits or plant-related drawings, such as this one of Rankins's redwood.

11 The front doors of the Asawa-Lanier house were carved by the family (under Asawa's guidance) from slabs of redwood. Cunningham's 1963 photographs of Asawa at the front doors capture their familiar meander pattern, one reminiscent of Asawa's drawings from the late 1940s through the 1950s.

12 Ruth Asawa, interview with Mary E. Harris, December 19, 1971, Ruth Asawa Papers, box 35, folder 3.

Untitled sculpture drawings
(SB.009), c. 1954.
Various mediums on paper in
hardbound sketchbook,
10 × 15¾ in. (25.3 × 40 cm)
open; 10 × 8 in. (25.3 ×
20.1 cm) closed. Achenbach
Foundation for Graphic Arts,
Fine Arts Museums of San
Francisco, Gift of the Artist,
2007.28.81.1–61

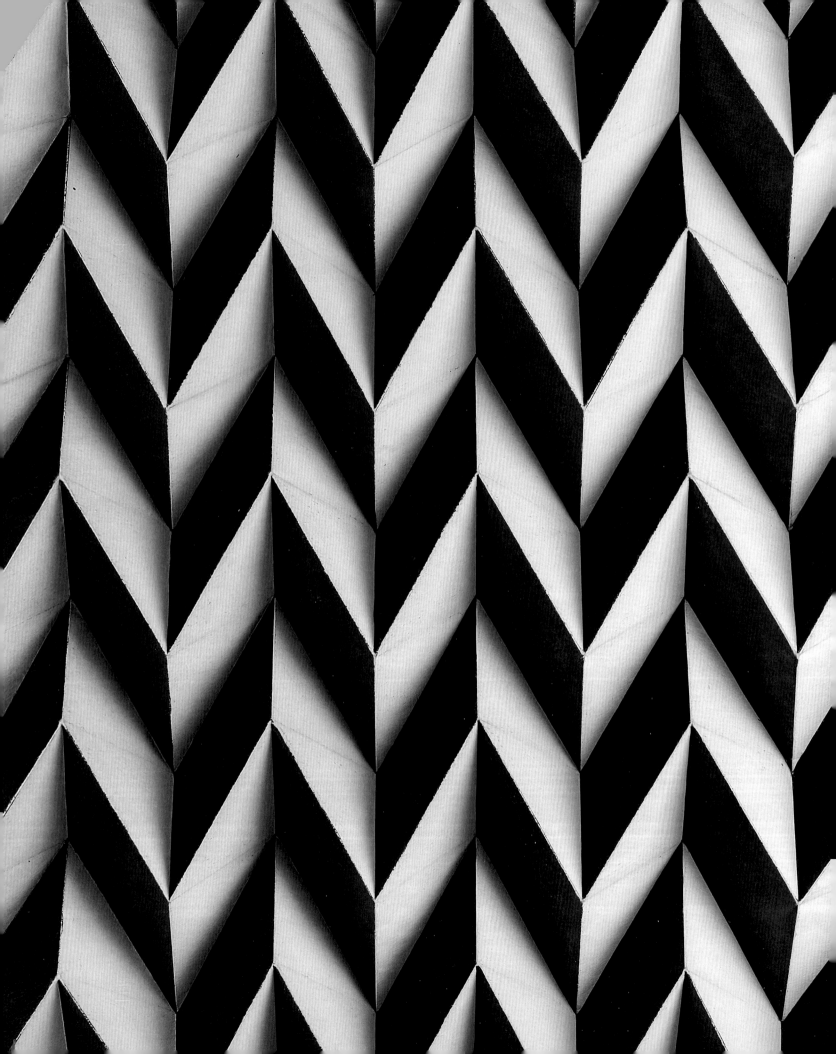

JORDAN TROELLER

THE PEDAGOGICAL VALUE OF PAPER

Detail of *Untitled* (S.839, Mounted Paperfold of Columns of Alternating Black and White Parallelograms), c. 1952, see p. 136

Ruth Asawa drawing in the exhibition *Ruth Asawa: Honor Award Show*, September 22–October 22, 1976, Capricorn Asunder (San Francisco Arts Commission Gallery), 1976. Photograph by Bruce Sherman

From Ruth Asawa's time as a student at Black Mountain College through to her public commissions of the 1980s, paper occupied a central role in her artistic practice. This engagement encompassed more than paper as a surface of representation, figurative or abstract, as we see in a photograph of Asawa, the perspective of which suggests that she is drawing one of her paper constructions in the foreground. Just as significant was her appreciation of this simple material as a three-dimensional object *in potentia*; as the object, in other words, that occupies her gaze. For Asawa, paper was as much the domain of sculpture as it was of drawing. Indeed, disturbing the boundary between these two mediums was achieved through a reimagination of this everyday material.

Asawa's engagement with paper began in the late 1940s and is inextricable from an educational context, at Black Mountain as well as in the San Francisco public school system, where she began teaching art in the late 1960s. As a student, Asawa encountered the classes Design and Color given by Josef Albers. Taught alongside his course in basic drawing, instruction in design and in color explored questions that were related to and also expanded on those crucial to drawing, such as questions around the use of illusionism

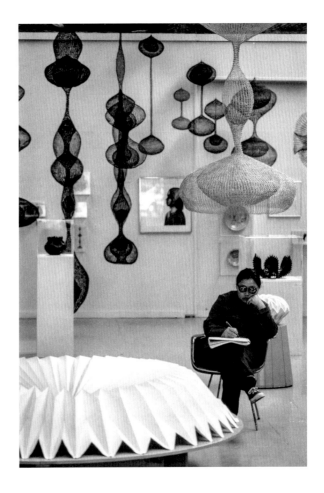

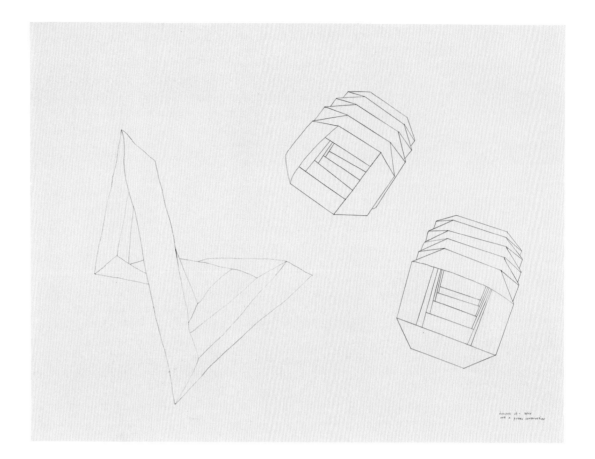

Drawing of a Bellows and a Paper Construction (BMC.12), c. 1946–49. Ink on paper, 16¼ × 21¼ in. (41.3 × 54 cm). The Josef and Anni Albers Foundation, 2007.30.15

Josef Albers and students manipulating a sheet of paper, Black Mountain College, 1946. Photograph by Genevieve Naylor

and negative space. Albers encouraged his students to go beyond thinking of paper as a plane and instead explore its inherent properties of volume in order to get it to do the unexpected: to stand up on its edge, to curve and pleat, or even to have it support weight. Students investigated how paper could curve in two directions at once, like a saddle, or form a spherical lantern, or even exhibit the ability to expand and contract like bellows—all exercises in which Asawa took part.[1] In each instance, students had to use all of the paper, leaving no part wasted; nor were they allowed to introduce crutches like tape or staples. The goal was to undertake a sustained examination of what paper could *do*—and how they could get it to do *more*.

This was a time in which a simple exercise, such as the above with paper, became a vehicle for more profound lessons as part of a general liberal arts education. Problem-solving, for example, fueled such engagements, and also fostered learning to recognize the value of independent and creative thinking for a greater good, over and above self-expression of the individual. Though three-dimensional in ambition, Albers's pedagogical experiments with paper asked students to visualize the relationship between illusionism, which we often associate with drawing and

painting, and the real space of construction, which is what many of these exercises became. Frederick Horowitz, an Albers student, recalls the German pedagogue asking them to question what was possible: "If we fold along a diagonal line between opposite corners a square, what will we get? Which planes will be concave? If two folds cross in the center, like an 'X,' where will the paper rest?"[2] As Asawa's own class notebooks attest, such paper exercises went hand in hand with lessons in geometry. Elaborate diagrams of square roots and proportion studies, for instance, explored the underlying logic of formal relationships. As one of Albers's best students, Asawa internalized these lessons and carried them with her throughout her life and work, often taking them to levels far beyond what her mentor had imagined.

When Asawa moved to San Francisco in 1949, she began freelance work as a young designer, often collaborating with Albert Lanier, her husband and fellow Black Mountain student. Both had tremendous respect for Albers and put many of his ideas into practice. One early design was a wall covering with an allover chevron pattern that bears resemblance to Asawa's

so-called In and Out paintings executed at Black Mountain (likely in Albers's Color class, for example BMC.93 [p. 125]). She had devised the pattern from sheets of paper, some of which were partly painted with black in order to visualize the play of light and shadow created by the up-and-down terrain of the wall covering's folded pattern. A manufacturer adapted the design to plastic, for durability, and marketed it as a "deep dimension" interior element, whose angled surface produced the effect of a richly textured space. At some point, the couple sent the design, which Lanier had helped to install in a showroom, to Albers, who proudly kept the photograph in his files as an example of the design potential of his paper pedagogy, inscribing the back as Asawa's "zick-zack paperfolding."[3]

Working with folded paper models that would then be scaled up or transferred to other materials, such as metal, became a common approach in Asawa's artistic practice. Examples of this can be seen in her large sculptural commissions as a public artist, such as the *Origami Fountains,* 1975–76, in San Francisco's Japantown. Asawa first approached the design on paper, working with large, heavy sheets to devise

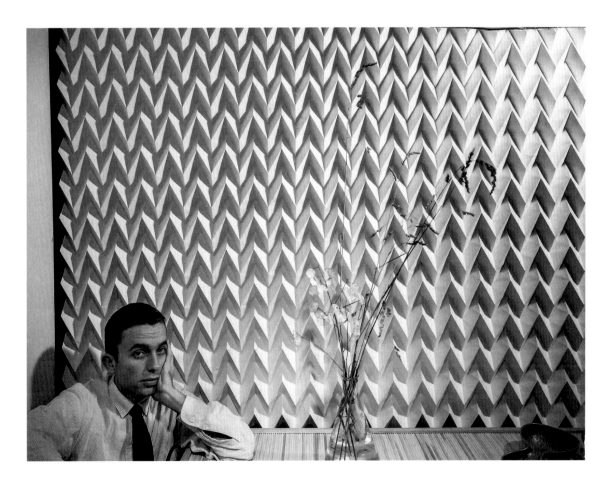

Albert Lanier sitting in front of the paperfold screen that Ruth Asawa designed for the Laverne Originals showroom, 1951. Photograph by Charles Wong

the right vertical folds and proportions of folds across the surface. She settled on fluted forms she described as lotus blooms, and although they did not move, their shapes invoke folded paper's dynamic properties: we can imagine their curved surfaces collapsing back into flat, compressed folds. As fountains, moreover, the folds interact with the water pumped over their surfaces. At the top, horizontally oriented ones provide a kind of umbrella awning which guide the water's flow into broad arches down to the stones below.

Certain elements of the fountains were created in collaboration with children of Japantown shopkeepers. This partnership had grown out of the Alvarado School Arts Workshop, which Asawa and the architectural historian and artist Sally Woodbridge had established in summer 1968 at their local primary school, Alvarado Elementary, where both women had children attending. The initial session took place in the school's cafeteria, where children from kindergarten through sixth grade molded animals, mermaids, cars, and flowers, using a homemade batch of flour, salt, and water that Asawa termed "baker's clay." Asawa would use the same material with the shopkeepers' children to create panels depicting Japanese fairy tales, which were installed on benches alongside the *Origami Fountains*. As in Albers's classes, this work with children was one in which "experimentation was openly invited," as two of the founding artist-mothers recall.[4] In addition to baker's clay, students worked with orange-crate weaving, papier-mâché, God's eyes, woodcarving, and origami. Over the next several decades, the Alvarado School Arts Workshop spread to dozens of public schools in San Francisco; it encompassed a formalized artist-in-residence program of professional artists working in a range of genres including drama, dance, music, and poetry as well as the visual arts, and shaped Asawa's own work as a sculptor.

Drawing on the Japanese tradition of origami along with Albers's lessons, Asawa, together with a large group of other artists invested in the public schools, including Nancy Thompson and Mae Lee, developed a folded-paper curriculum. It progressed from very simple folded forms, which young children could do on their own, all the way up to very complex constructions that carried with them lessons in advanced geometry. Again, recycled and throw-away items supplied the necessary materials: not only reused paper, but also empty milk cartons, Popsicle sticks, and donated paper plates. Asawa even had intentions

of one day writing a "paper folding book (origami) based on Josef Albers's basic design course," which could be used in the schools.[5] This is likely the text that became *Milk Carton Sculpture*, a homemade booklet of increasingly complex geometric shapes that can be created out of empty milk cartons. Written in 1983 together with Asawa's eldest daughter, Aiko Cuneo, as well as John Brunn, Mae Lee, Mary Lee, and Sara Morgan, it conveys geometric solids in step-by-step progressions that older children can grasp physically, through the act of paper-folding.

This approach adapted Albers's instruction in drawing, basic design, and color to a level appropriate for school-age children. As Jeffery Saletnik has argued, Albers's pedagogical approach derived from a tradition of progressive German educational theory and practice in which drawing proved essential. And here it is useful to recall that Albers himself was trained as a primary school teacher and drawing instructor in Wilhelmine Germany, where he absorbed the shift from education as a matter of rote memorization to education as the cultivation of sensory perception in a direct and playful encounter with one's immediate environment. Observation, practiced as much in putting pencil to paper as in manipulating paper's spatial properties, became a central goal. The *process* of learning, through the encounter with various learning aids, was more important than whatever may have been produced. Furthermore, as Saletnik argues, Albers regarded these "pedagogical forms" as more than simple learning aids; they evidenced "creative behavior, material manifestations of the investigative processes that brought them into being."[6]

Students exposed to the Alvarado School Arts Workshop would have known paper in this multidimensional aspect: as a latent picture as well as a potential object. Indeed, drawing as the engagement with two-dimensional representation and making as the construction of three-dimensional forms would come to occupy a continuous spectrum of paper's possibilities. Children moved seamlessly between depicting themselves and their environment and creating objects using paper with which they could then reshape those environments. This included elaborate milk carton globes hung from the ceiling of the school corridors, some of which even encased lightbulbs to create luminous white-and-red orbs. But it also involved extending the capabilities of folded paper's physical properties, as in the incorporation of one of

Ruth Asawa teaching paper-folding, John Swett School Workshop, Alvarado School Arts Workshop, c. 1980s. Courtesy of the Department of Special Collections, Stanford University Libraries

Asawa's own folded paper constructions into a dance performance featuring students from San Francisco's School of the Arts—the public arts high school to which Asawa devoted her energies beginning in the early 1980s (now named the Ruth Asawa San Francisco School of the Arts).

What is perhaps most remarkable in the convergence of paper and pedagogy in Ruth Asawa's work is that it furnishes the most concrete example of how the artist saw no distinction between her work as a professional artist and her work in the public school system. This distinction is one to which art history holds fast, and many of the recent exhibitions to focus on Asawa have tended to marginalize the latter. But Asawa herself continually strove to overcome this boundary, often even incorporating the work produced within the Alvarado School Arts Workshop into exhibitions of her own studio work. In Asawa's hands, and in the many

hands involved in the workshop over its several decades of existence, drawing expanded into new dimensions. No longer an act of mark-making or of ordering the blank page, drawing became a process of spatial orientation that crossed mediums and audiences.

1 Frederick A. Horowitz and Brenda Danilowitz, *Josef Albers: To Open Eyes; The Bauhaus, Black Mountain College, and Yale* (London: Phaidon, 2006), 107.
2 Horowitz and Danilowitz, *Josef Albers: To Open Eyes*, 126.
3 See Josef Albers inv. no. 90.7, The Josef and Anni Albers Foundation, Bethany, CT.
4 Andrea Jepson and Sharon Litzky, *The Alvarado Experience: Ten Years of a School-Community Art Program* (San Francisco: Alvarado School Art Workshop, 1978), 5–6.
5 Ruth Asawa, "For James Lick Junior High School for the Fall of 1969–70," typewritten sheet, Ruth Asawa Papers, box 134, folder 4.
6 Jeffrey Saletnik, *Josef Albers, Late Modernism, and Pedagogic Form* (Chicago: University of Chicago Press, 2022), 48.

Ruth Asawa folding paper,
c. 1975. Digital print from
color transparency, 10 × 8 in.
(25.4 × 20.3 cm). Photograph
by Laurence Cuneo.
Courtesy of the Department
of Special Collections,
Stanford University Libraries

Ruth Asawa holding a
paperfold, c. 1970s. Gelatin
silver print, 10 × 8 in.
(25.4 × 20.3 cm). Photograph
by Laurence Cuneo.
Courtesy of the Department
of Special Collections,
Stanford University Libraries

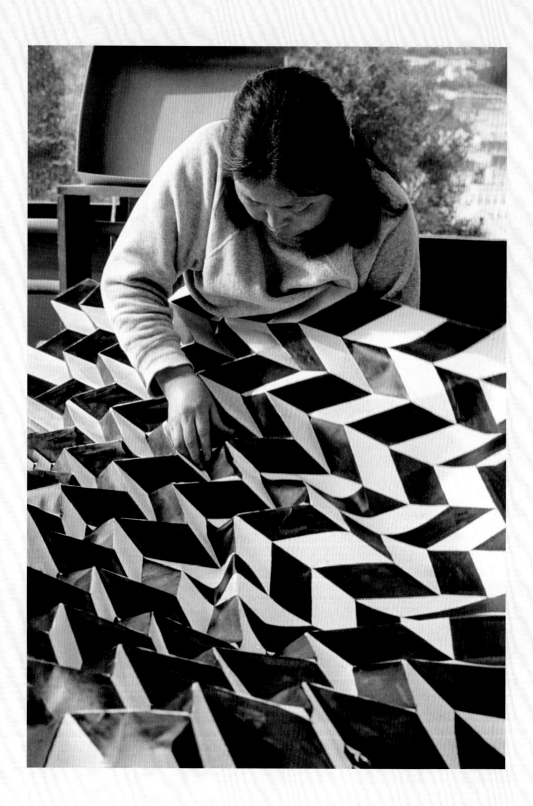

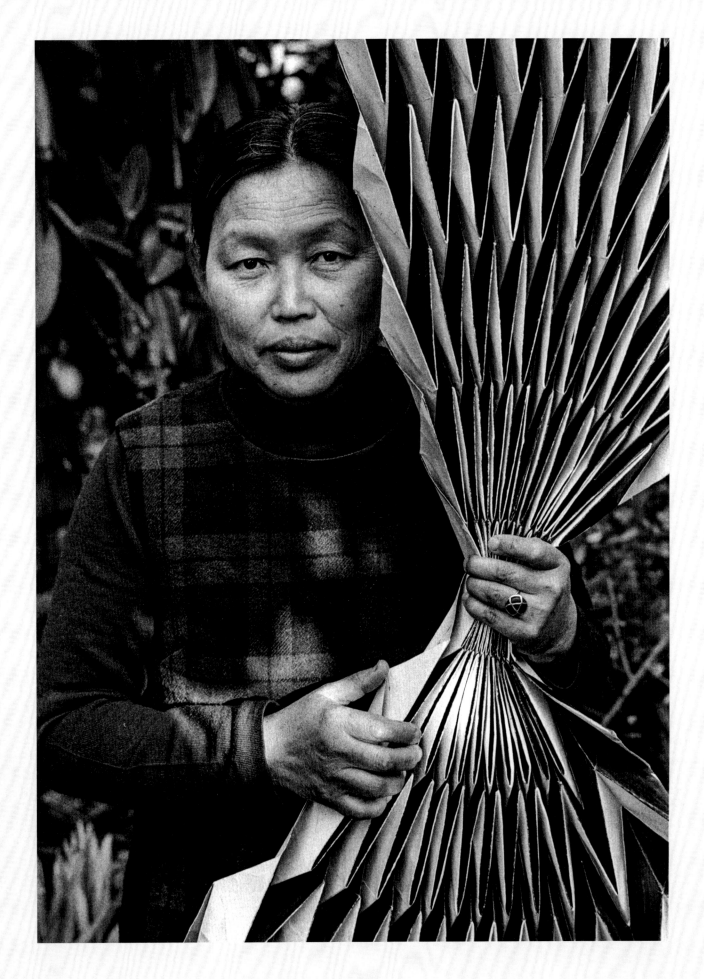

Addie Laurie Lanier and Aiko Cuneo discussing a paperfold model for San Francisco Japantown's *Origami Fountains* (PC.006), 1975. Gelatin silver print, 10 × 8 in. (25.4 × 20.3 cm). Photograph by Laurence Cuneo. Courtesy of the Department of Special Collections, Stanford University Libraries

Various paperfold models, c. 1970s. Gelatin silver print, 8 × 10 in. (20.3 × 25.4 cm). Photograph by Laurence Cuneo. Courtesy of the Department of Special Collections, Stanford University Libraries

Dancers rehearsing with large paperfolds for *Breathing*, performed at School of the Arts, San Francisco, 1989. Gelatin silver print, 6¼ × 9¼ in. (15.9 × 23.5 cm). Photograph by Tom Wachs. Courtesy of the Department of Special Collections, Stanford University Libraries

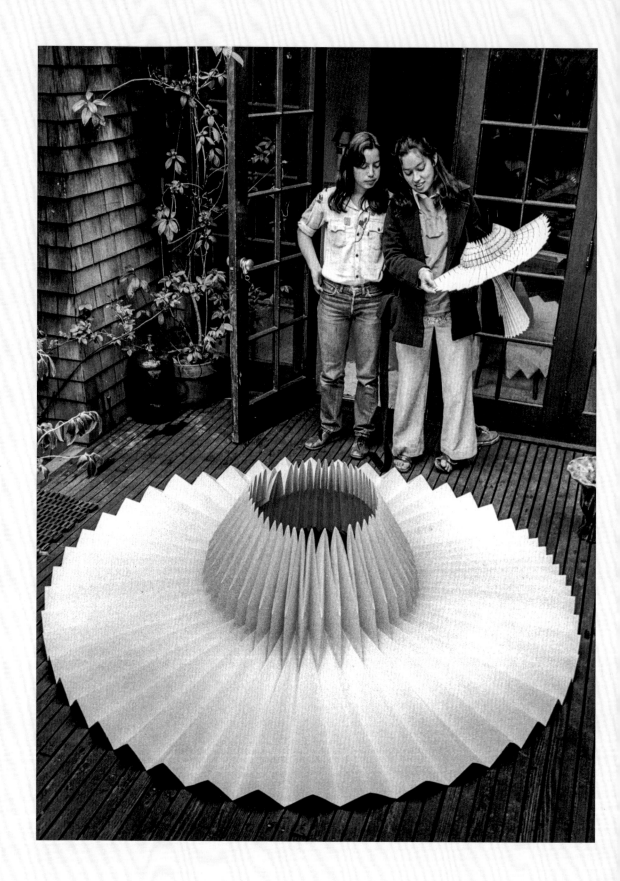

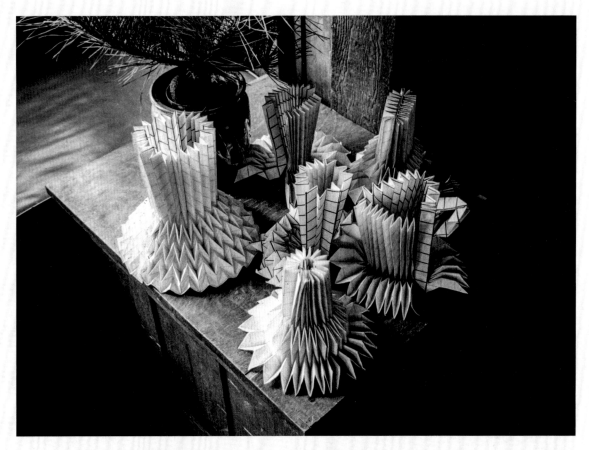

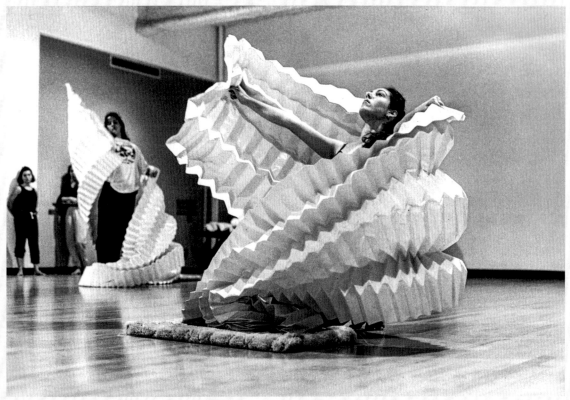

EDOUARD KOPP

INSTINCT AND INQUIRY

Ruth Asawa's Use of Drawing Materials and Techniques

Detail of *Untitled* (PT.062, Blue and Black Ink Wash [Water]), c. early 1960s, ink on coated paper, see p. 189

I try to explore the total capacity of materials and techniques and often that takes me where I would not otherwise go.[1]
—RUTH ASAWA

Looking at an accomplished, pen-and-ink drawing by Ruth Asawa (see page [60]), one marvels at the assured, coherent quality of the line, the sensitivity and calligraphic elegance with which she described the contours of nasturtiums. It speaks of close observation, intense focus, and seamless execution. As she reflected, drawing was always her "greatest pleasure and the most difficult, because it tells you what control your hands have to do what your eyes see."[2] In other words, for Asawa, drawing was a measure of eye-hand coordination. And while she recognized the importance of control, artistic vision, and intention in the immersive practice of drawing, she also realized, early on, the agency of materials and techniques: "I do know the means is exciting, and I think that the end is in the means. They seem to work jointly. If one is concerned with the means, the end is inevitable."[3]

Asawa was always very attentive to the means of her art. She was genuinely fascinated with materials and techniques, and their interactions, and explored them thoroughly. She considered them essential agents in her creative journey, with outcomes that were not predetermined but truly open to contingency and discovery. The artist continuously challenged herself, shifting the terms of her practice by searching for new approaches to materiality. This kept her eyes and mind receptive and alert, allowing her to probe the boundaries of drawing and, more widely, to connect with the world around her, to question it, and to transform it in turn.

As a result, Asawa's body of work is rich, complex, and diverse, often upending expectations: from line drawings to watercolors, collages, and monoprints, as well as reliefs in paper or metal, and works in the round made with looped or tied wire. With such a broad material and technical range, she was able to push the idea of drawing through her choice and her use of materials. She was thus able to traverse very different aesthetic territories and develop an array of sensibilities and creative approaches to drawing in search of formal innovation and, ultimately, a means of self-expression.

This essay addresses some key aspects of the materiality of Asawa's expansive, genre-defying drawing practice, starting from her exposure to Josef Albers's foundational teachings on materials at Black Mountain College in

Untitled (BMC.8, Leaf Study [Gold/Brown Leaves on Light Blue Background]), c. 1948–49. Meadow rue leaves on colored paper, 16½ × 22½ in. (41.9 × 57.2 cm). The Josef and Anni Albers Foundation, 2007.30.17

the mid-to-late 1940s, to her own, mature explorations of the physical and aesthetic potential (and limitations) of the materials and techniques she employed. As she explained, "techniques are simple to learn. Digesting them and making something that represents you will take a lifetime."[4] As a matter of fact, her material search and growth as an artist were inextricably linked, and both were driven by instinct and inquiry.

MATIÈRE

During her time at Black Mountain College, Asawa was exposed to radical experimentation based on the Bauhaus foundation course, which consisted of a series of hands-on studies. In that context, she developed an understanding of the fundamental properties of materials, both visual and tactile, and how these two sensory dimensions connected. This was largely thanks to Josef Albers, who aimed to teach students to search

for new things, not to repeat what had already been done, and "to see in the widest sense," namely to awaken the senses and cultivate perceptual acuity.[5] His intention was not to elevate the optical above the other senses—instead, he wanted to situate vision within a wider context, in part by revaluing touch and by advocating a haptic mode of understanding that would also amplify the operation of sight. He urged students to think about materials in terms of "the limits of their strength, their particular structure, texture, rigidity, and color."[6] Two components of Albers's Basic Design (or *Werklehre*) course, which he called *matière studies* and *material studies*, were about using commonly found though often overlooked materials, and as few tools as possible, in order to cultivate a "feeling for material and space" and seek "untried possibilities."[7] *Matière* studies were about developing in students an awareness of the appearance and identity of

materials, in particular of their structure, facture, and texture as they impacted optical or tactile perception. *Material* studies were "concerned with the capacity of materials . . . in short technical properties" such as firmness, looseness, elasticity, and bendability.[8]

LAYERING

As part of Albers's teaching, Asawa had to make collages and learn how to combine materials that were readily at hand.[9] She made several collages involving leaves, which were intended as twin studies of matter and color; they are the closest things to matière studies to have survived in her case. As she explained, "we gathered leaves for Albers's leaf studies. In the fall, in the spring we'd find things around us. . . . We used everything that was natural . . . [b]ecause we didn't have bought things around us, and I think that was all very new to me although I grew up on a farm, and I knew that we always improvised on the farm. So, I felt very much at home because it came out of necessity rather than having everything in front of us."[10] The material scarcity and spirit of resourcefulness that characterized Black Mountain compelled Asawa to create with an economy of means. Doing more with less is an ethic she had first assimilated through her upbringing, and which was then reinforced by her interaction with teachers such as Albers and Buckminster Fuller.

Each of her known leaf studies is made up of multiple leaves of one kind, adhered flat to a monochrome surface. In one, she arranged a large number of leaves on a sheet of blue colored paper (BMC.8). Forming a field of foliage of varying density, the leaves (likely meadow rue or early meadow rue) appear to float like falling flakes of gold. Ultimately, the viewer's eye is attracted to the matte physicality and complex structure of the leaves, whose appearance manifestly changed over time.

In another collage made as part of Albers's course (BMC.121, [p. 73]), Asawa created undulating forms by cutting colored papers, which she pasted on paper prepared with blue opaque watercolor on orange wove paper. Here, she employed aesthetic maneuvers inherent to the genre of collage, notably layering and overlapping, and she used strong color contrasts (orange and red on the one hand, blue on the other) in order to create a dynamic composition with a sense of spatial illusion. This work operates both as a study of form and color, and as a work of art in its own right.

In the mid-to-late 1950s, Asawa returned to collage using a specific technique with screentone, also known by the common brand name Zip-A-Tone, which was then frequently used in graphic design. It involved the dry transfer of patterns to paper from preprinted, flexible and transparent sheets of dots or lines to create texture or tonal value. An economical and mechanically controlled alternative to shading useful for creating space in an image, the printed patterns were transferred to the paper with a stylus and remain fixed thanks to an adhesive layer. The dot patterning came in a variety of gray-tone percentages,

Untitled (BMC.117, BMC Laundry Stamp on Newsprint), c. 1948–49. Stamped ink on newspaper, 16½ × 22 in. (41.9 × 55.9 cm). Harvard Art Museums/ Busch-Reisinger Museum, Gift of Josef Albers, BR49.390

including graded tones, and in different sizes of dots. Asawa usually applied several layers of the material, using multiple gradations, which allowed her to achieve sophisticated effects of space and transparency (ZP.16B [pp. 112–13]) with overlapping or interpenetrating shapes, and forms within forms, that probe the relatedness between interior and exterior, identity and alterity. She used the technique creatively to imagine elaborate compositions involving multiple, adjacent looped-wire sculptural forms, rendered either in gray or black on white to suggest positive space, or conversely in white on dark to suggest negative space (ZP.04 or ZP.05 [p. 111]). She even made photocopies of her own screentones (sometimes inverting the blacks and whites with the machine for tonal experiments) examples of which she included in her 1955 Guggenheim Fellowship application to showcase her practice.[11]

STAMPING
In 1948–49, Asawa explored ready-made rubber stamps as a way of creating unique works on paper. While working in the laundry room at Black Mountain, she found that utilitarian stamps used to mark sheets either *BMC* or *DOUBLE-*

SHEET could be temporarily repurposed into drawing implements of sorts for Albers's Design course. She created a group of simple yet sophisticated compositions in which she varied the placement, orientation, density, and intensity of the simple ink marks applied with the rubber stamp, thereby achieving complex visual effects through an iterative process.

In several untitled examples formerly in Albers's collection, she experimented with abstract patterns on newspaper. Seen up close, the stamped letters in BMC.120 are clearly legible over the printed matter underneath, a page from the classified advertisements section of the *New York Times* that has yellowed over time and thus altered the contrast between background and foreground.[12] From a distance, however, the stamped letters merge into wider, dynamic patterns, reminiscent of the rhythmic geometry of Constantin Brancusi's *Endless Column*, for example, but more pointedly, they are evocative of textile designs, namely tectonic compositions by Anni Albers that Asawa would have been aware of. Her resulting image transcends its modest material and its mundane, ephemeral subject matter. In BMC.117, she

Untitled (BMC.120, Double Sheet Stamp on Newsprint), c. 1948–49. Stamped ink on newspaper, 22 × 16 in. (55.9 × 40.6 cm). Harvard Art Museums/Busch-Reisinger Museum, Gift of Josef Albers, BR49.391

Detail of *Untitled* (Leaf from the Sacramento Delta), c. early 1990s, ink on Japanese paper, see p. 99

applied the BMC stamp with such density that the letters often overlap, slipping into illegibility. By slightly varying the direction of the markings over the underlying modularity of the newspaper, she was able to suggest a measure of non-linearity within the pattern and a sense of dynamism in the figure-ground relationship, so that one gets the impression, again at a distance, of seeing fabric inhabiting space. In another (BMC.78 [p. 92]), the composition and visual effect are altogether different: leaving much of the sheet untouched to serve as negative space, Asawa created a centripetal arrangement of lines radiating outward that evoke a sunburst. Partly broken at intervals, the lines give an impression of clockwise rotation, particularly at the center.

Around 1951–52, Asawa returned to the idea of stamping, but this time employing even more unexpected tools. In one instance, she repurposed a bicycle pedal to serve as a printing matrix (SF.043e [p. 94]). Using part of the pedal, she created a mechanized yet imperfect and all-too-human floral pattern across the page, alternating black marks with more lightly inked gray ones resulting from second stampings. In other examples, she transformed not man-made objects but basic pantry items into stamps in order to produce rhythmic compositions. In one group, she sliced a potato and carved a simple organic motif into its face, and she applied different colors in turn, and then, with a simple gesture, she pressed the vegetal stamp against Japanese paper to create layers of marks, some of them

Ruth Asawa's photocopy of a fern, c. 1980s. Courtesy of the Department of Special Collections, Stanford University Libraries

Japanese fish prints, known as *gyotaku*, a term that means literally "fish impression" or "fish rubbing." It is a traditional method of nature printing with sumi, a black ink, on thick *washi* (soft and absorbent long-fibered Japanese paper), dating back to the 1830s, that was meant to effectively preserve a true record of a fisherman's catch, and that also became an art form in its own right.[15] Asawa appears to have been aware of or curious about that process by the mid-1950s.[16] She would ink a fish with a sponge and then gently rub a sheet of Japanese paper with her fingers on top of its surface to register the details, obtaining a fine impression of the fish on the inner side of the paper (LP.009 [pp. 100–101]).[17] Using a similar technique, she took impressions of unusually large taro leaves (LP.001 [p. 98]), which she found in the White Slough, an inlet in the Sacramento–San Joaquin Delta, and captured their texture and ramified, underlying structure on a large sheet of Japanese paper.

In line with this interest of hers in the indexical representation of nature, she experimented with reproductive technologies, including mimeography,[18] to duplicate her drawings, as well as xerography or photocopying to make entirely new work. Toward the end of her life, she acquired a copy machine, first to help document bills, correspondence, and grants, but then used it to make art too.[19] Using the dry photomechanical process of the Xerox machine, she was able to transform natural elements, such as leaves and branches, into a new visual language of crisp black-and-white images ranging from partly tonal to fully saturated, depending on how light did or did not pass through objects on the copier bed. In one she created a lively composition with a branch of fern, playing with the plant's opacity to create a stark and lively vegetal silhouette against the white paper, while in other examples, she exploited the qualities of transparency of different species.

translucent (e.g., SF.045a [p. 97]). "An artist is an ordinary person," she once noted, "who can take ordinary things and make them special."[13]

Asawa was not only interested in creating patterns from repeatedly printing a single object, she was also attracted to the idea of choosing a single thing with a surface that has inherent patterning. In that case, she applied onto paper *the very thing* she sought to represent, thereby obtaining a mirror image of it by contact and transfer of the ink. Later in her career, she made direct impressions of intact natural things, which appear to have stemmed mostly from the activities of her adult children. When her son Adam went fishing in the San Francisco Bay, he would bring her salmon or bass.[14] To record the gift, she would make works on paper in the spirit of

MARKING

In the 1950s, Asawa started making drawings using a broad felt-tip marker pen intended for commercial signage, which she carved to create grooves, so that it allowed her to conceive a regular structure made up of multiple, parallel lines at once, and designs echoing patterns found in nature and the world around her: from ocean waves to land- and cityscapes, quilted blankets, and chairs (see "Rhythms and Waves" thematic introduction). She could vary the graphic effects she achieved with her uniquely

modified implement by altering the trajectory, angle, and pressure of her hand on the support, creating either supple, continuous lines or staccato, rectangular marks akin to the effect of a stamp. While Asawa made most of her marker drawings on paper, she also made some on wood, including an extraordinary example (now damaged) which she displayed in her exhibition at the de Young Museum in 1960. It features two wooden Thonet chairs, and it is easy to imagine what it might have meant for Asawa to take as subject matter an icon of modern design known for its repeating, curvilinear bentwood forms that emulate organic forms. She rendered the

chairs in negative space through the application of hundreds of similar but not uniform marks, whose shapes and intensity vary slightly. Leaving the natural pattern of the wood mostly apparent, the artist made the latter an integral part of her image of objects made of the same matter—the work has material integrity in this sense.[20]

The sense of touch and applied pressure that went into the making of these works would have been even more pronounced when she created works in copper foil (CF.13 [p. 114]), which, technically, are embossed and debossed line drawings or low reliefs, where patterns also play a big part. This particular use of material and

Ruth Asawa's felt-tipped pens, tips, and Flo-master ink. Photograph by Hudson Cuneo

Installation view of Ruth Asawa's
solo exhibition at M.H. de Young
Museum, 1960. Photograph by
Paul Hassel

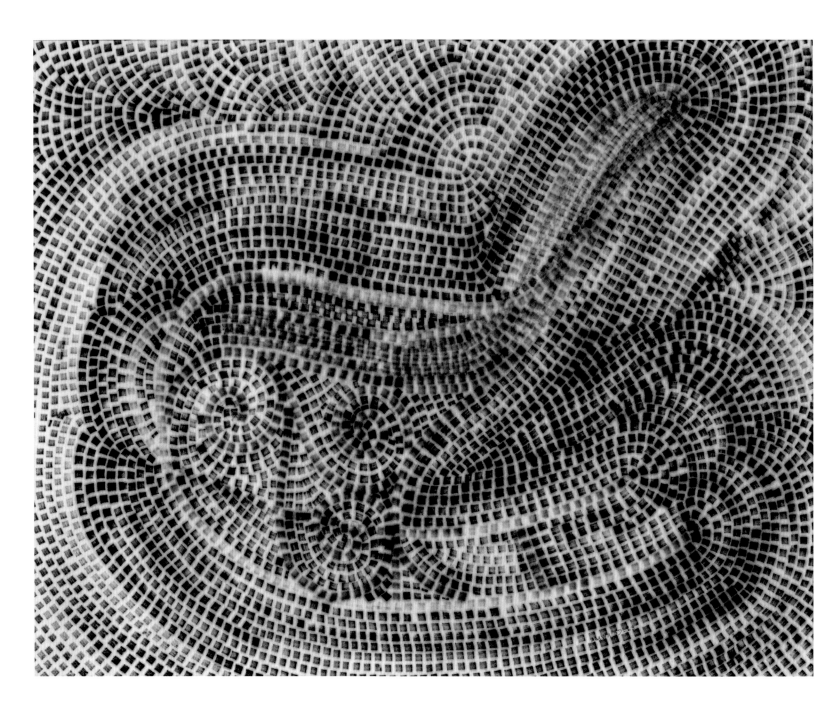

technique appears to have emerged out of two
commissions Asawa received in 1979: one for a
stoneware clay plaque to commemorate the 1979
Annual Meeting in San Francisco of the National
Conference of State Legislatures; the other, for a
cast bronze plaque for the Crown Zellerbach
Corporation.[21] For both of these projects, she
created her original designs in metal foil.

The idea of working on both sides of
her material/support was certainly not new to
Asawa. At Black Mountain, she often used both
the recto and verso of sheets of paper, an econ-
omy of materials Albers insisted upon.[22] She
dramatized this practice in later drawings, as in
one of a bentwood rocking chair. She was able

to create subtle contrasts between the clearly
defined, sometimes lightly inked marks applied
from the front, and the fuzzier, more muted
marks applied from the back, visible from the
recto due to the paper's translucency. From the
early 1950s onward, using both sides of the
paper had been also integral to her practice of
origami and paperfolds (see Jordan Troeller's
text in this volume).

PAPER

Asawa had a lifelong passion for paper, and a
deep, sustained engagement with the material
since her time at Black Mountain. There, she had
begun exploring its possibilities under Albers who,

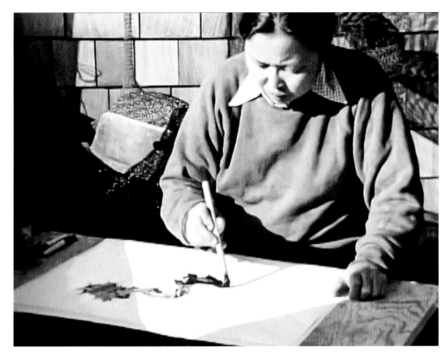

Ruth Asawa painting a plane tree, c. 1976, frames from Robert Snyder's 1978 film *Ruth Asawa: Of Forms and Growth*

as she later explained in a public lecture, "had a great respect for paper. From the most modest material one can build bridges, curves. He did not treat it like a preliminary step to something else. He believed that if somebody would take paper and explore it to the end something will come out of it that could be duplicated in no other material."[23] Asawa also remembered Buckminster Fuller's teaching: "he would talk about breathing, how paper breathes."[24] For her, paper was indeed a living thing, and understanding its full capacities and limits was crucial to her approach: "You have to respect what the material will do for you. You have to find the tools. You don't start out with preconceptions but work with the material itself."[25]

Over the course of her career, Asawa played with papers of very different kinds (newsprint, blotting paper, graph paper, vellum paper, Japanese paper, traditional European wove and laid papers), and she became keenly aware of what each could or could not do. While certain papers must have been well suited for paper-folding, others responded fittingly to the application of aqueous mediums. She was manifestly curious about the encounter between paper, whether sized or unsized, and ink or watercolor, and studied the agency of these mediums: how they behave and saturate appealingly different types of supports. She did not attempt to force a chosen subject matter upon her materials; instead, she was open to see what they might lend themselves to representing from her environment, be it a shell (MI.108 [pp. 190–91]) or persimmons (WC.252 [p. 195]), for instance, when she explored the potential of watercolor, ranging from blurred color effects in one case to crisp rendering in the other.

A case in point is her series of so-called Plane Tree drawings started in 1959, semi-abstract depictions of plane trees in Golden Gate Park. Footage from Robert Snyder's 1978 documentary *Ruth Asawa: Of Forms and Growth* shows the artist brush in hand, applying ink in strokes, ranging from short, rapid ones that caused the ink to splash on the coated paper, to long, fluid ones—liquid lines, as it were. As she noted, "I'm trying to make the trees fit into the nature of the strokes and the ink and the paper. The sycamore trees were the most ideal thing because they're gnarled, and where the paint puddles it makes a knot."[26]

Waxed, coated papers allowed Asawa to explore pooling effects (PT.062 [p. 48]), but also to create contrasts between shiny areas where the paper was left in reserve, and matte areas, where color was applied. As a result, the color

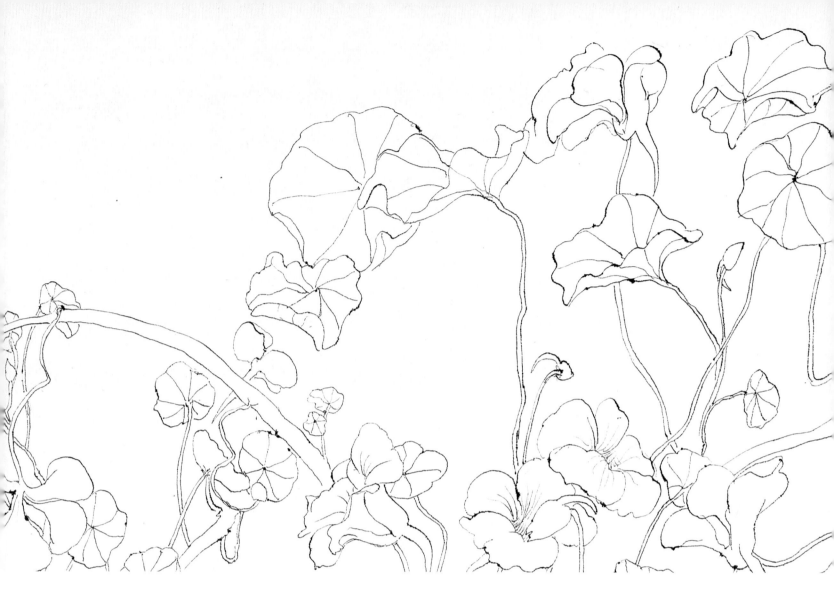

Detail of *Untitled* (PF.099, Nasturtiums), 1994, ink on Japanese paper, see pp. 214–15

seems to float on top of the surface, which it literally does because the pigment, blocked by the wax, was prevented from sinking into the paper fibers. Ultimately, she may not have embraced the character of a particular paper more fully than when she left most of the sheet untouched, whether its surface was smooth and shiny, or more matte and textured, in the case of mulberry fiber paper. A hallmark of mulberry paper is that the fibers tend to be very visible and they can create myriad natural lines, which Asawa made part of her work. She selected papers with a variety of characteristics and behaviors that interacted with her chosen mediums, in effect placing much of the burden of artistic intention on her choice of material.

IN CONCLUSION
Ruth Asawa's ideas about materiality were largely informed by her time at Black Mountain College, where she further explored values from her own

childhood and family, such as resourcefulness, curiosity, and respect. However, the way she transformed these values and put them to creative use, incorporated them into her drawing practice, and invested them with experience and feeling, was entirely her own. So was her abiding love for drawing and the thread of its possibilities. Her sensitivity and keen observation allowed her to see the potential of materials; her instinct and inquiry enabled her to realize it. In *Of Forms and Growth*, she compared her artistic relationship to her materials to that of a mother, who will know when to guide a child and when to step back and let them have the space they need to grow. Careful detachment was integral to her modus operandi: "I try to stay out of the picture and let it make itself. I enjoy watching it happen."[27] In doing so, she was able to find an authentic mode of self-expression and start anew. "In art," she observed, "everything happens for the first time. Every new drawing . . . is new, unique, individual."[28]

The value of instinct and inquiry was clearly imparted to Ruth Asawa by her teachers at Black Mountain College. Max Dehn "was always asking, asking, asking. . . . He never told us anything. He was always asking. I think that that process—the teachers at Black Mountain were teaching us a process of discovery or questioning or *inquiry*." . . . And "Albers asked, 'What do you want to do.' And I said, 'Well, I want to paint flowers.' He said, 'Oh, okay. You paint. So long as they are Asawa flowers.' He wanted every person to follow their own *instincts*." (emphasis added) Ruth Asawa, interview with Mary Emma Harris, February 17, 1998, Ruth Asawa Papers, box 35, folder 8. I am grateful to Scout Hutchinson for sharing these references.

1 Ruth Asawa, artist statement, March 29, 2002, Ruth Asawa Papers, box 191, folder 2.

2 Ruth Asawa, artist statement, 1968(?), Ruth Asawa Papers, box 127, folder 1.

3 Ruth Asawa, excerpt from Senior Exam, 1946–47, Black Mountain College, quoted in Jonathan Laib, *Ruth Asawa: Line by Line* (New York: Christie's, 2015), 14.

4 Ruth Asawa, letter to unknown recipient, April 25, 1972, Ruth Asawa Papers, box 127, folder 2.

5 Josef Albers, "Concerning Art Instruction," *Black Mountain College Bulletin* 2 (1944), 3.

6 Josef Albers quoted in Frederick A. Horowitz and Brenda Danilowitz, *Josef Albers: To Open Eyes. The Bauhaus, Black Mountain College, and Yale* (London: Phaidon, 2006), 103 n20.

7 Albers, "Concerning Art Instruction," 5.

8 Albers, "Concerning Art Instruction," 5.

9 On the practice of collage at Black Mountain College, see Helen Molesworth, "Collage," in *Leap Before You Look: Black Mountain College, 1933–1957* (Boston: Institute of Contemporary Art, in association with Yale University Press, New Haven, 2015), 57–63.

10 Asawa, interview with Mary Emma Harris, February 17, 1998, Ruth Asawa Papers, box 35, folder 8.

11 See Ruth Asawa, application for a Guggenheim Foundation Fellowship, 1955, Ruth Asawa Papers, box 129, folder 2.

12 The date header on the newspaper is cropped out, however there are mentions of mid-November and early December leases, and Asawa ran the Black Mountain College laundry beginning in the summer of 1948, so the newspaper appears to date from the fall of 1948.

13 Ruth Asawa, statement in the wall text of her exhibition at the Oakland Museum of California, 2001–2, cited by the *Contra Costa Times*, July 6, 2002.

14 I am grateful to Addie Lanier for sharing this information; email message to the author, October 23, 2022.

15 See Yoshio Hiyama, *Gyotaku: The Art and Technique of the Japanese Fish Print* (Seattle: University of Washington Press, 1964). On nature printing more generally, see Roderick Cave, *Impressions of Nature: A History of Nature Printing* (London: British Library; New York: Mark Batty Publisher, 2010), 177–78.

16 Correspondence in the Ruth Asawa Papers regarding a 1954 article on Japanese fishing and fish prints suggests that by the mid-1950s she was aware of and curious about this specific process, Ruth Asawa Papers, box 100, folder 11.

17 The artist used a brand of paper sold as Tableau which came in sheets measuring 24 × 36 inches and two other sizes.

18 See Jennifer L. Roberts, "The Mimeograph and the Chrysanthemum," in *Ruth Asawa: All Is Possible,* Helen Molesworth et al. (New York: David Zwirner Books, 2022), 144–46.

19 Vivian Tong, archivist, Ruth Lanier Inc., email message to the author, August 23, 2022.

20 Only fragments of this work have survived.

21 Both projects were documented by booklets published by the commissioning institutions. Copies of these booklets are kept in the archives at Ruth Asawa Lanier Inc.

22 See Jordan Troeller, "Drawing Lessons: Ruth Asawa's Early Work on Paper," in *Object Lessons: The Bauhaus and Harvard,* ed. Laura Muir (Cambridge, MA: Harvard Art Museums, 2021), 153.

23 Ruth Asawa, museum talk on Josef Albers given in the 1950s or 1960s, Ruth Asawa Papers, box 127, folders 1, 3.

24 Ruth Asawa, interview with P3 Gallery, 1989, Ruth Asawa Papers, box 127, folder 5.

25 Ruth Asawa, in Jacqueline Hoefer, "Ruth Asawa: A Working Life," in *The Sculpture of Ruth Asawa: Contours in the Air,* Timothy Burgland and Daniell Cornell et al. (San Francisco: Fine Arts Museums of San Francisco, and Berkeley: University of California Press, 2007), 26.

26 Ruth Asawa in *Ruth Asawa: Of Forms and Growth*, film by Robert Snyder (Santa Barbara, CA: Masters & Masterworks, 1978).

27 Ruth Asawa, letter to Daniel Rhodes, March 20, 1964, Ruth Asawa Papers, box 102, folder 4.

28 Ruth Asawa, speech for Asian American Arts Foundation Award, typescript, October 7, 1995, Ruth Asawa Papers, box 127, folder 7.

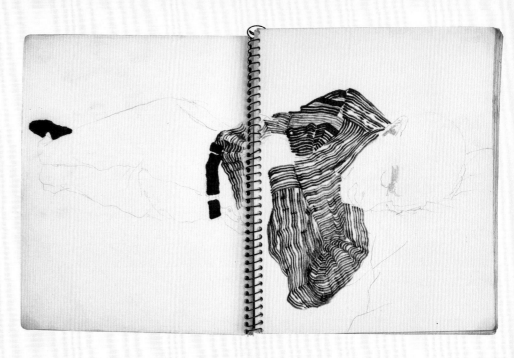

Untitled drawings
(SB.024), late 1950s–60s.
Spiral-bound sketchbook,
various mediums,
10 × 17¼ in. (25.4 × 43.8 cm)
open; 10 × 8½ × ¾ in. (25.4 ×
21.6 × 1.9 cm) closed.
Private collection

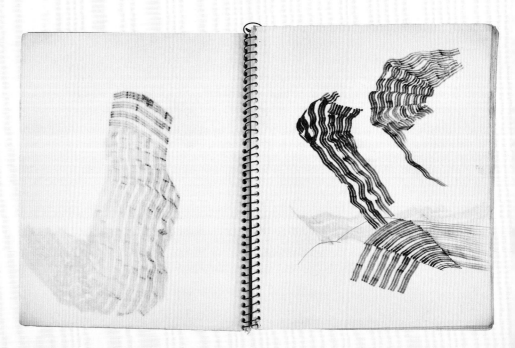

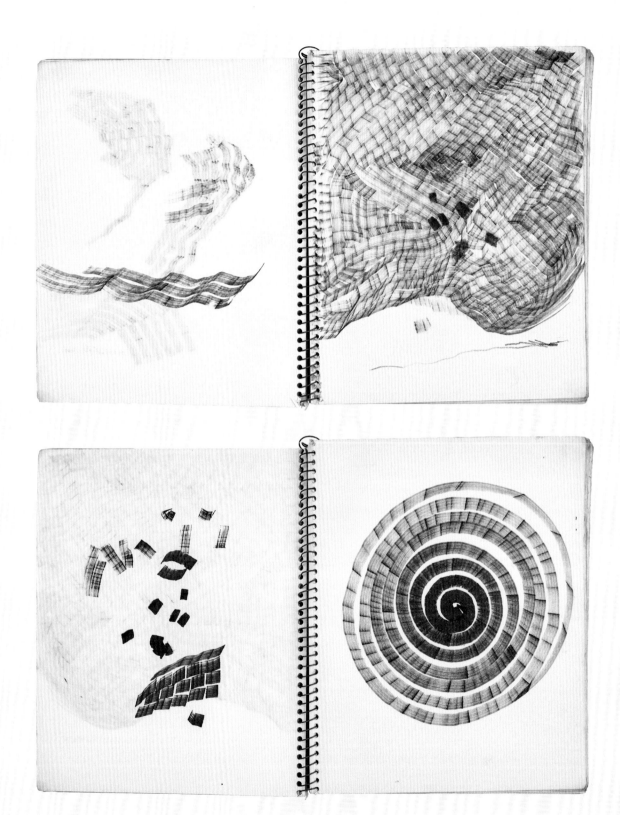

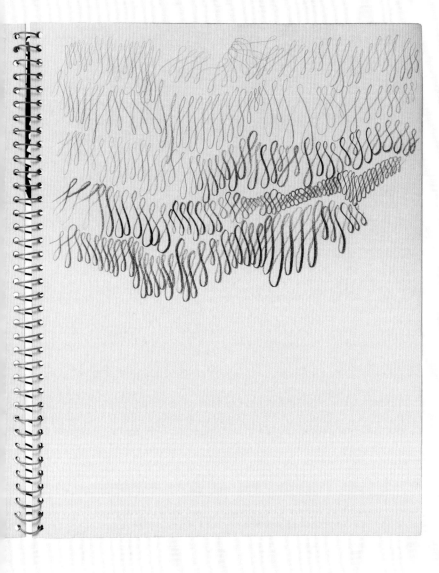

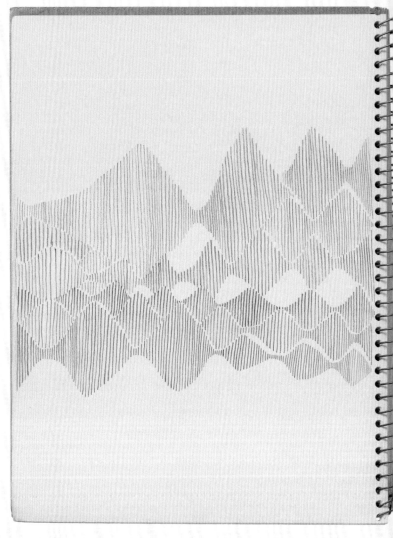

Untitled drawing
(SB.059), 1971. Graphite
on paper in spiral-bound
sketchbook, 14 × 11 in. (35.6 ×
27.9 cm) open; 14 × 12 × 1 in.
(35.6 × 30.5 × 2.5 cm) closed.
Private collection

Untitled drawing
(SB.070), 1973. Graphite
on paper in spiral-bound
sketchbook, 12 × 9 in.
(30.5 × 22.9 cm) open; 12 ×
10 × 1½ in. (30.5 × 25.4 ×
3.8 cm) closed.
Private collection

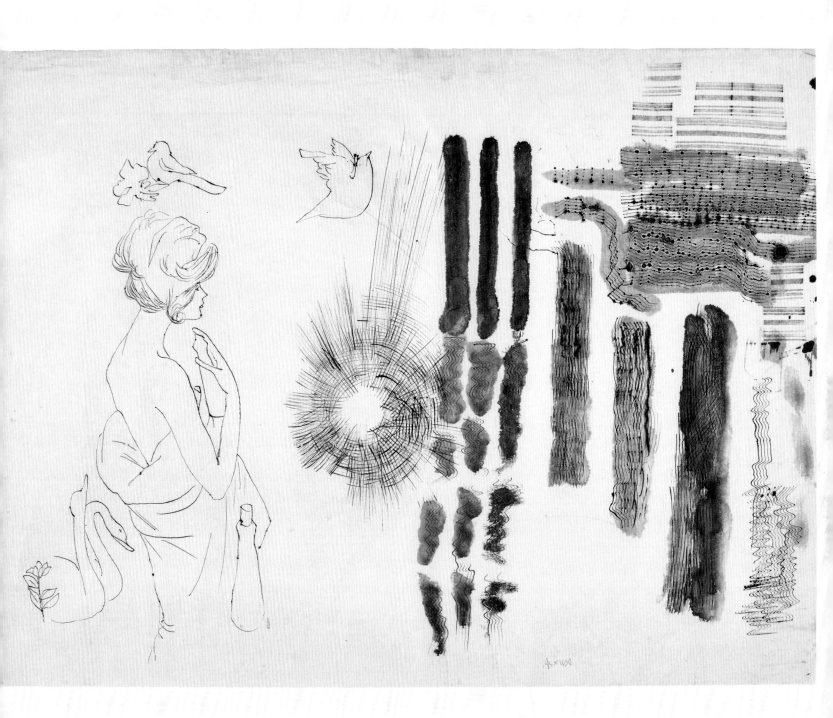

Untitled (FF.1053,
Experimental Pen and Ink
and Brushed Ink Technique
Examples), c. late 1950s–
early 1960s. Ink and
felt-tipped pen on Japanese
paper, 18 × 24¼ in.
(45.7 × 61.6 cm). Private
collection

EIGHT THEMES

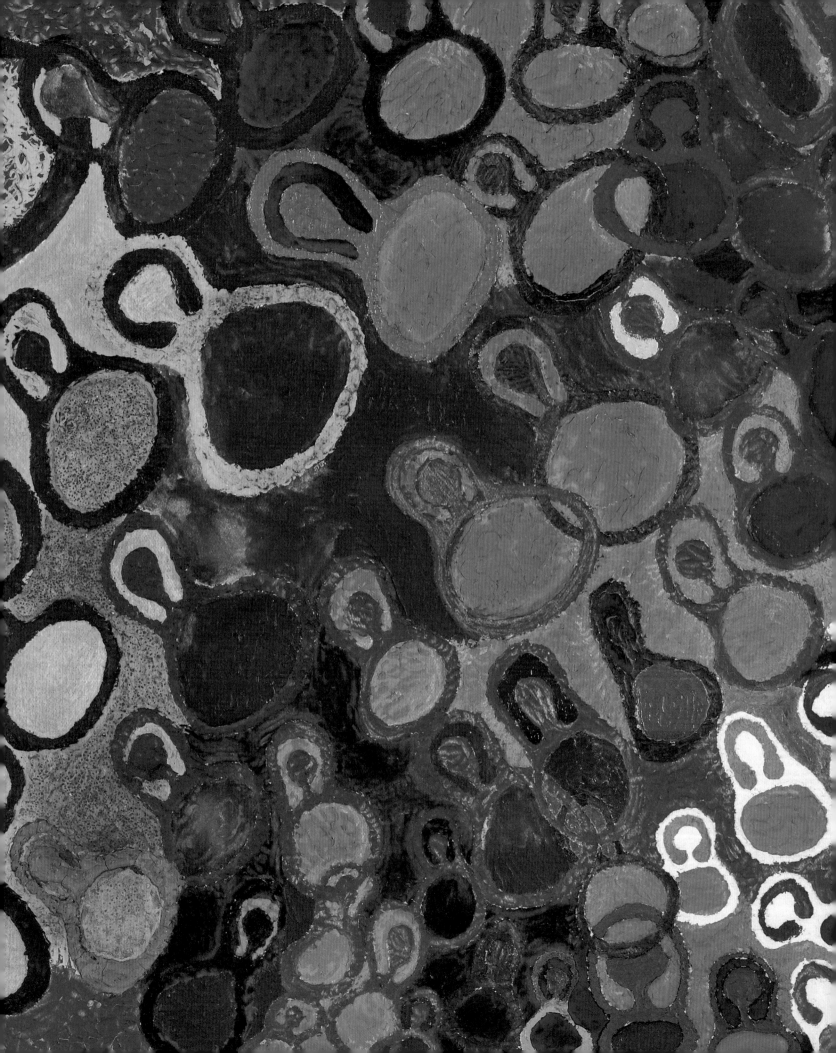

LEARNING TO SEE

Ruth Asawa's dancers can be hard to see, at first. But slow down with just one of these cellular bodies and a figure's stretching, bending limbs may start to appear. Take one of the forms in the upper-right corner of an untitled drawing from about 1948–49 (BMC.56), for example, where green surrounds blue, shaping it into a horseshoe above, and an egg below. Push the blue back, let the green come forward, and a dancer who is all limbs and head and hardly a body might billow into form—arms meeting in a continuous line above the head, legs bowed, impossibly, into a circle below. Lose your concentration, and just as quickly as this hint of a figure appeared, so it may spin out of focus, pirouetting back into amoebic abstraction.[1]

Asawa spent three years at Black Mountain College, from the summer of 1946 through the spring of 1949, attuning her eye to just these sorts of formal dynamics. In extensive, repeated coursework with Josef Albers—ten classes in total—she rigorously tested the dimensions of positive and negative space. She was learning, as she would later put it, to push the balance between figure and ground so that "one thing didn't dominate the other" and "the background became the figure and the figure became the background."[2] It was a process of not so much learning to draw as learning to see.[3]

The drawings in this section revel in these challenges of perceptual attention and planar equivalency. A close look at their workings offers a glimpse into Asawa's learning process, into how she brought a sense of spatial play to classroom exercises, from color studies to *matière* (the Bauhaus-descended practice whereby students defamiliarized materials through juxtapositions of texture and context). She found inspiration everywhere she turned on campus, from the circular motifs of Wonder Bread packaging in the dining hall (BMC.110 [p. 81]) to fallen dogwood leaves on the grounds (BMC.84 [p. 82]).[4] In the process, she sharpened a sensitivity to visual phenomena that would inform her work for decades to come.

Certain forms, such as the parallelogram, make repeat appearances. Informed by the elementary shape's emergence in classroom paper-folding exercises (see the "In and Out" section and Jordan Troeller's text in this volume), Asawa played its parallel lines out across the mediums of graphite, gold leaf, cut paper, and oil paint textured with a palette knife. She mirrored its malleable slant into zigzagging ribbons (BMC.98 [p. 79]). She unfolded it, boxlike, into winged contraptions (BMC.101 [p. 80]). She excised the negative of its reflected V form from paper and set the resulting arrows against bands of blue and green so that they vibrate, like the barbs of a feather, or a series of vertebrae (BMC.126 [p. 71]).

In drawing such varied subjects as Jello molds, the numeral 3, and her own hands and feet, she challenged spatial orientations and

maximized the negative-space potential of the blank sheet through object rotation (BMC.48 [p. 75], BMC.70 [p. 76], BMC.123 [p. 74]). Wrists and ankles open in all directions. Multiple iterations of *3s* collapse against their mirrored and angled counterparts, morphing into unfamiliar forms. The Jello molds are a lesson in the economy of line: notice how the circular bases at center emerge through the abrupt ending of lines that form the side ridges, rather than the addition of another line. This absence pushes the paper both forward and back, and through this surface play the molds grow flexible—shape-shifting into pulsing orbs, swinging skirts, and perhaps even pulsating jellyfish—recalling their absent gelatinous holds.

Asawa delighted in these free associations, in the way in which one formal possibility cascaded into another. She would return to the parallelograms, to the leaves, to her hands, to so many other forms, again and again, in various guises and configurations in the years to come, as the following seven themes attest. And yes, even the dancers would spiral back into view, as their generative inside-outside, forward-backward, negative-positive dynamics twirled on in her mind. As Asawa would reflect, some time later, in 1971: "This was a form, a dancing figure, which I used simply because I liked the idea of a figure and a background, and the figure and the background problem. And this preceded the forms I used in sculpture. Actually, it might have influenced me. Maybe the idea came from that."[5]

— ISABEL BIRD

1 For more on the figural dimensions of Asawa's dancers, see Ruth Asawa, interview with Aiko Cuneo, December 2003, Ruth Asawa Papers, box 35, folder 8. See also Mary Emma Harris, "Black Mountain College," in *The Sculptures of Ruth Asawa: Contours in the Air*, Timothy Anglin Burgard and Daniell Cornell et al., rev. ed. (San Francisco: Fine Arts Museums of San Francisco; Oakland: University of California Press, 2020), 85. The first sentence of this paragraph is informed by Yvonne Rainer's classic observation that "dance is hard to see." See Carrie Lambert-Beatty, *Being Watched: Yvonne Rainer and the 1960s* (Cambridge: MIT Press, 2008), xx.

2 Asawa, interview with Cuneo, December 2003.

3 On Asawa's distinction between learning to draw and learning to see, see her interview with Mary Emma Harris, February 1998, Ruth Asawa Papers, box 35, folder 8. This distinction aligns with that of another influential art instructor, Kimon Nicolaïdes; Asawa compares Albers to Nicolaïdes in the same interview. See Kimon Nicolaïdes, *The Natural Way to Draw: A Working Plan for Art Study* (Boston: Houghton Mifflin Company, 1941), 5.

4 Asawa discusses the origins of these works in an interview with Mary E. Harris, December 1971, Ruth Asawa Papers, box 35, folder 3.

5 Asawa, interview with Harris, December 1971.

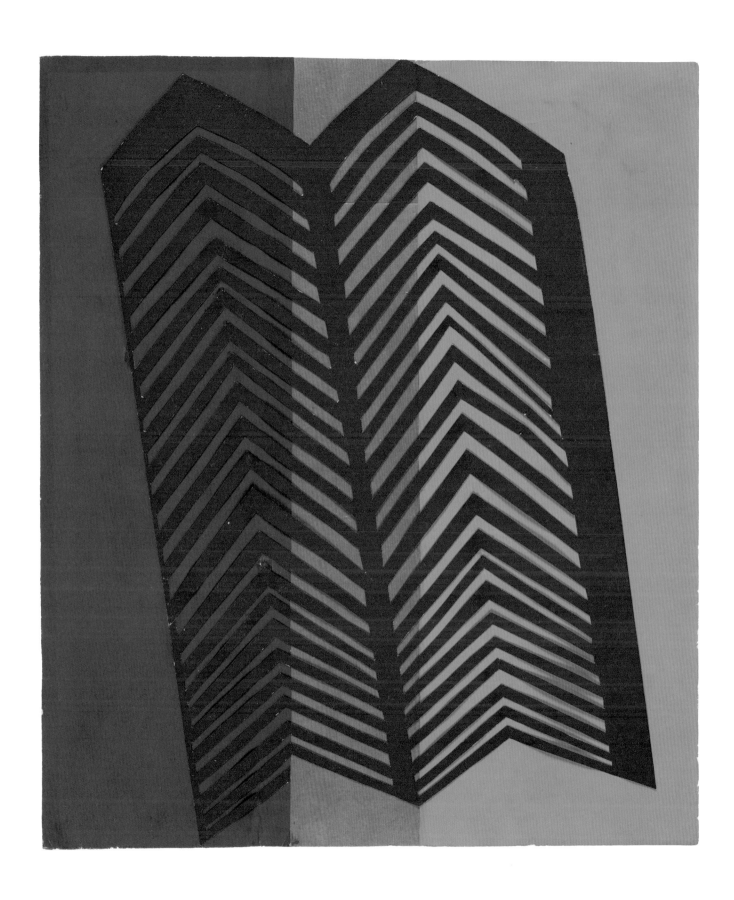

Untitled (BMC.126, Study in Primary Colors), c. 1946–49
Collage of cut colored papers mounted to three colored papers, 13⅜ × 11½ in. (34 × 29.2 cm)
Harvard Art Museums/Busch-Reisinger Museum, Gift of Josef Albers, BR49.416

Untitled (BMC.127, Meander in Green, Orange, and Brown), c. 1946–49
Collage of colored papers mounted to brown paper, 17¼ × 22⅜ in. (43.8 × 56.8 cm)
Harvard Art Museums/Busch-Reisinger Museum, Gift of Josef Albers, BR49.408

Untitled (BMC.121, Exercise in Color Vibration and Figure Background), c. 1948–49
Collage of colored papers and opaque watercolor on paper, 23¹⁵⁄₁₆ × 18¹⁄₁₆ in. (60.8 × 45.9 cm)
Harvard Art Museums/Busch-Reisinger Museum, Gift of Josef Albers, BR49.407

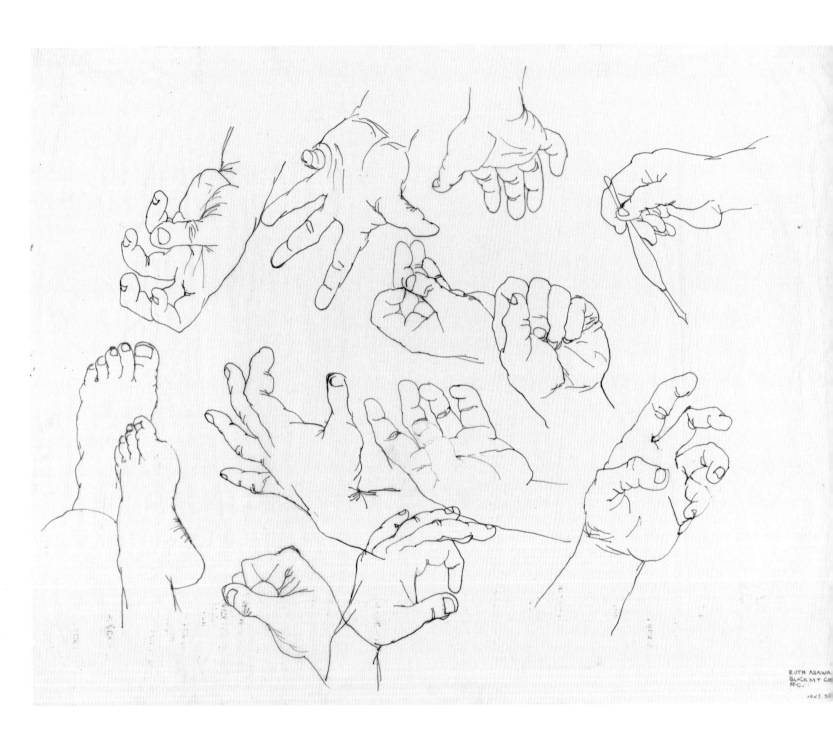

Untitled (BMC.123, Studies of Hands and Feet), c. 1946–49
Ink on tracing paper, 18¾ × 23¾ in. (47.6 × 60.3 cm)
Harvard Art Museums/Busch-Reisinger Museum, Gift of Josef Albers, BR49.385

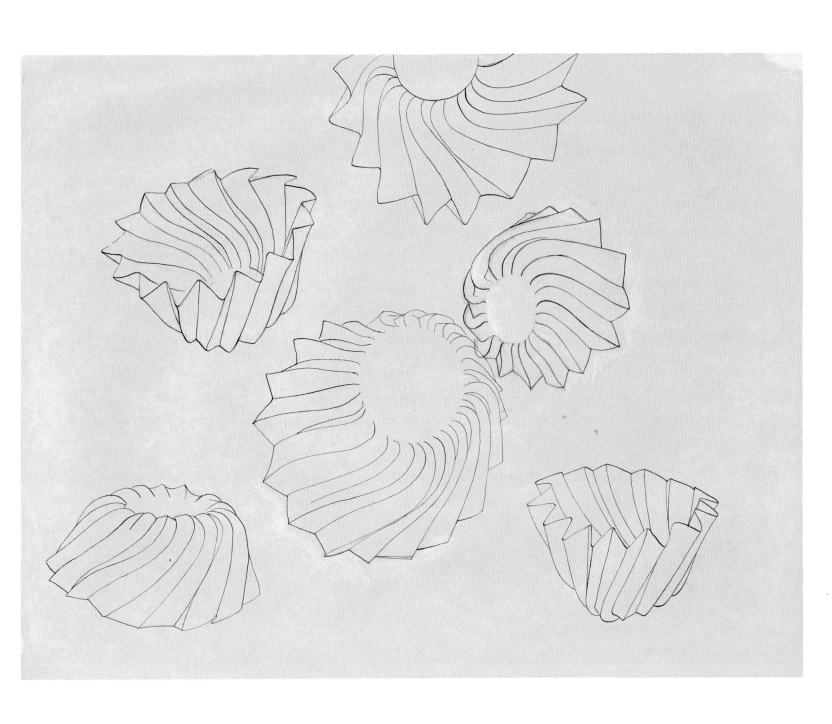

Untitled (BMC.48, Jello Molds), c. 1946–49
Ink and graphite on paper, 17 × 22 in. (43.2 × 55.9 cm)
Achenbach Foundation for Graphic Arts, Fine Arts Museums of San Francisco,
Gift of the Artist, 2007.28.57

Untitled (BMC.70, *3*'s and *S*'s), c. 1946–49
Graphite, ink, and watercolor on paper, 17 × 22 in. (43.2 × 55.9 cm)
The Josef and Anni Albers Foundation, 2007.30.32

Untitled (BMC.132, Color Study of Many Colored Squares and Triangles), c. 1946–49
Oil on paper, 16 × 9½ in. (40.6 × 24.1 cm)
The Josef and Anni Albers Foundation, 1976.30.4

Untitled (BMC.112, Receding Circles), c. 1948–49
Oil on paper, 10 × 12 in. (25.4 × 30.5 cm)
The Josef and Anni Albers Foundation, 2007.30.22

Untitled (BMC.98, In and Out), c. 1948–49
Oil and graphite on board, 8⅛ × 11 in. (20.6 × 27.9 cm)
Private collection

Untitled (BMC.101, Birds), c. 1948–49
Oil on board, 7½ × 12 in. (19.05 × 30.48)
Private collection

Untitled (BMC.108, Stacked Triangles), c. 1948–49
Oil and watercolor on paper, 5½ × 12 in. (14 × 30.5 cm)
The Josef and Anni Albers Foundation, 2007.30.12

Untitled (BMC.110, Circles), c. 1948–49
Oil on paper, 5 × 12 in. (12.7 × 30.5 cm)
The Josef and Anni Albers Foundation, 2007.30.13

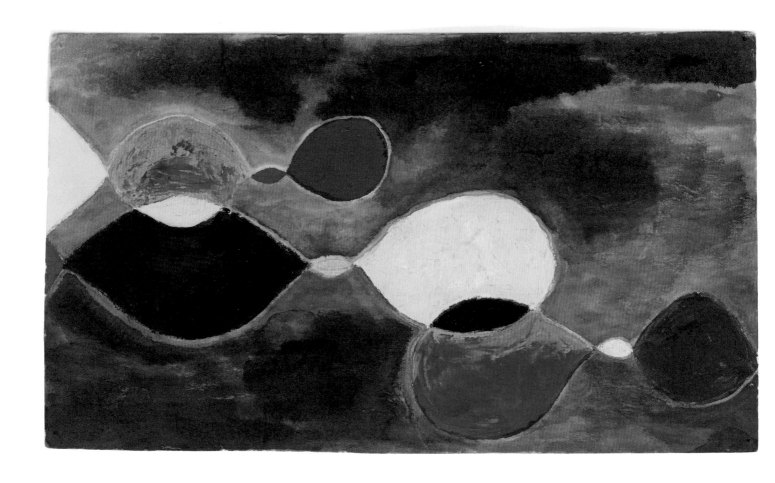

Untitled (BMC.84, Dogwood Leaves), c. 1948–49
Oil and watercolor on paper, 7 × 12 in. (17.8 × 30.5 cm)
The Josef and Anni Albers Foundation, 2007.30.6

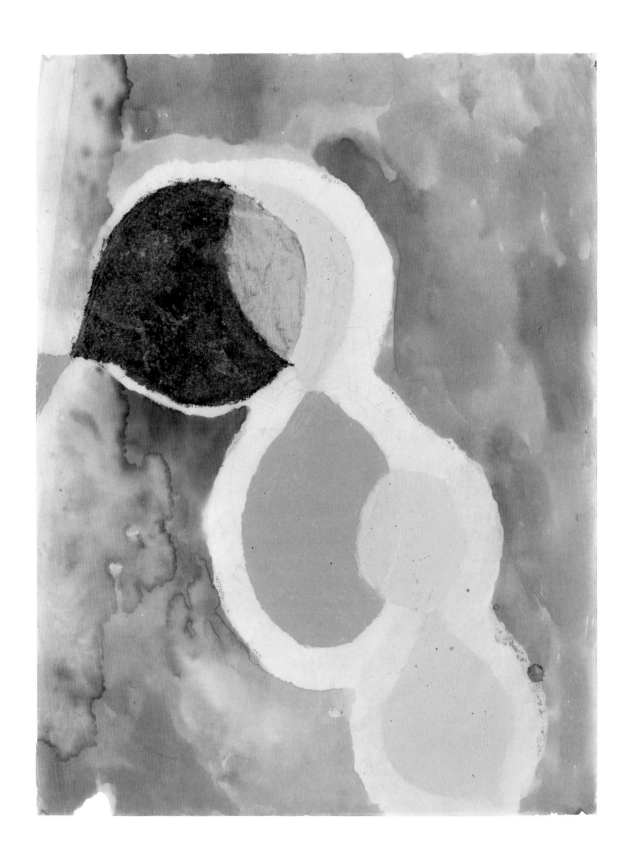

Untitled (BMC.86, Dogwood Leaf), c. 1948–49
Oil and watercolor on tracing paper, 10½ × 8 in. (26.7 × 20.3 cm)
The Josef and Anni Albers Foundation, 2007.30.10

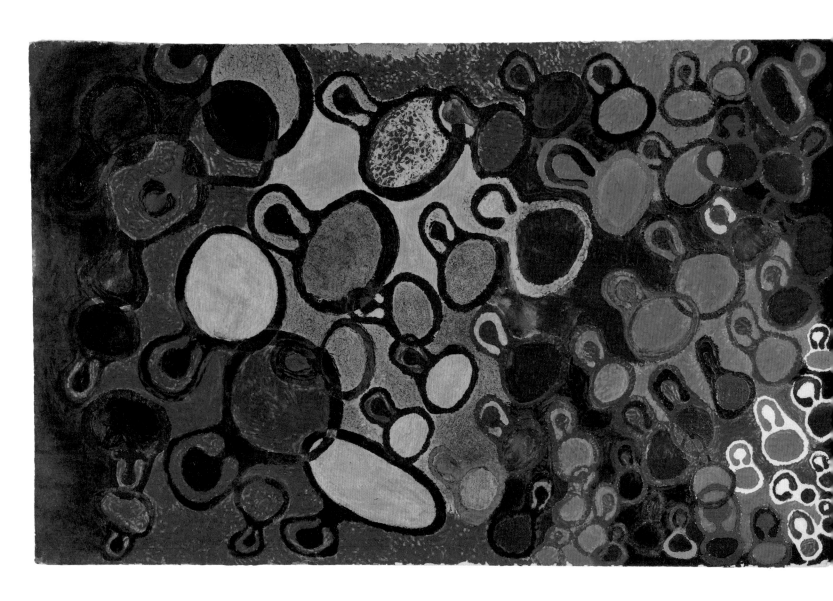

Untitled (BMC.56, Dancers), c. 1948–49
Oil and gouache on paper, 12 × 19 in. (30.5 × 48.3 cm)
Private collection

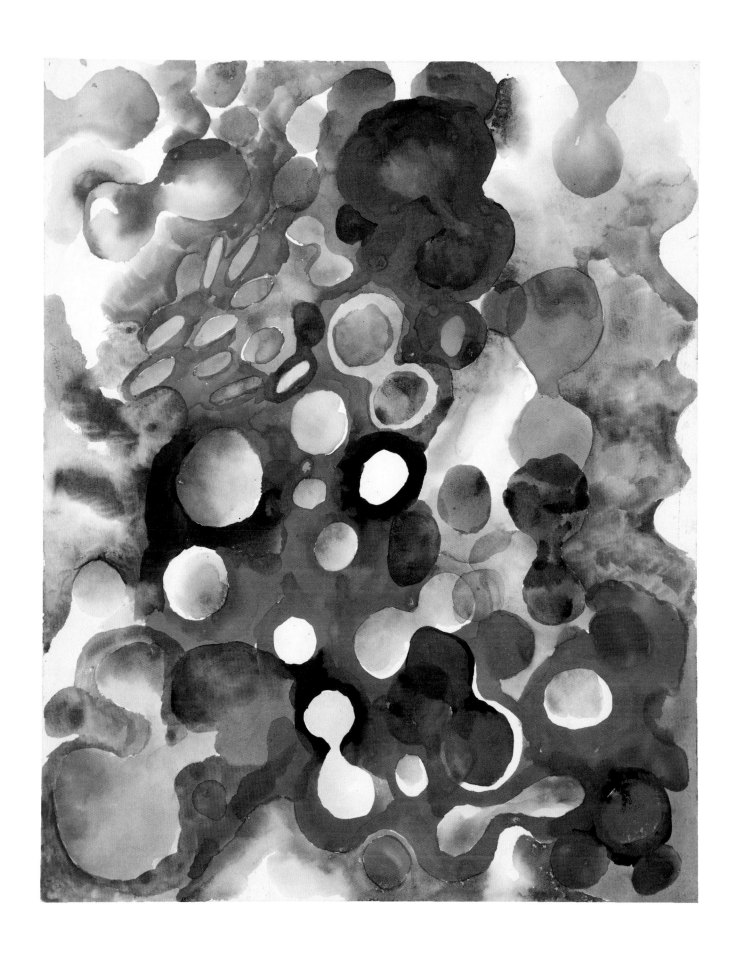

Untitled (BMC.107, Dancers), c. 1948–49
Watercolor and gouache on paper, 19¾ × 16 in. (50.2 × 40.6 cm)
Private collection

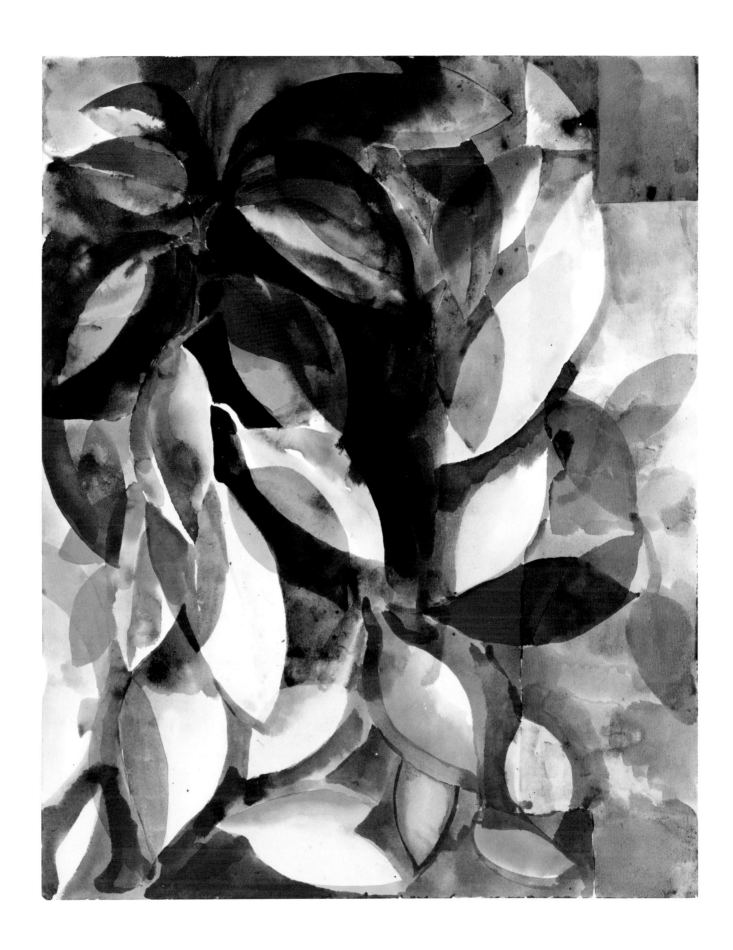

Untitled (BMC.68, Stem with Leaves), c. 1948–49
Watercolor on paper, 19¾ × 16 in. (50.2 × 40.6 cm)
Achenbach Foundation for Graphic Arts, Fine Arts Museums of San Francisco,
Gift of Aiko and Laurence Cuneo, 2007.29.3

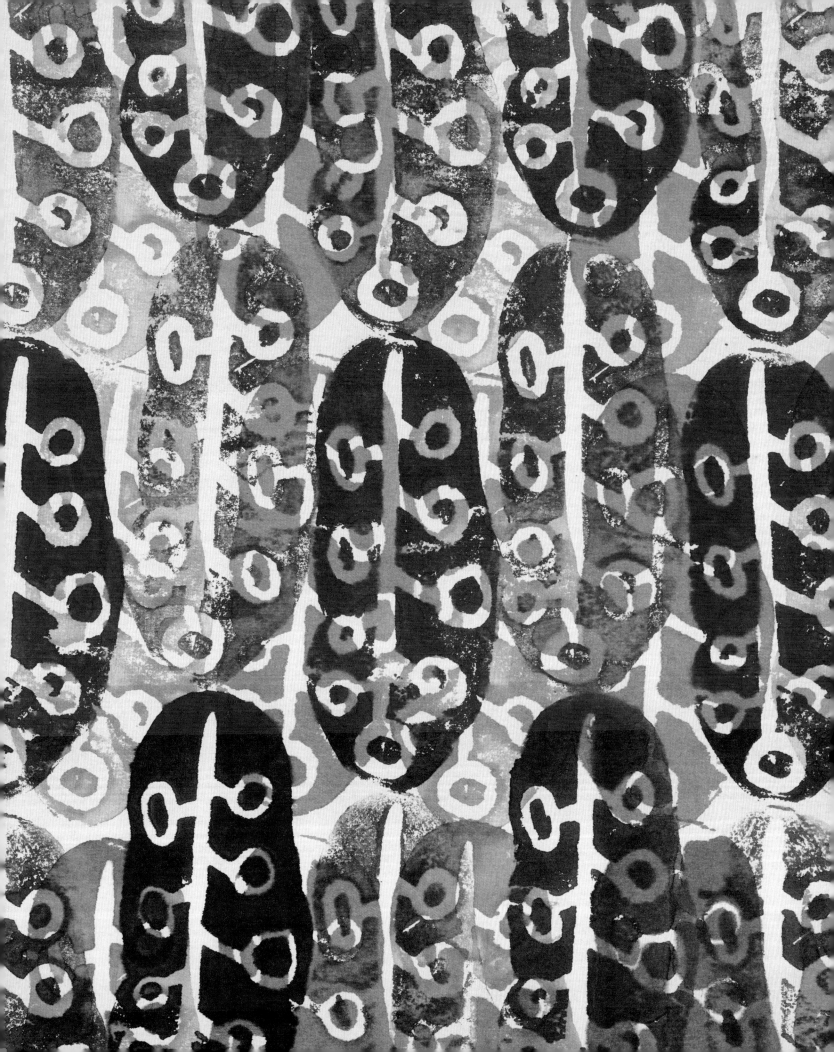

FOUND AND TRANSFORMED

The paucity of formal art supplies at Black Mountain College encouraged students to work with what was at hand, a material and creative challenge that Ruth Asawa readily accepted: "We had to scrounge around with things that were around us. And I think that was very good for us."[1] While Asawa made collages from leaves and ferns to explore the interaction of color and texture, the works in this section show her testing out found materials as implements for expanded mark-making. The Laundry Stamp works, for example, were born out of her 1948 summer session at Black Mountain, when she worked in the school's laundry room. There she discovered a drawing instrument in the stamps used to mark the linens. Borrowing these utilitarian tools to complete exercises for Josef Albers's Design course, she filled pages of paper and newsprint with *DOUBLE SHEET* and *BMC* stamps in dense, repetitive rows (BMC.74 [p. 91]) or spare, radial compositions (BMC.78 [p. 92]).

In the early 1950s, working from her home in San Francisco, Asawa began making her own stamps from everyday objects: bike pedals, wine corks, apples. Their impressions repeat across the page, often overlapping or tilting out of line, forming loose grids that embrace irregularity and variation.[2] A number of these works were made by halving a potato lengthwise, carving a treelike design into its center, and repeatedly pressing its incised face to the paper with different colored inks. In one (SF.045c [p. 96]), we can see the echo of Albers's instruction; here Asawa made impressions across the paper in three neat rows, varying both the concentration of marks and saturation of color. The gradation from dense to sparse and from opaque to transparent recalls Albers's "line weight" or "engineer's scale" drawing exercises, but here, as in one of her Laundry Stamp works (BMC.74), Asawa experimented with using a stamp rather than drawing rows of straight graphite lines. As the purpose of the original drawing assignment was to vary the pressure of one's drawing tool to create lighter or darker marks, Asawa's substitution of a stamp here is a fitting one.

Later stamped works show Asawa moving away from altering a found object or arranging it into a pattern in favor of making a simple index of the thing itself. These prints are direct impressions of organic materials, which Asawa pressed just once onto the paper's center. To make works like *Untitled* (LP.009 [pp. 100–101]), she used a sponge to transfer black ink to an object, here a bass, then covered it with a sheet of Japanese paper and used her hands as a baren to gently transfer the impression of its fins and scales. Her process seems to demonstrate a tenderness and reverence for the subject that may stem from her series of life masks, begun in the mid-1960s (see Aleesa Pitchamarn Alexander's text in this volume). With these plaster casts, Asawa expressed a desire to suspend time: "I like the idea of stopping the moment. . . . And it's going to disappear.

I know it's going to go away but I like that, I like that moment."[3] The leaf prints achieve a similar goal, capturing the branching veins of freshly picked foliage before it wilted and decayed. Precursors to these late prints can be traced to experiments from the early 1950s, in which Asawa stamped her first two children's small feet onto the page, preserving their delicate contours in blue, pink, and yellow ink.[4]

Working with found materials had been part of Asawa's world since early childhood, the result of growing up on a working farm where resourcefulness and improvisation were skills necessary for the success of the crops, but which also encouraged art to emerge from the remnants of daily life. For Asawa, there had always been wonder in the everyday, a point which she

seems to have emphasized with each impression of the laundry stamp, every potato printed in fuchsia or sky blue, and each inked leaf carefully peeled away from the paper to reveal its reverse.

— SCOUT HUTCHINSON

1 Ruth Asawa, in "Oral History Interview with Ruth Asawa and Albert Lanier," by Mark Johnson and Paul Karlstrom, June 21–July 5, 2002, Archives of American Art, Smithsonian Institution, unpaginated transcript, https://www.aaa.si.edu/collections/interviews/oral -history-interview-ruth-asawa-and-albert-lanier-12222.
2 See Taylor Davis, "Radiant and Productive Atmosphere," in *Ruth Asawa: All Is Possible*, Helen Molesworth et al. (New York: David Zwirner Books, 2022), 106.
3 Asawa, in "Oral History Interview."
4 Ruth Asawa, in conversation with Aiko Cuneo, December 10, 2003, Ruth Asawa Papers, box 79, folder 5, side A.

Untitled (BMC.74, Double Sheet Stamp), c. 1948
Stamped ink on newsprint, 17⅛ × 22 in. (43.5 × 55.9 cm)
Asheville Art Museum, Black Mountain College Collection,
gift of Aiko & Laurence Cuneo, 2010.33.02.60

Untitled (BMC.78, BMC Sunburst), c. 1948–49
Stamped ink on newsprint, 17 × 22 in. (43.2 × 55.9 cm)
The Josef and Anni Albers Foundation, 2007.30.44

Untitled (BMC.75, Double Sheet Clusters), c. 1948–49
Stamped ink on newsprint, 17¼ × 22 in. (43.8 × 55.9 cm)
Achenbach Foundation for Graphic Arts, Fine Arts Museums of San Francisco,
Gift of the Artist, 2007.28.60

Untitled (SF.043e, Bike Pedal – Black/Gray [Checkerboard]), c. 1951–52
Stamped ink on Japanese paper, 14¼ × 10¼ in. (36.2 × 26 cm)
Private collection

Untitled (SF.047a, Potato Print – Cross, Blue/Black), c. 1951–52
Stamped ink on Japanese paper, 14¼ × 10 in. (36.2 × 25.4 cm)
Private collection

Untitled (SF.045c, Potato Print – Branches, Purple/Blue), c. 1951–52
Stamped ink on Japanese paper, 14¼ × 10¼ in. (36.2 × 26 cm)
Whitney Museum of American Art, New York; purchase, with funds from the Drawing
Committee, the Director's Discretionary Fund, and partial gift of Paul Lanier, 2018.112

Untitled (SF.045a, Potato Print – Branches, Magenta/Orange), c. 1951–52
Stamped ink on Japanese paper, 14¼ × 10¼ in. (36.2 × 26 cm) (approximate)
Achenbach Foundation for Graphic Arts, Fine Arts Museum of San Francisco,
Gift of the Artist, 2010.51.6

Untitled (LP.001, Large Leaf), c. early 1990s
Ink on Japanese paper, 17¾ × 17 in. (45.1 × 43.2 cm)
Private collection

Untitled (Leaf from the Sacramento Delta), c. early 1990s
Ink on Japanese paper, 43⅛ × 25¹¹⁄₁₆ in. (109.5 × 65.3 cm)
Courtesy of the Department of Special Collections, Stanford University Libraries

Untitled (LP.009, Fish), 1987
Ink on Japanese paper, 22 × 40 in. (55.9 × 101.6 cm)
Private collection

FORMS WITHIN FORMS

In a fascinating letter from 1952 addressed to Ruth Asawa (next page)—the sheet itself an intricate labyrinth of holepunches and inkblots, with sentences oriented in all four directions— the artist Ray Johnson detailed how he wished to trade a painting for one of his friend's sculptures: "My favorite is the one [. . .] of forms within forms within forms."[1] Perhaps the best-known genre of her work, Asawa's Form within a Form sculptures, as they are now commonly known, have been interpreted in terms of their relationship to biology and to craft, and as three-dimensional drawings in space.[2] Asawa herself felt that her drawings were the foundation for these looped-wire sculptures, which featured lobes of graduated size in either layered, enclosed, or continuous configurations (S.270 [p. 121]).[3]

The artist later remembered tracing similar hourglass shapes in the dirt with her feet while growing up on the farm in California.[4] At Black Mountain College, various form-within-a-form line drawings resembling topographical maps appear in her notes from classes with Josef Albers, while hand-drawn diagrams of cell fission from her 1949 biology course with Yu-ching Tsui similarly capture forms contained within surrounding contours, or more precisely, nuclei within cell walls.[5] Another early motif Asawa credited with influencing the curvilinear contours of her sculptures was derived from the figure of a dancer (BMC.56 [p. 84], BMC.107 [p. 85]) (see "Learning to See" section introduction). In this simplified shape, which she

reduced to a head atop a circular body with arms raised above, Asawa found a generative form to probe problems of positive and negative space, transparency, and continuity across mediums.

When Asawa began exploring continuous surfaces in looped wire around 1951, her dancer motif served as a basis for some of these sculptures. A drawing Asawa included as part of her 1952 application for a Guggenheim Fellowship shows her further abstracting the original figural form. In the suspended sculpture drawing at the right of this sheet, Asawa extended the contour of her dancer, adding a third curved layer (p. 119). In her words, this expanded dancer motif makes "use of the space inside" and captures how "an outer surface can become an inner surface and then an outer surface and so on," a concept she hoped to advance after earning this prestigious fellowship.[6] In this way, her continuous surfaces aligned directly with the logic of the ornamental pattern of the meander, which had so fascinated her at Black Mountain (see "Rhythms and Waves" theme).

Indeed, for Asawa, wire was "a natural extension of drawing on paper—transferring the line of ink into metal and moving it into space."[7] In her transmedial practice, Asawa very often drew first, later "doing" her drawings "into sculpture."[8] She also drew after, using works on paper as a means to document and classify her sculptures. While Asawa used contour line drawings to design and record the shapes of her looped-wire sculptures, she also learned

Ruth

I also have a job making

I would like to trade

Stiles in San Francisco.

And it is seven feet high and

recently paintings his of slides color beautiful some

which is like a plus sign;

I am making

a painting

had, Bolotowsky Ilja the that

frames,

a painting knute

for a wire sculpture.

forms within forms within forms

wide.

Do you ever see Lavernes?

I saw

Please let me know

My favorite

what you think.

I saw

Ray

Letter from Ray Johnson to Ruth Asawa (RJ.027), c. 1952
Ink on paper, 10½ × 7½ in. (26.7 × 19.1 cm)

104 Private collection

through drawing how the negative space between three-dimensional forms could become activated for the viewer: "From drawings I know that a sensation of watching metamorphosis can be achieved through the grouping of related forms at studied distances apart."[9]

Another method Asawa explored for recording her looped-wire sculptures and investigating their potential interactions was screentone collage (ZP.16B [pp. 112–13], ZP.04 [p. 111], ZP.05 [p. 111]). Using adhesive films made by Zip-A-Tone, Asawa would cut, burnish, and layer undulating shapes of patterned film in order to render the transparent, interlaced mesh and "roundness" of her looped-wire surfaces.[10] Reproductions of screentone collage drawings accompanied Asawa's 1955 application for a Guggenheim Fellowship as a means of visualizing arrangements of her sculptures, assembled together in two dimensions. A year later she exhibited a screentone collage publicly, establishing that she viewed such experimental, yet documentary, works as finished in their own right.[11]

Years later, Asawa would return to her continuous Form within a Form motif by experimenting with new techniques and materials: she rendered it in minute ink dots, varying in density in the 1960s (SD.106 [p. 109]); in washes of watercolor around 1980 (WC.133 [p. 108]); and as a relief drawing in copper foil around 1980 (CF.13 [p. 114]). One would eventually become her chop design, used to blind-stamp her papers with an embossment, serving as a sort of signature and as an encapsulation of her artistic concerns. Coincidentally, perhaps, Ray Johnson's aforementioned letter not only embodies some of these concerns—it is, in fact, transparent in its perforations, rotational in its orientation—but also features, at center, this very design.

— KIRSTEN MARPLES

1 Johnson, who knew her first in Milwaukee and then as a fellow student at Black Mountain College, had apparently seen an Asawa sculpture installed at Laverne Originals showroom in New York in 1952.
2 See, respectively, Jason Vartikar, "Ruth Asawa's Early Wire Sculpture and a Biology of Equality," *American Art* 34, no. 1 (Spring 2020), 3–19; Krystal Reiko Hauseur, "Crafted Abstraction: Three Nisei Artists and the American Studio Craft Movement: Ruth Asawa, Kay Sekimachi and Toshiko Takaezu" (PhD diss., University of California, Irvine, 2011); and Mary Emma Harris, "Black Mountain College," in *The Sculpture of Ruth Asawa: Contours in the Air*, Timothy Anglin Burgard and Daniell Cornell et al., rev. ed. (San Francisco: Fine Arts Museums of San Francisco; Oakland: University of California Press, 2020), 84.
3 "I had no intentions of going into sculpture, but found that sculpture was just an extension of drawing, which was really what I'm primarily interested in. . . . it's almost like drawing in space." Asawa, interview with Mary E. Harris, December 19, 1971, Ruth Asawa Papers, box 35, folder 3.
4 "We used to make patterns in the dirt, hanging our feet off the horse-drawn farm equipment. We made endless hourglass figures that I now see as the forms within forms in my crocheted wire sculptures." Ruth Asawa, typed artist statement, c. August 14, 2001, Ruth Asawa Papers, box 107, folder 3.
5 For examples, see Ruth Asawa Papers, box 174, folder 9; box 174, folder 17 [page 6]; box 175, folder 1.
6 Ruth Asawa Papers, box 129, folder 1.
7 Asawa, typed statement for J.J. Brookings Gallery, June 5, 1995, Ruth Asawa Papers, box 127, folder 7.
8 "I have hundreds of drawings that are very beautiful that need doing into sculpture." Ruth Asawa, letter to Mr. Hohnsbeen, November 15, 1955, Ruth Asawa Papers, box 100, folder 15.
9 Asawa, application for Guggenheim Fellowship, 1952, Ruth Asawa Papers, box 129, folder 1.
10 Ruth Asawa interview with Aiko Cuneo, December 10, 2003, Ruth Asawa Papers, box 79, folder 5, audio recording, side B. A commonly used brand of transfer screentones was originally trademarked as Zip-A-Tone.
11 In 1956, Asawa exhibited a "zip-a-tone" in the San Francisco Art Association's *20th Annual Drawing and Print Exhibition* at the San Francisco Museum of Art. See Emily K. Doman Jennings, "Chronology," rev. Lauren Palmor with Jaime Schwartz, in *The Sculpture of Ruth Asawa: Contours in the Air* (2020), 280–81.

Untitled (AB.014, Continuous Form within a Form), c. 1950s
Ink and oil on paper, 9½ × 12 in. (24.1 × 30.5 cm)
Private collection

Untitled (SF.063, Continuous Form within a Form), c. 1950s
Pastel and gouache on board, 9½ × 12 in. (24.1 × 30.5 cm)
Private collection

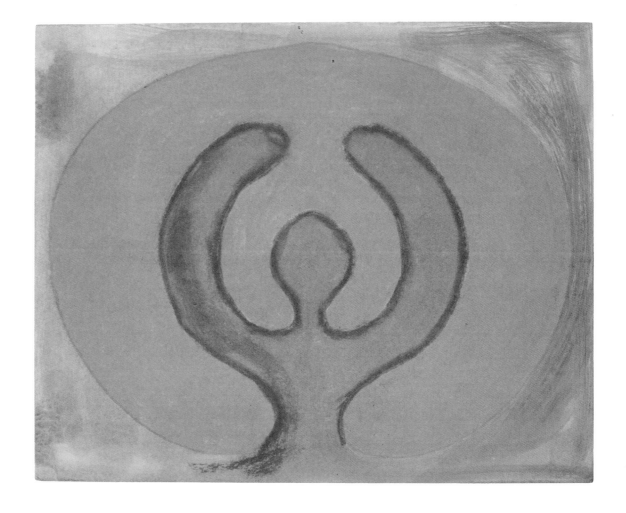

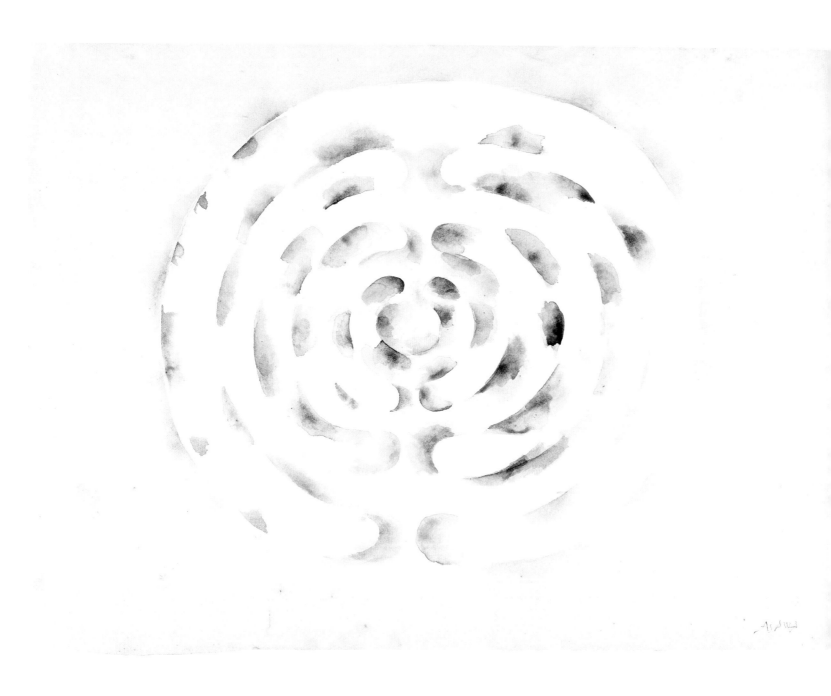

Untitled (WC.133, Continuous Form within a Form), after c. 1980
Watercolor on paper, 15½ × 21½ in. (39.4 × 54.6 cm)
Private collection

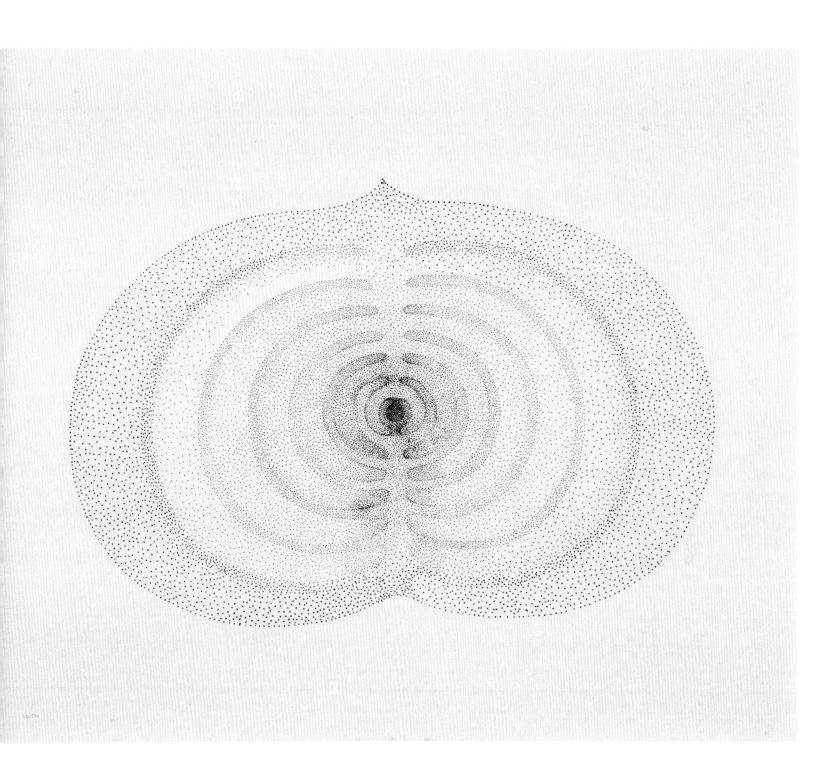

Untitled (SD.106, Continuous Form within a Form Sculpture Drawing Rendered in Dots), c. 1960s
Ink on Japanese paper, 20 × 24 in. (50.8 × 61 cm)
Private collection

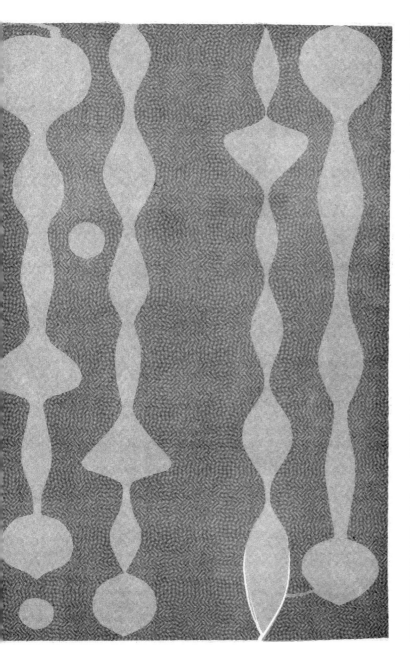
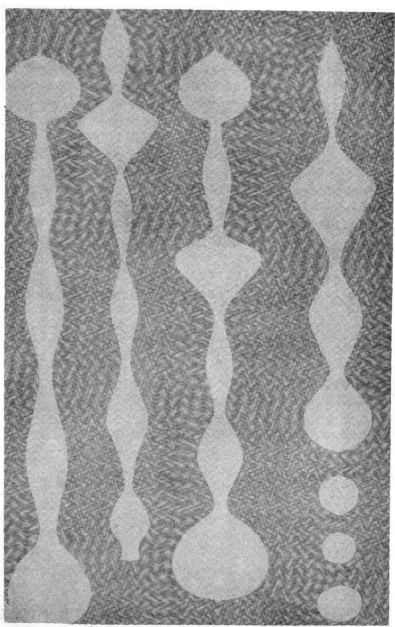

Untitled (ZP.04, Four Looped-Wire Sculptural Forms), c. mid-to-late 1950s
Screentone on board, 11¼ × 8 in. (28.6 × 20.3 cm)
Private collection

Untitled (ZP.05, Four Looped-Wire Sculptural Forms), c. mid-late 1950s
Screentone on board, 11½ × 7½ in. (29.2 × 19.1 cm)
Private collection

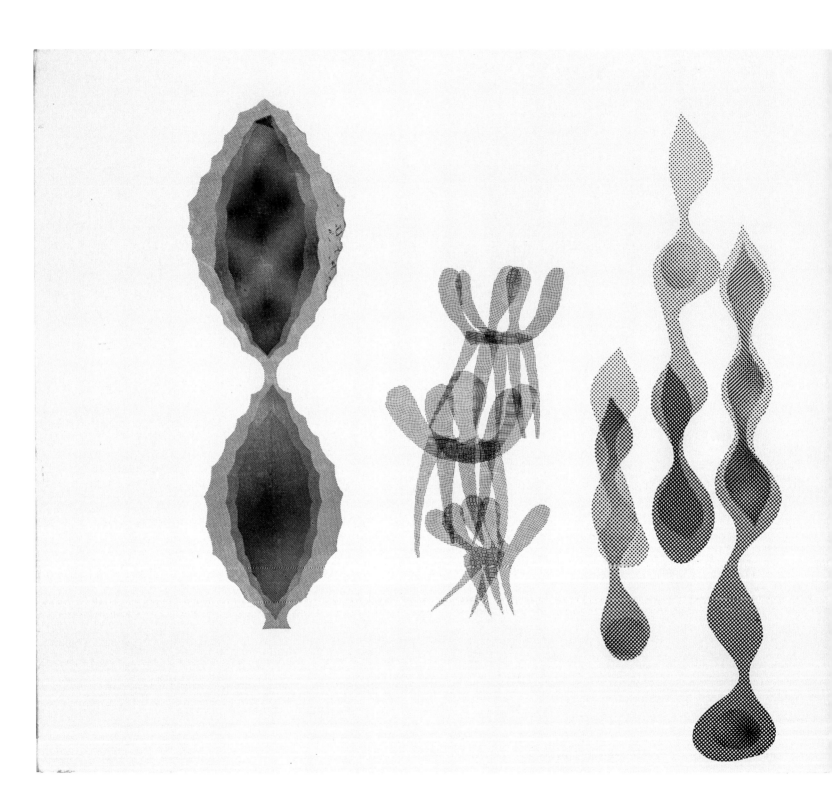

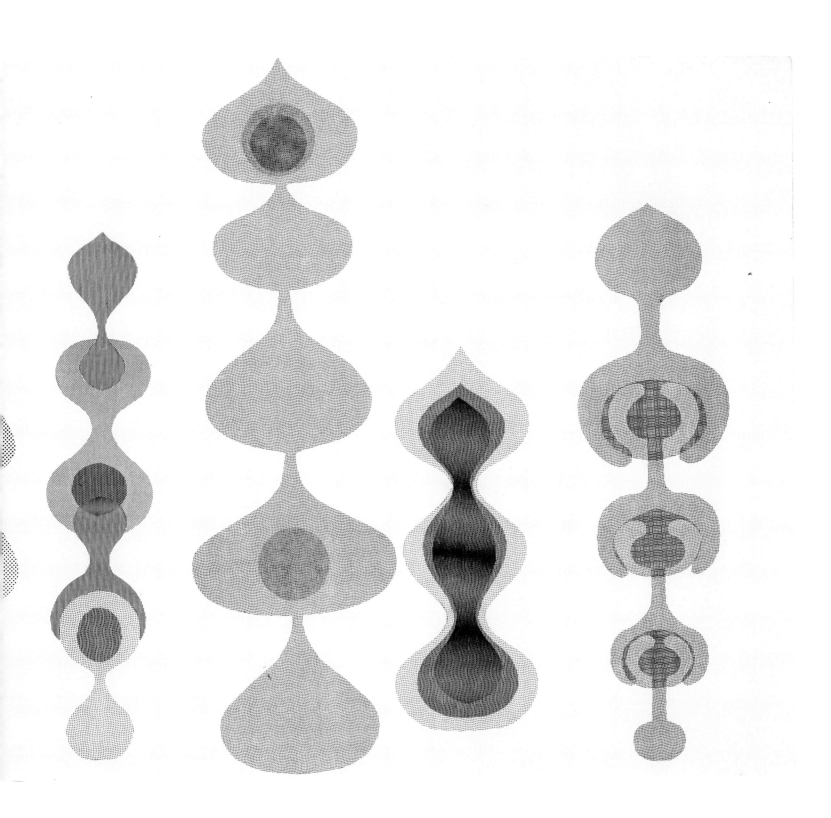

Untitled (ZP.16B, Twelve Looped-Wire Sculptural Forms), c. mid-to-late 1950s
Screentone on board, 10 × 24 in. (25.4 × 61 cm)
Private collection

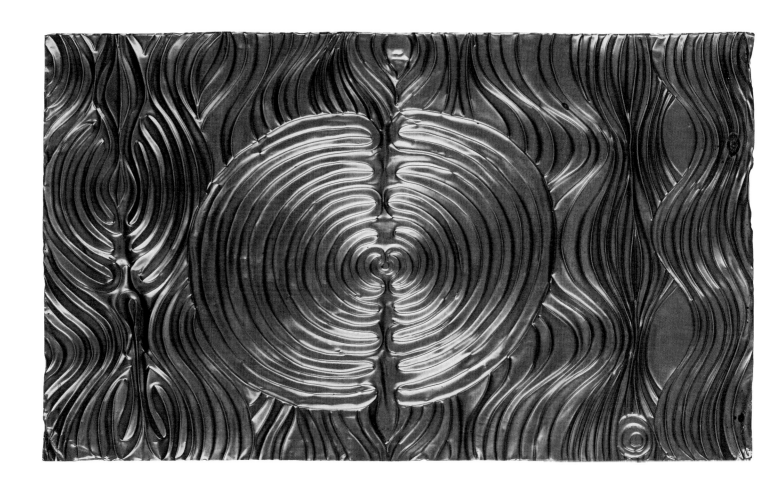

Untitled (CF.13, Sculpture, Continuous Form within a Form), c. 1980
Copper sheet, 7 × 12 × ¼ in. (17.8 × 30.5 × 0.6 cm)
Private collection

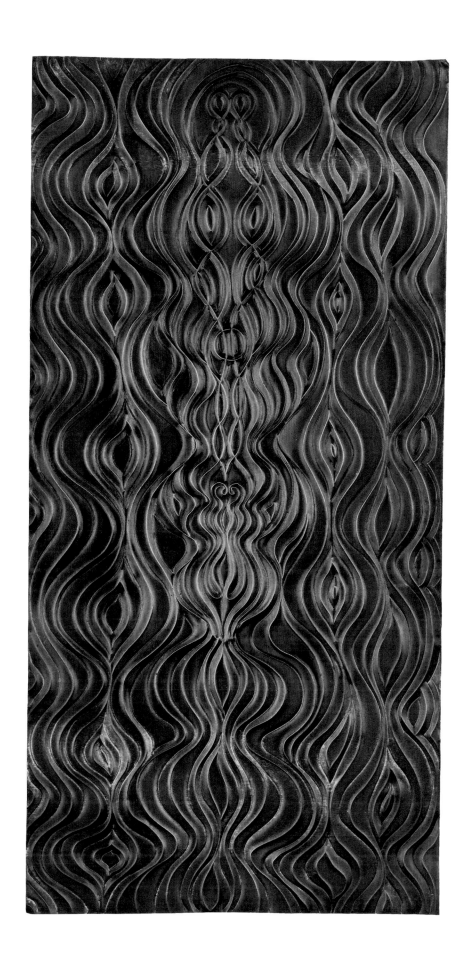

Untitled (CF.11, Sculpture, Continuous Form within a Form), c. 1980
Copper sheet, 16 × 8 × ¼ in. (40.6 × 20.3 × 0.6 cm)
Private collection

Untitled (SD.264, Looped-Wire Five-Lobed Sculpture Drawing), 1957
Ink and colored pencil on colored paper, 48 × 28 in. (121.9 × 71.1 cm)
Private collection

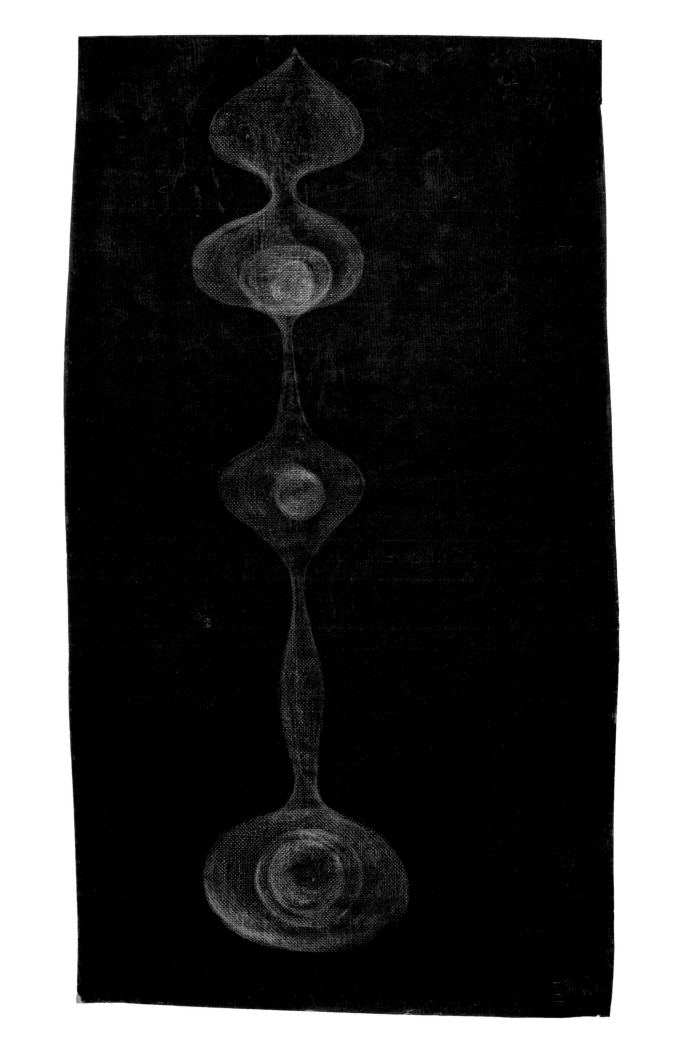

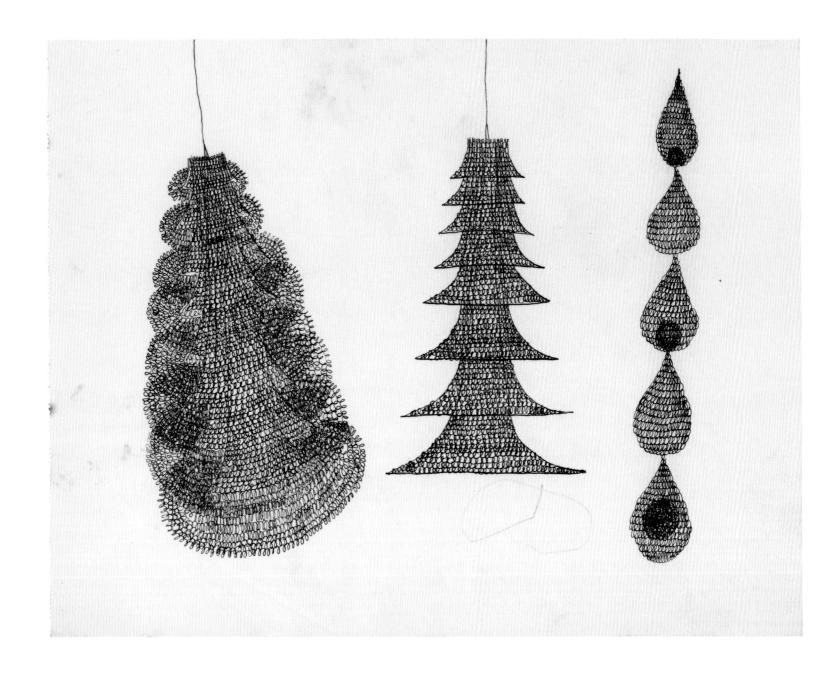

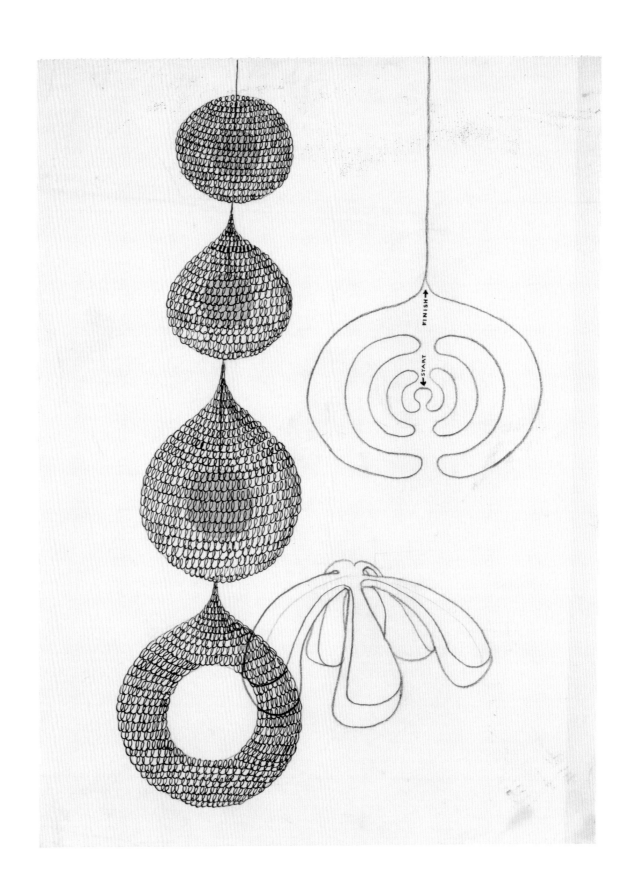

Looped-wire sculpture drawings included in Ruth Asawa's Guggenheim Fellowship application, 1952
Ink and graphite on tracing paper, 8 × 11 in. (20.4 × 28 cm) and 11 × 8 in. (28 × 20.4 cm)
Courtesy of the Department of Special Collections, Stanford University Libraries

Untitled (S.270, Hanging Six-Lobed, Complex Interlocking Continuous Form within a Form with Two Interior Spheres), 1955, refabricated 1957–58
Brass and steel wire, 63⅞ × 14¹⁵⁄₁₆ × 14¹⁵⁄₁₆ in. (162.2 × 37.9 × 37.9 cm)
Whitney Museum of American Art, New York; gift of Howard Lipman, 63.38

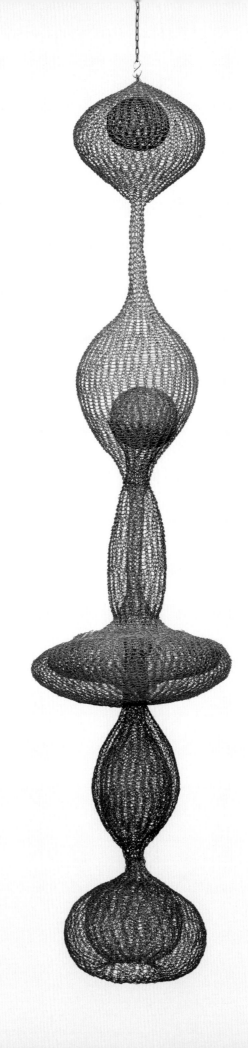

IN AND OUT

While Ruth Asawa's drawings and brushed-ink paintings evince her delight in the way materials moved across and activated the page, her folded paper constructions demonstrate her appreciation for the sheet itself. Unlike traditional drawing practices, in which marks are produced by applying medium to surface, paper-folding is neither an additive nor a subtractive process; here line and form are created by manipulating the paper, allowing Asawa to see what the page itself was capable of—"and that's what excites me," she explained.[1]

Asawa's enthusiasm for paper was stoked at an early age. She had learned to make origami as a child, and when she encountered the art at Black Mountain College—albeit in the "European approach"—she was drawn to it because "it brought my past into the present."[2] In Josef Albers's Design course, students were encouraged to test paper's structural and visual possibilities while respecting its inherent properties; scissors and tape were not necessary to create a new form. Repetitive pleats and folds rendered the paper pliant, allowing it to bear weight or tolerate twisting—pressures it could not have withstood as a flat sheet. Through paper-folding, she learned that she could "redefine what paper does" and still smooth it flat again, producing a page that holds the memory of its altered form in a complex web of crease patterns.[3]

At Black Mountain, student paperfolds became prompts for drawing exercises (BMC.91 [p. 127], BMC.93 [p. 125], BMC.94 [p. 126], BMC.102 [p. 127]).[4] In these works in oil on paper or board, rows of nested parallelograms in varying shades suggest the rippling topography of a zigzag tessellation, a common paperfold problem in Albers's class. Asawa sought out color combinations that would successfully make the arrow-like forms appear to project out from, or recede into, the picture plane. Though there are several times in Asawa's career when she approached an aesthetic problem in both drawing and sculpture, these works show her taking the sequence a step further; after transforming a flat sheet of paper into a three-dimensional object, she then translated its ridges and valleys back into two dimensions. Studying the properties of a paperfold and observing the way light hit its surface helped her to understand how to make a flat sheet of paper appear to undulate and heighten the effect of an oscillating figure-ground relationship.

Asawa continued to make paperfolds after moving to San Francisco in 1949, producing stark black-and-white constructions. Comparing a group of paperfolds that share similar zigzag tessellations (S.839–S.843 [pp. 136–141]), we can see the striking visual effects of movement and dimensionality produced by Asawa's application of ink to the folded sheet. In S.842 [p. 140], horizontal bands result in a vibrating chevron pattern, while vertical stripes create the illusion of flattened columns in S.841 [p. 137]. The

alternating dark and light triangles in S.840 [p. 139] closely resemble those in an untitled Black Mountain triangle study (BMC.128 [p. 128]) inspired by thorns she would gather from around Lake Eden and fasten together by pinning the barb of one into the base of another, repeating until she had a chain-like length of thorns; in the paperfold, she even left three triangles uninked, their thin black outlines seeming to reference the contour lines of the earlier drawing.

In 1951, Asawa enrolled in a silkscreen course at San Francisco State College, where she produced a series of screenprints that feature a dizzying geometric design known as a logarithmic spiral (SF.039b [p. 130], SF.039c [p. 131]). Each presents a grid of fifteen near-identical compositions in which triangles appear to coil out from a shared central point; the spiraling effect is achieved by a series of nested squares in red ink on blue or orange Color-Aid paper that grow exponentially as they rotate counterclockwise by degrees. Asawa first encountered the logarithmic spiral at Black Mountain, where Albers assigned it as a study in proportion, repetition, and positive and negative space. A growth pattern commonly found in nature, the spiral also appeared in her geometry lessons with the philosopher and mathematician Max Dehn.

Black Mountain's curricular emphasis on the relationship between art, nature, and mathematics would become an undercurrent of Asawa's own teaching philosophy, particularly in her paper-folding workshops (see Jordan Troeller's text in this volume). Observing one of these workshops, a reporter marveled at the magic of watching Asawa work, noting that her "hands are an interesting study in time and motion. She does not seem to hurry, yet she no sooner describes what she is doing than it's done."[5] Manipulating paper in this way seemed almost second nature to Asawa, and the practice remained with her throughout her life. Folded paper forms adorned the family Christmas tree; they tumbled out of envelopes sent to friends and acquaintances or served as the stationery itself, as in a 1947 letter to fellow Black Mountain College classmate Lorna Blaine, where each fold reveals another handwritten passage.[6] Decades later, a friend remarked: "When she comes to see me, she just picks up a piece of scrap paper and makes a

bunny or something; she made me purses, eyeglass cases and little boxes—all with folded paper. . . . [S]he couldn't keep her hands quiet."[7]

Reflecting on Buckminster Fuller's paper-folding lessons at Black Mountain, in which he assigned students exercises like recreating a camera bellows from paper, Asawa recalled that he emphasized "how paper breathes."[8] Albers imparted a similar anatomical analogy for paper's ability to move, claiming that "the folded paper had its own heartbeat."[9] The notion of expansion and contraction, of a pulse within a seemingly inanimate material, resonated with Asawa. In 1989 she collaborated with School of the Arts students and fellow artists on a dance performance in which folded paper served as props and scenic elements. Made from narrow white sheets several feet long, the constructions could be manipulated to stretch the width of the stage or coil to cocoon a dancer, becoming flexible, dynamic forms. The performance, which premiered that December, was titled *Breathing* ([pp. 123, 124]).

— SH

1 Ruth Asawa, in "Oral History Interview with Ruth Asawa and Albert Lanier," by Mark Johnson and Paul Karlstrom, June 21–July 5, 2002, Archives of American Art, Smithsonian Institution, unpaginated transcript, https://www.aaa.si.edu/collections/interviews/oral-history-interview-ruth-asawa-and-albert-lanier-12222.

2 Ruth Asawa, *Art, Competence, and Citywide Cooperation for San Francisco* (Berkeley, CA: Regional Oral History Office, Bancroft Library, University of California, Berkeley, 1980), 137.

3 Ruth Asawa, interview with Katie Simon, June 26, 1995, Ruth Asawa Papers, box 127, folder 7.

4 Ruth Asawa, Presentation for Tamarind Lithography Workshop (recording), August 29, 1965, Tamarind Institute Records (MSS 574 BC), box 31, CD 020, Center for Southwest Research and Special Collections, University of New Mexico, Albuquerque, provided by Nancy Brown-Martinez.

5 Nancy Scott, "Ruth Asawa: Building a Better World with Milk Cartons," *San Francisco Examiner,* August 28, 1987.

6 Ruth Asawa, letter to Lorna Blaine, February 28, 1947, 78.2005.53, Blaine folder 6, box 3, Black Mountain College Project Collection, PC.7008, Western Regional Archives, State Archives of North Carolina, Asheville.

7 Clarellen Adams, in Emily Gurnon, "Japantown Fountains Awaken: 'Folded' Sculptures Flow Again," *San Francisco Examiner,* October 21, 1999.

8 Ruth Asawa, interview with P3 Gallery, 1989, Ruth Asawa Papers, box 127, folder 5.

9 Ruth Asawa, lecture on Josef Albers, n.d., Ruth Asawa Papers, box 1, folder 4.

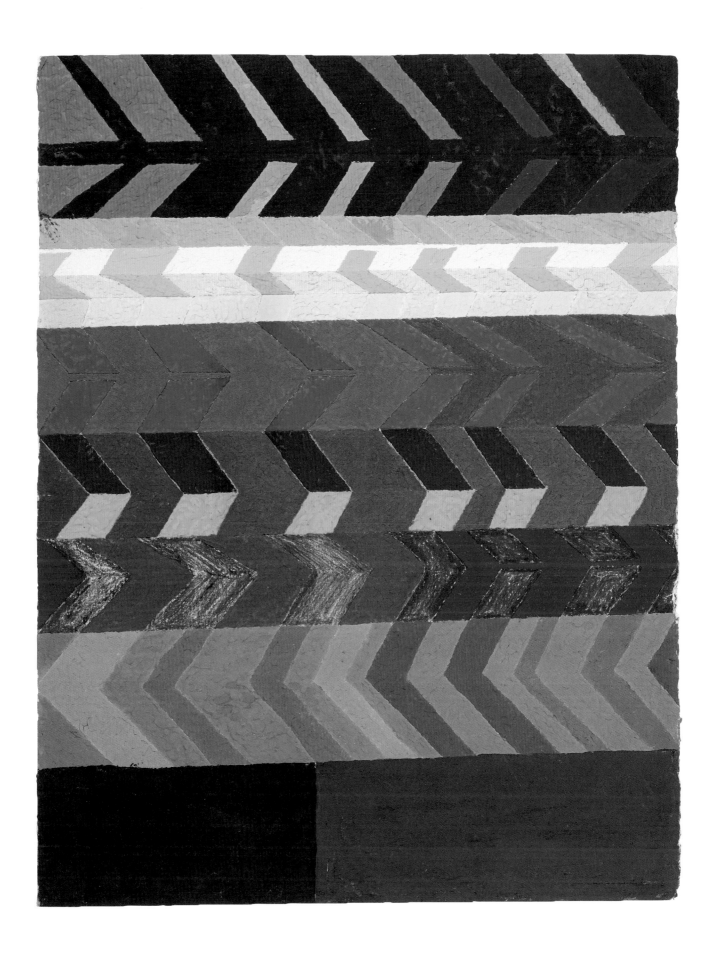

Untitled (BMC.93, In and Out), c. 1948–49
Oil and graphite on paper, 16½ × 13 in. (41.9 × 33 cm)
Private collection

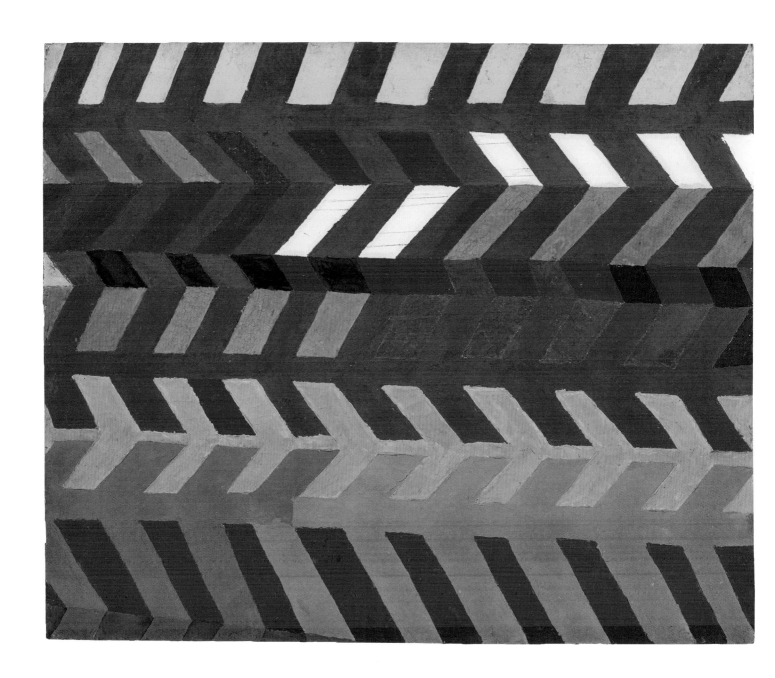

Untitled (BMC.94, In and Out), c. 1948–49
Oil on board, 12 × 14½ in. (30.5 × 36.8 cm)
Private collection

Untitled (BMC.91, In and Out), c. 1948–49
Oil on board, 8¼ × 14¼ in. (21 × 36.2 cm)
Achenbach Foundation for Graphic Arts, Fine Arts Museums of San Francisco,
Gift of Aiko and Laurence Cuneo, 2007.29.4

Untitled (BMC.102, In and Out), c. 1948–49
Oil on paper, 3½ × 13 in. (8.9 × 33 cm)
The Josef and Anni Albers Foundation, 2007.30.11

Untitled (BMC.128, Study in Repeated Vertical Angular Lines [Triangles]), c. 1948–49
Black and purple inks over graphite on tracing paper, 16¾ × 22¼ in. (42.6 × 56.5 cm)
Harvard Art Museums/Busch-Reisinger Museum, Gift of Josef Albers, BR49.386

Untitled (BMC.125, Squares and Circles), c. 1946–49
Ink over graphite on tracing paper, 17½ × 22¾ in. (44.5 × 57.8 cm)
Harvard Art Museums/Busch-Reisinger Museum, Gift of Josef Albers, BR49.378

Untitled (SF.039b, Logarithmic Spiral Squares, Navy/Blue), c. 1951–52
Screenprint on colored paper, 20 × 12 in. (50.8 × 30.5 cm)
Private collection

Untitled (SF.039c, Logarithmic Spiral Squares, Orange/Orange), c. 1951–52
Screenprint on colored paper, 20 × 12 in. (50.8 × 30.5 cm)
Private collection

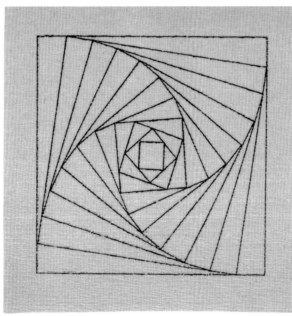
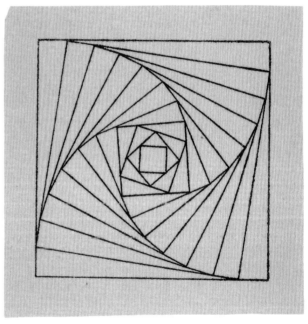

Untitled (SF.037b,a,b,b) Logarithmic Spiral Square Notecard [Black or Red]), c. 1951
Screenprint on paper, 5 × 5 in. (12.7 × 12.7 cm) each

Courtesy of the Department of Special Collections, Stanford University Libraries

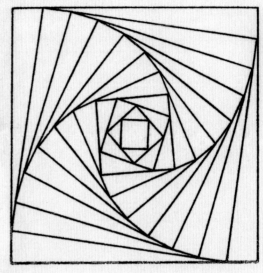

Dear Bobbie:
The sweaters look like new! They are colorful and fit
perfectly. Thanks a lot. The babies are growing so ra-
pidly and talking like magpies. Sunday we saw the John
Swakhamers and their baby boy Egbert. He has grown very
much walks and eats everything. He's 2 months older than
Xavier. This spring John will have some of the songs and
piano music performed. He is very actâve among the musi-
cians here, particularly at Cal.
I am sending you a sample of my silkscreen work at San Fran-
cisco ˢtate College. They refuse to take BMC credits, so
Iˆll have to talk to them about it.
This Friday we shall go to see Merce Cunningham dance and
John Cage play.
Trudi's wedding party was quite a festival. Her ceremony
was extremely beaꭒtiful. We had champagne, and Peit was
the perfect hostess. John Elsesser is very nice and has
a mustache.
Thanks again, Bobbie, hope to hear from you soon. Love,
 Ruth

Letter from Ruth Asawa to Barbara (Bobbie) Loines Dreier, April 20, 1951
Screenprint and typewriter ink on paper, 9¹⁵⁄₁₆ × 9¹⁵⁄₁₆ in. (25.3 × 25.3 cm)
Courtesy of the Western Regional Archives, State Archives of North Carolina

Untitled (S.691, Wall-Mounted Paperfold with Horizontal Stripes), 1951
Ink on paper, 69½ × 29 × 2¼ in. (171.5 × 73.7 × 5.7 cm)
Private collection

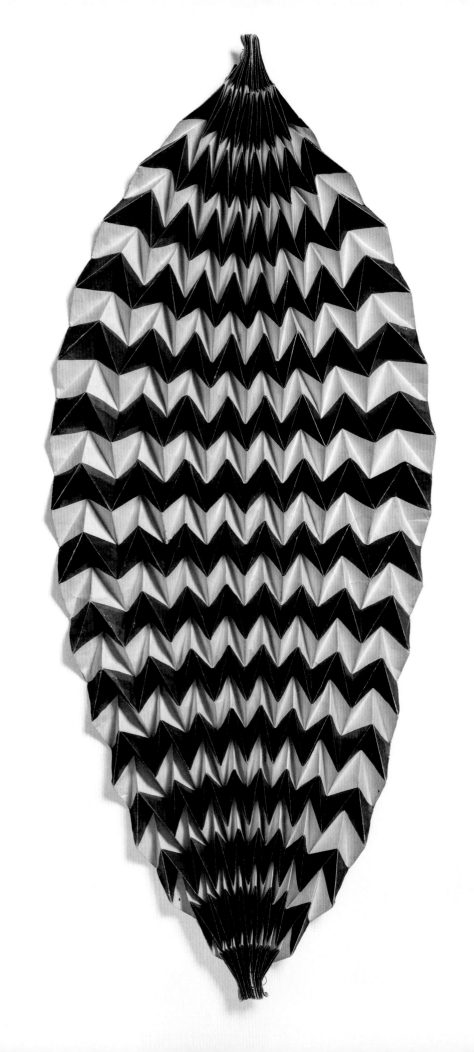

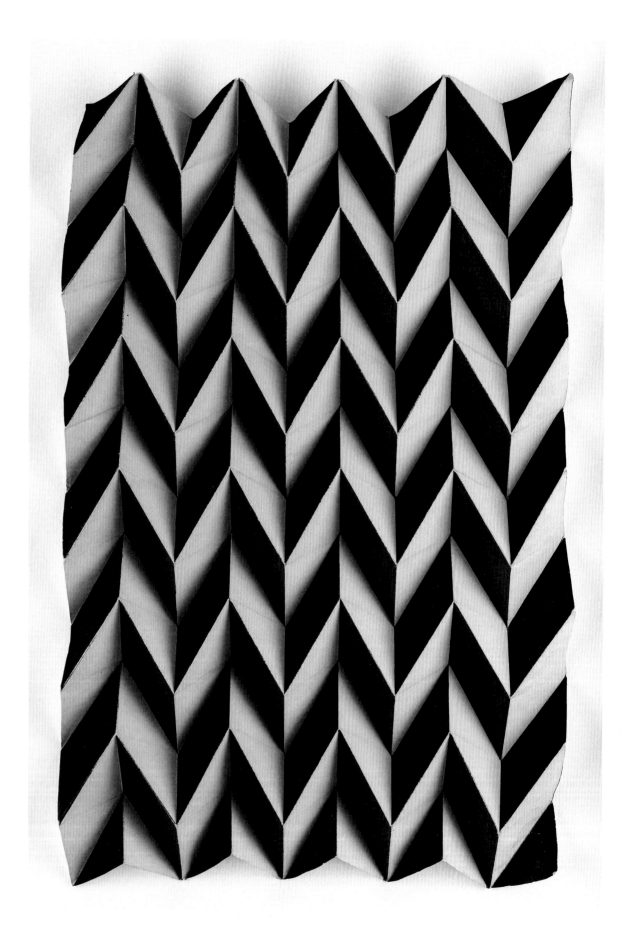

Untitled (S.839, Mounted Paperfold of Columns of Alternating Black and White Parallelograms), c. 1952
Ink on paper, 20⅛ × 13 × 1⅛ in. (51.1 × 33 × 2.9 cm)
Private collection

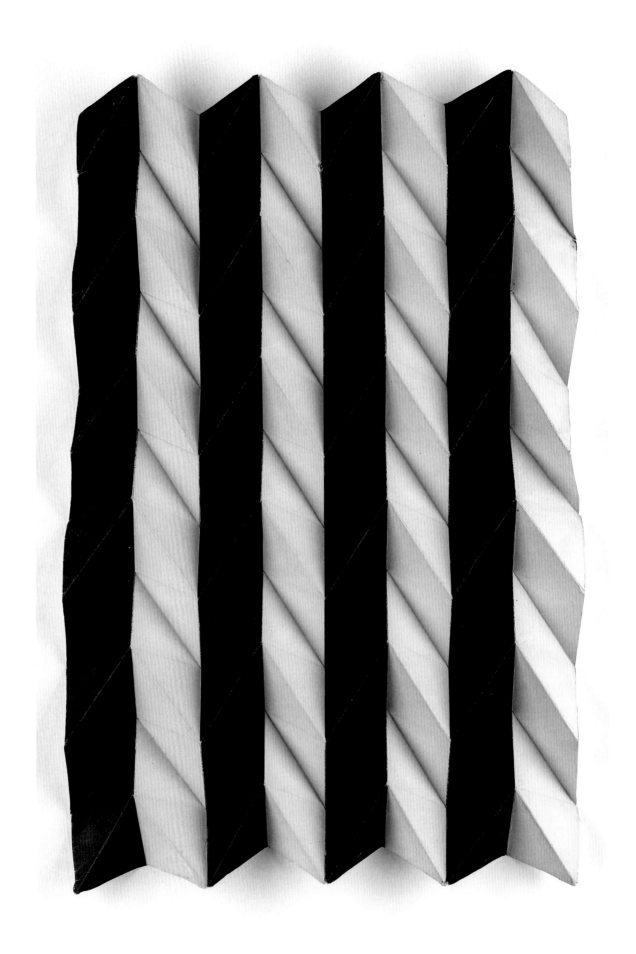

Untitled (S.841, Mounted Paperfold of Alternating Vertical Black and White Stripes), c. 1952
Ink on paper, 21 × 13 × 1¼ in. (53.3 × 33 × 3.2 cm)
Private collection

Untitled (S.840, Mounted Paperfold of Alternating Columns of White and Black Triangles), c. 1952
Ink on paper, 20⅜ × 11½ × 1⅛ in. (51.8 × 29.2 × 2.9 cm)
Private collection

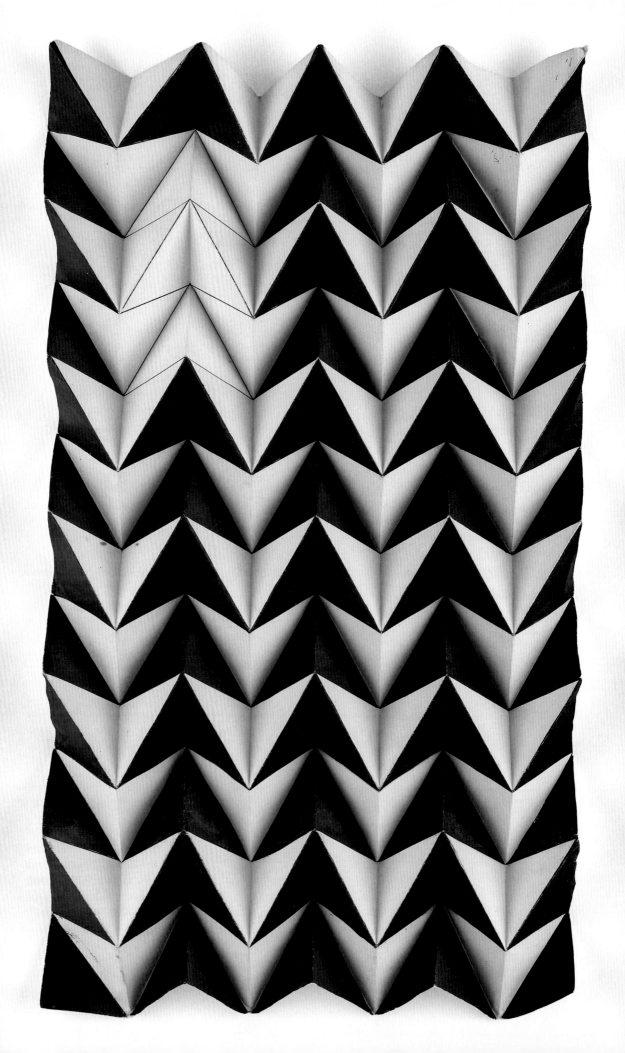

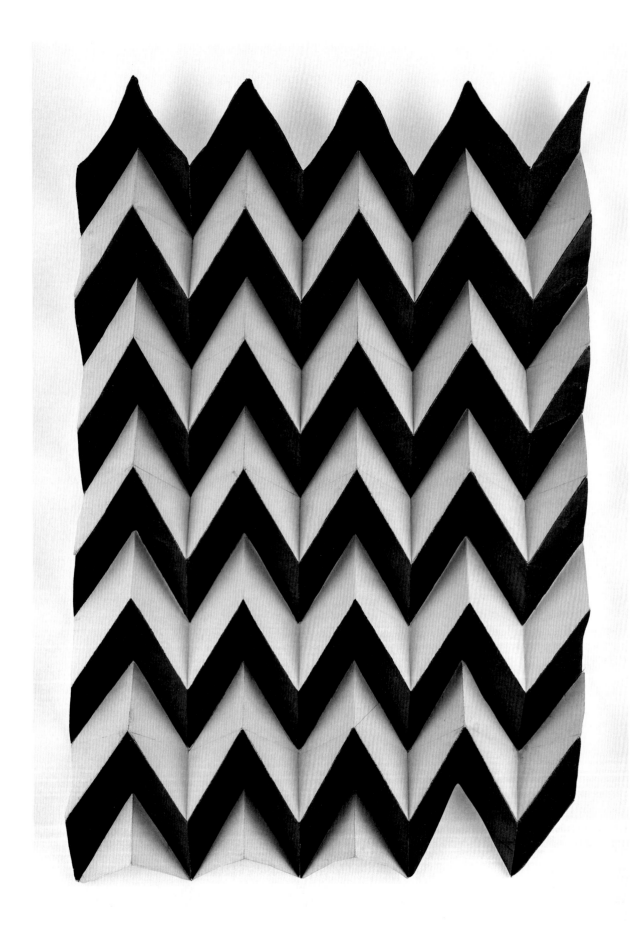

Untitled (S.842, Mounted Paperfold of Alternating Horizontal Black and White Zig-Zag Pattern), c. 1952
Ink on paper, 19¾ × 13½ × 1⅛ in. (50.2 × 34.3 × 2.9 cm)
Private collection

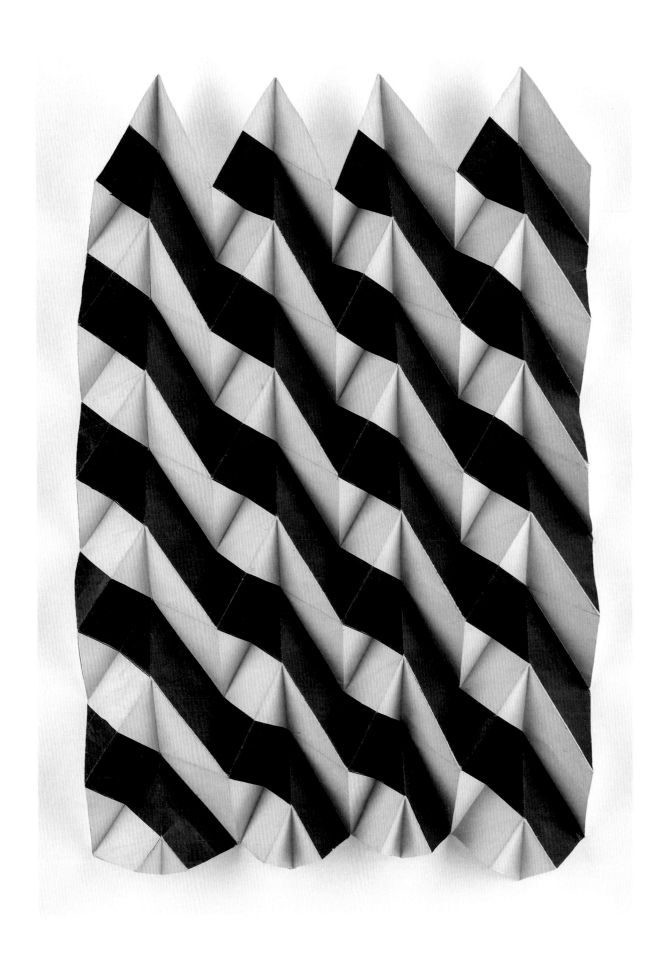

Untitled (S.843, Mounted Paperfold of Diagonal Black and White Stripes), c. 1952
Ink on paper, 17⅝ × 11¾ × 1⅛ in. (43.2 × 29.8 × 2.9 cm)

Private collection

Stills from *Breathing*, School of the Arts, San Francisco, 1989
Digitized video recording, 14:50 min.
Courtesy of the Department of Special Collections, Stanford University Libraries

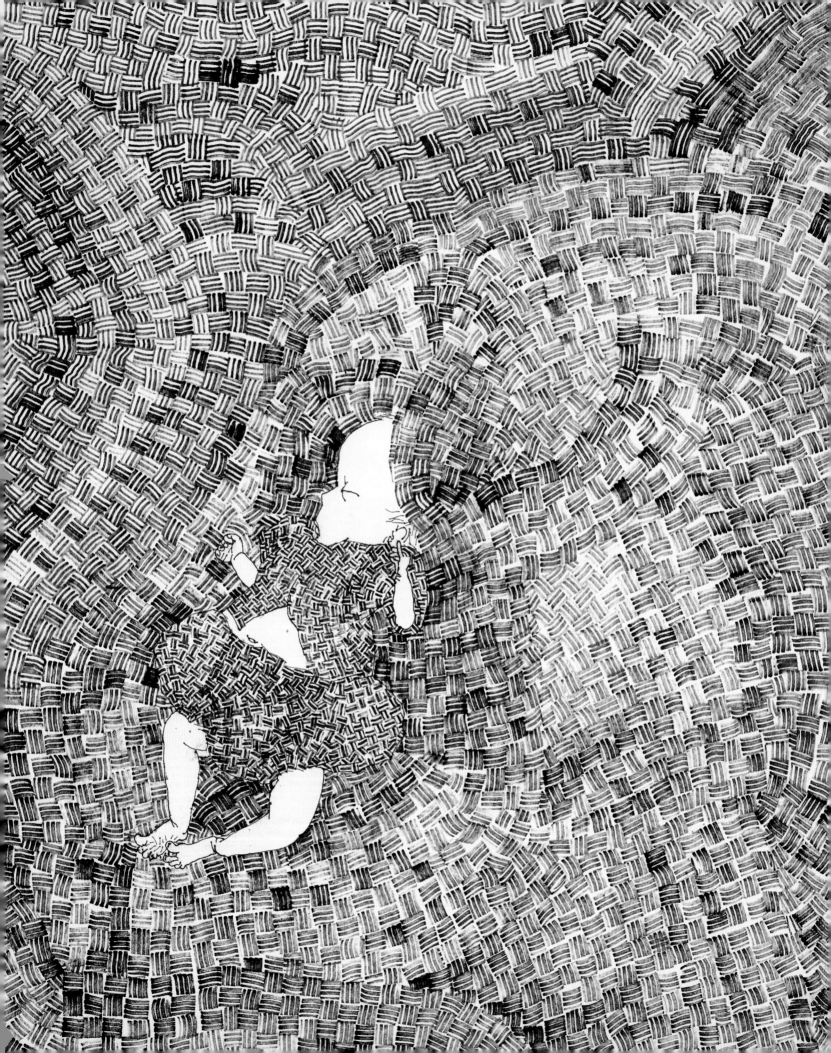

RHYTHMS AND WAVES

"SERVING and SERVED," Ruth Asawa jotted on a sheet of ruled notebook paper dated July 16, 1946, alongside which she wrote "Highest social philosophy."[1] One of many social maxims Josef Albers offered his students alongside pedagogical exercises in his Black Mountain College Design course, an asterisk drawn near this particular note suggests it resonated with Asawa. This message of reciprocal action accompanied Albers's instruction on the meander, an ornamental pattern that, when drawn by hand, requires skilled hand-eye coordination in order to ensure negative and positive spaces are treated equally. Pages of Asawa's college notes are filled with the exercise, both straight and curved, which she refined in her corresponding free studies (BMC.59 [p. 149], BMC.124 [p. 150]).[2] The mental, visual, and manual challenges presented by the meander and related formal prompts held a lasting appeal for Asawa. A meander reappears in a gouache painting on board dating to the late 1950s intended as a commercial design for wallpaper (SF.031 [p. 151]) and even as a fabric design for a folding lawn chair in 1998.[3]

In the 1950s, Asawa's concern for pattern dovetailed with her interest in material experimentation in her marker drawings, a series of works in which she utilized a refillable Flo-master felt-tip pen across myriad paper supports.[4] Asawa "grooved" her felt tips with incisions, which, when put to paper, created a regular group of parallel lines with each stroke.[5] Observing patterns in the world around her, in 1963, Asawa used several of these modified implements on a sheet of bitumen waterproof paper (commonly known as tar paper) to represent a block of San Francisco rowhouses with protruding bay windows and matching cornices, set against dark undulating hills (MI.053 [p. 154]). Perhaps inspired by her family trips to beaches around the Bay Area, Asawa also used notched markers to create a series of wave drawings. In one dating to about the late 1950s to early 1961, Asawa employed the blank sheet and her incised marker in repeated scalloped motions to render rows of gently rocking waves (AB.004 [p. 157]).

A subset of the marker drawings, Asawa's series of chairs—from wicker to bentwood—allowed her to further probe ideas related to positive and negative space that she first learned at Black Mountain, sometimes utilizing stencils. In one, Asawa defined several chairs by filling the surrounding void with a near mosaic of ink blocks, skillfully forgoing contour lines for forms demarcated by background (MI.153 [pp. 160–61]). In this drawing, patterning appears not only in Asawa's repetitive mark-making but also in the subject matter; the chair is repeated across the sheet as seen from different viewpoints and is even cropped at the margins—an interesting throughline to her object studies of hands, hammers, and Jello molds done at Black Mountain. In another, Asawa drew on both sides of the sheet to create tonal variation in the tessellated ink

marks composing *Bentwood Rocker*, c. 1959–63; the expansive, allover composition presents an optical challenge for the viewer as they attempt to distinguish figure from ground.[6] In a group of related works, Asawa selected the most intimate and immediately available subject matter for further experimentation in felt-tip pen: her infant son Paul. Using a tip cut to produce four lines at once in a 1961 drawing, she alternated the orientation of each mark to suggest an intricately woven blanket (FF.1211 [p. 159]). The textile nearly consumes the baby, whose bare skin is left in reserve.

In Asawa's meanders and marker drawings, every stroke of the pen served a purpose and was equally served *by* the surrounding space. Thus the ethos of equality and service embodied in the meander and instilled in her by Albers stayed with her through the years. "When he talked about art he talked about democracy, he talked about equality," Asawa remembered, "you could either be involved in visual problems of equality on the page, on the pictorial page, or if you wanted to interpret it as his way of talking about living, about life, then you could interpret it in the same way."[7] It is only fitting, then, that in 1961, Asawa and her children carved one of her curved meander motifs across two large redwood doors, which served as the portal to their Noe Valley home, greeting family and friends with a message for years to come.

— KM

1 Ruth Asawa Papers, box 175, folder 9. See illustration on page 17.
2 Albers framed the meander in relation to not only Gestalt psychology and figure/ground relationships, but also Mimbres pottery, and the logic of yin and yang. On Albers's understanding of the global history of the meander beyond ancient Greece (the Americas for instance) and the "social equality" embodied in the form, see Frederick A. Horowitz and Brenda Danilowitz, *Josef Albers: To Open Eyes: The Bauhaus, Black Mountain College, and Yale* (London: Phaidon, 2006), 132–33.
3 See Sigrun Åsebø and Vibece Salthe, "Art as an Approach to Living," in *Ruth Asawa: Citizen of the Universe*, ed. Emma Ridgway and Vibece Salthe (Oxford, UK: Modern Art Oxford; Stavanger, Norway: Stavanger Art Museum MUST; in association with Thames & Hudson, London, 2022), 104. For a photograph of and correspondence related to this chair, see Ruth Asawa Papers, box 106, folder 10.
4 Jordan Troeller, "Ruth Asawa on Paper: The Two-Dimensional Work of a Sculptor," lecture for "Bauhaus 100: Object Lessons from a Historic Collection" symposium, Harvard Art Museums, Friday, March 29, 2019, https://www.youtube.com/watch?v=l64ZRp189rI.
5 This is Asawa's term. She speaks about her marker drawings in her Presentation for Tamarind Lithography Workshop (recording), August 29, 1965, Tamarind Institute Records (MSS 574 BC), box 31, CD 020, Center for Southwest Research and Special Collections, University of New Mexico, Albuquerque, provided by Nancy Brown-Martinez.
6 Asawa mentioned that she drew on the reverse of at least one of her chair drawings in order to "get the transparency which can be done in ink." See her Presentation for Tamarind Lithography Workshop.
7 Asawa in interview with Ruth Asawa and Albert Lanier by Walt Park, June 28, 1968, Ruth Asawa Papers, box 35, folder 2. This interview was conducted for Martin Duberman's book *Black Mountain: An Exploration in Community* (New York: E.P. Dutton, 1972).

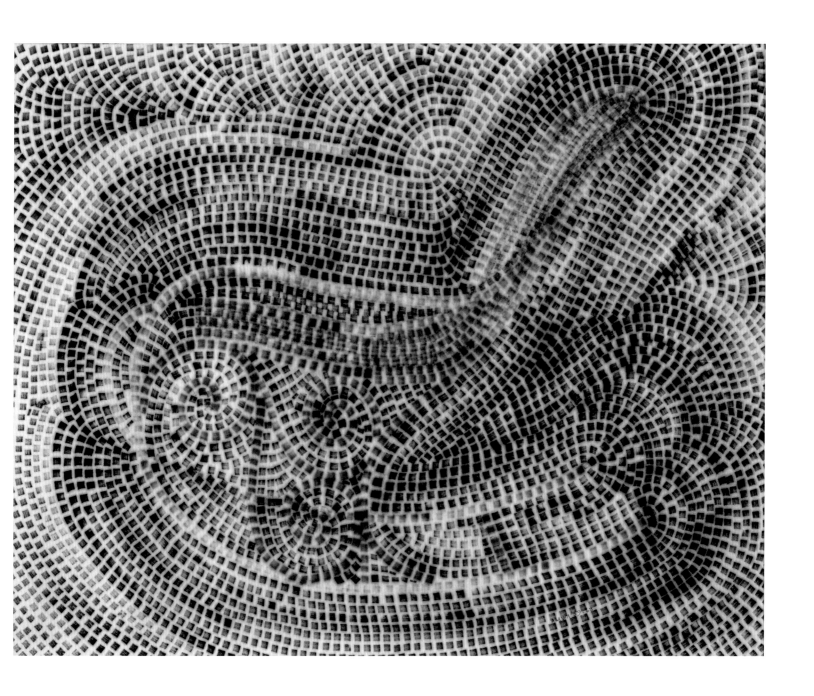

Bentwood Rocker (MI.176), c. 1959–63
Felt-tipped pen on paper, 18 × 22¾ in. (45.7 × 57.8 cm)
Black Mountain College Museum + Arts Center, Gift of Rita Newman, 2006.10.1

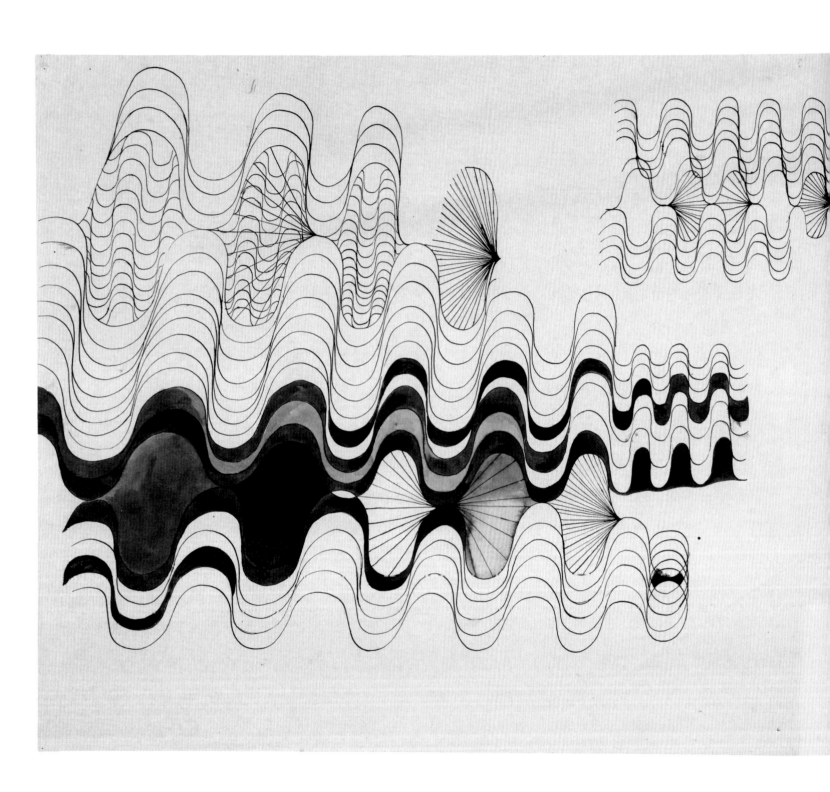

Untitled (BMC.57, Curved Lines), c. 1946–49
Ink on paper, 15¼ × 18 in. (38.7 × 45.7 cm)
Private collection

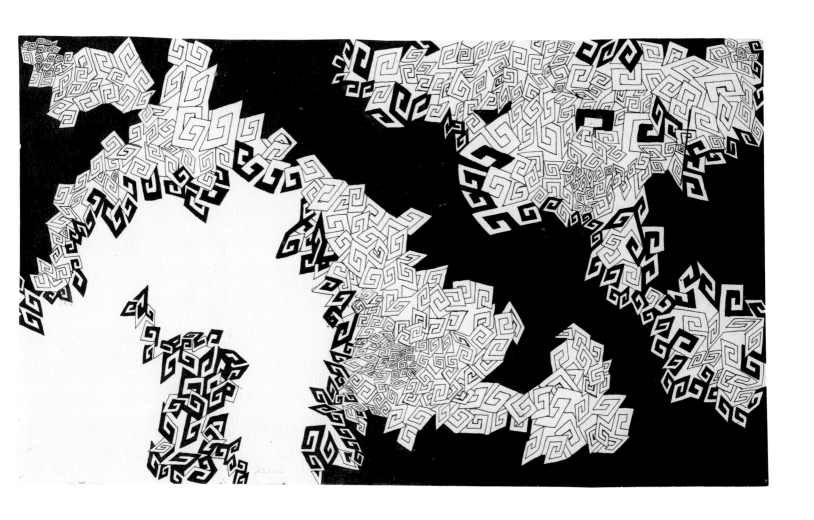

Untitled (BMC.59, Meander – Straight Lines), c. 1948
Ink on paper, 7⅞ × 13½ in. (20 × 34.3 cm)
Private collection

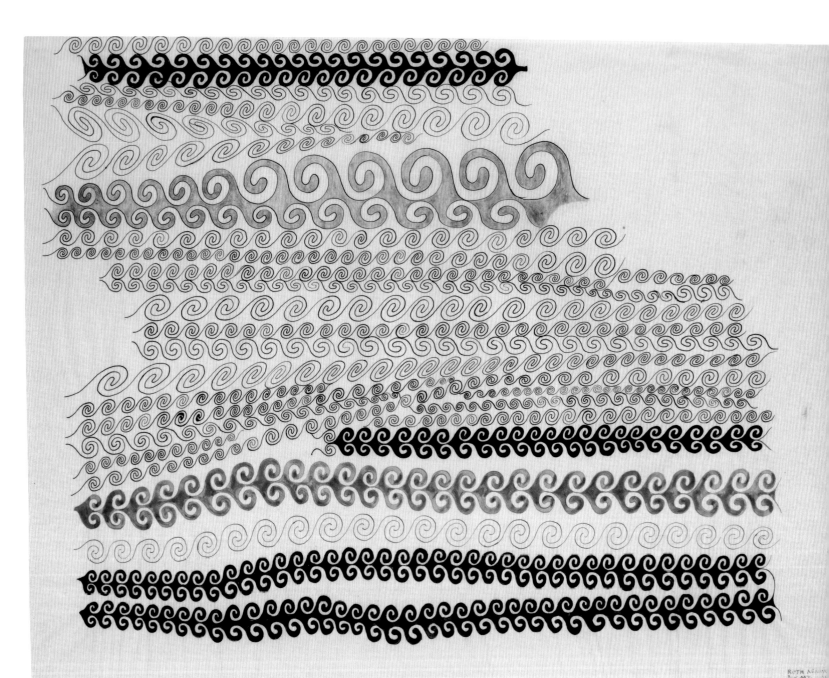

Untitled (BMC.124, Meander – Black and Red), 1949
Black and red inks and graphite on tracing paper, 17⅛ × 22 in. (43.4 × 55.9 cm)
Harvard Art Museums/Busch-Reisinger Museum, Gift of Josef Albers

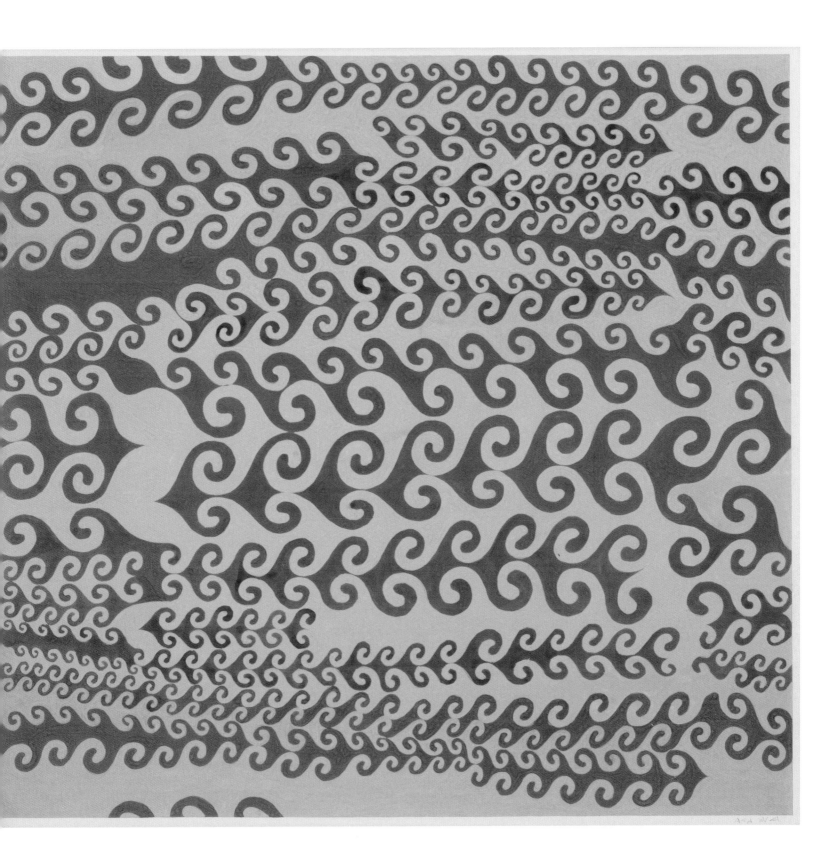

Untitled (SF.031, Red Meander on Pink), c. late 1950s
Gouache and graphite on board, 28 × 30 in. (71.1 × 76.2 cm)
Private collection

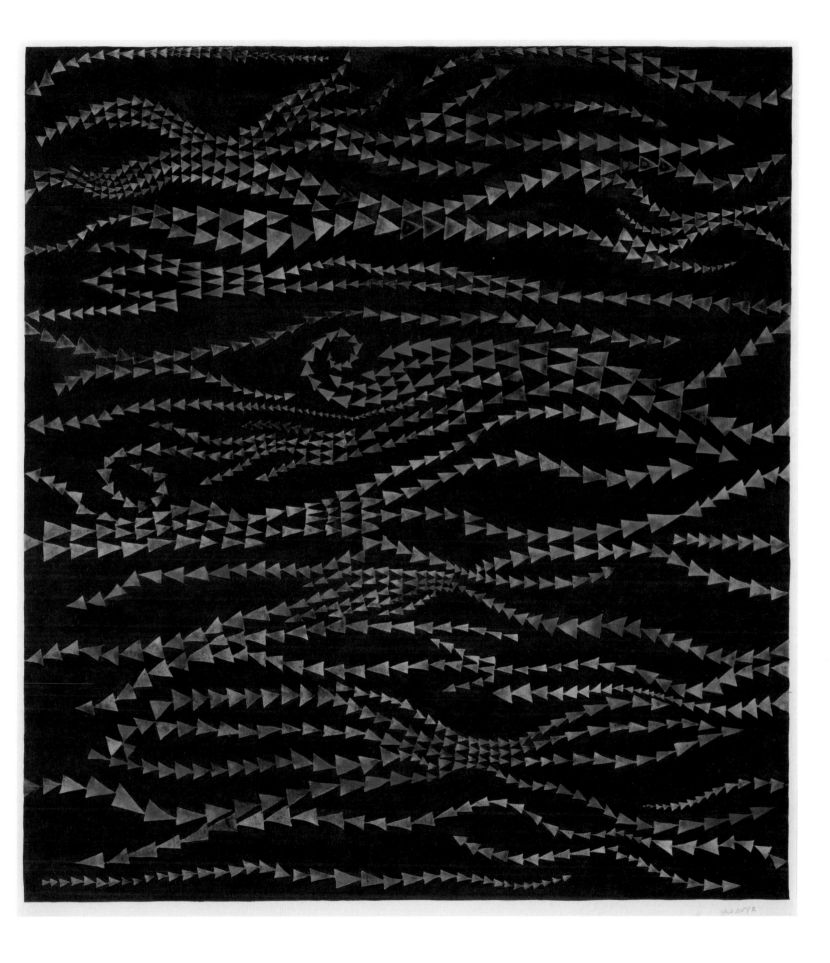

Untitled (SF.030, Blue Triangles on Brown), c. late 1950s
Watercolor, gouache, and graphite on board, 30 × 28 in. (76.2 × 71.1 cm)
153 Private collection

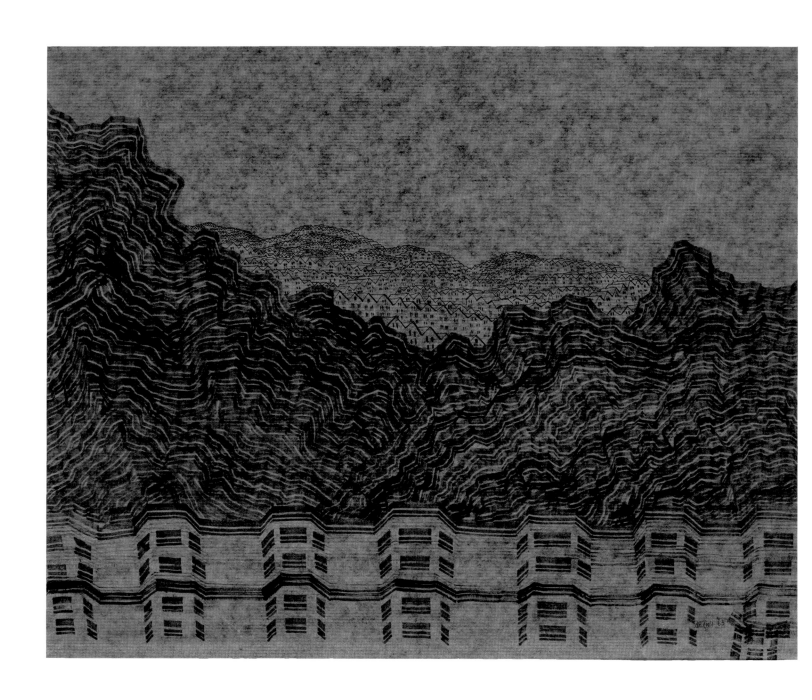

Untitled (MI.053, Houses and Hills), 1963
Felt-tipped pen on bitumen waterproof paper, 14¼ × 18 in. (36.2 × 45.7 cm)
Private collection

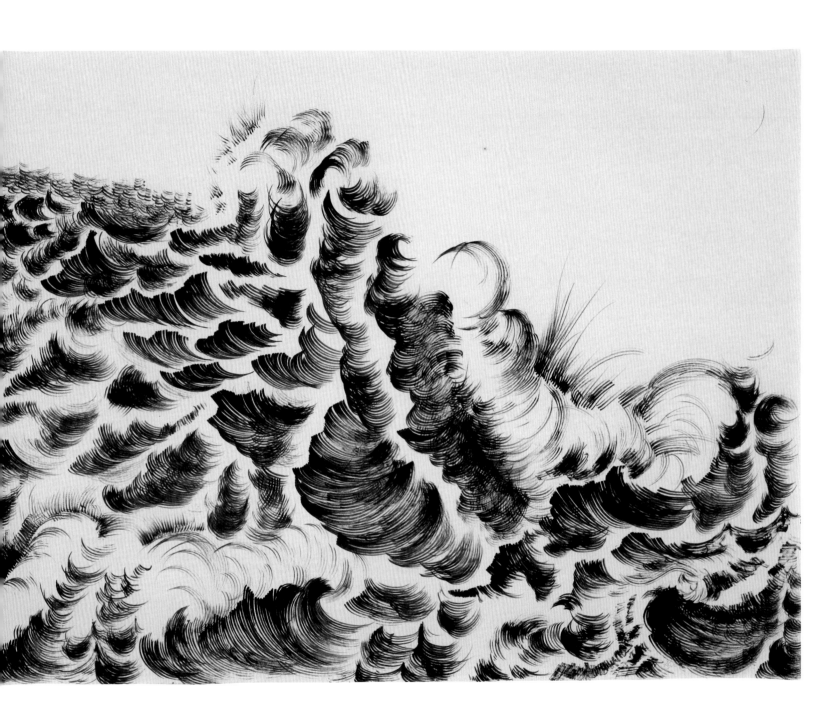

Untitled (AB.002, Waves 2), c. late 1950s
Felt-tipped pen on paper, 19 × 25 in. (48.3 × 63.5 cm)

Private collection

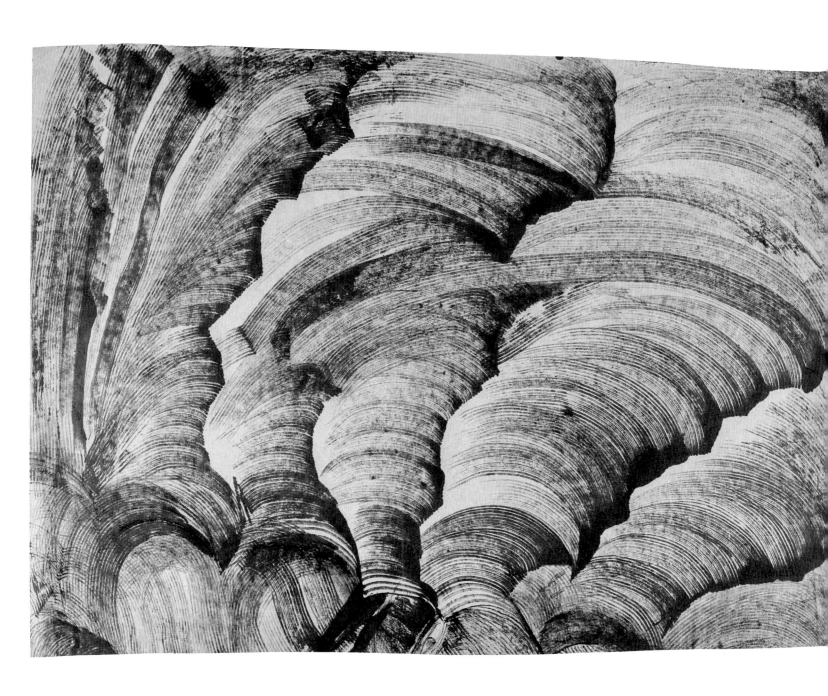

Untitled (AB.005, Waves), c. late 1950s–1961
Felt-tipped pen on paper, 17½ × 24 in. (44.5 × 61 cm)
Private collection

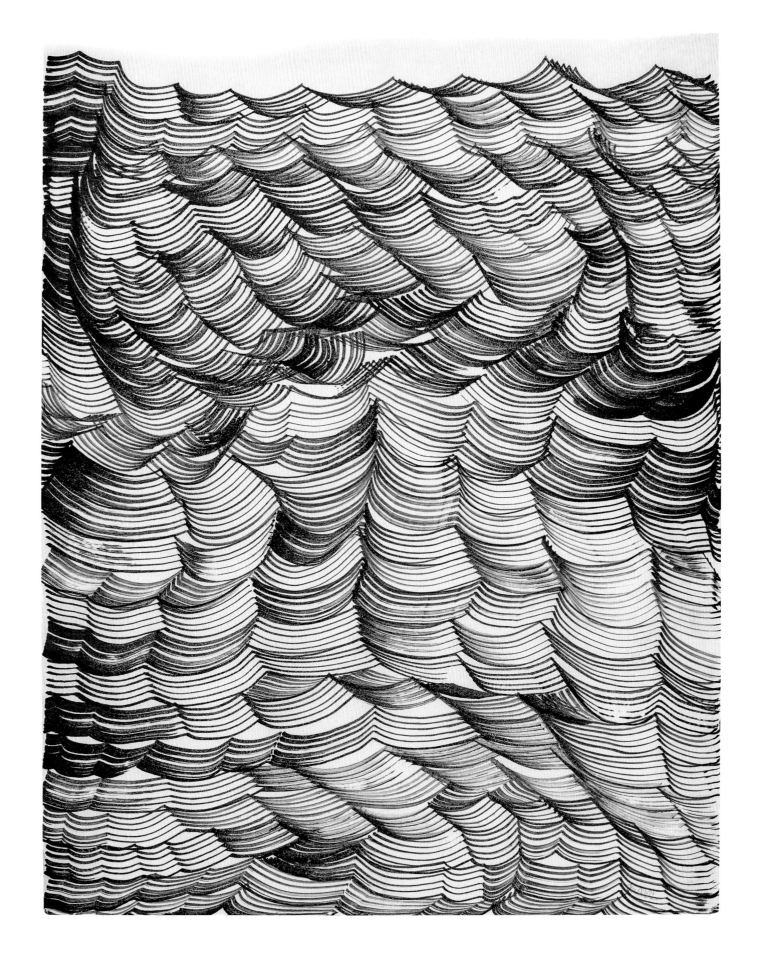

Untitled (AB.004, Waves), c. late 1950s–early 1961
Felt-tipped pen on paper, 23¾ × 19 in. (60.3 × 48.3 cm)
Private collection

Untitled (FF.1211, Paul Lanier on Patterned Blanket), 1961
Felt-tipped pen on paper on board, 31 × 21 in. (78.7 × 53.3 cm)
Private collection

Untitled (MI.153, Seven Thonet-Style
Bentwood Chairs), c. 1950s
Felt-tipped pen on paper, 42 × 60 in.
(106.7 × 152.4 cm)
Glenstone Museum, Potomac, Maryland

GROWTH PATTERNS

"Study nature's way, and learn its principles" was one of Ruth Asawa's key takeaways from her time spent as a student of Josef Albers and Buckminster Fuller at Black Mountain College.[1] This guiding concept reverberates throughout her oeuvre. It also unites the works included under this theme, which considers Asawa's method of working outward from a central point, whether in concentric rings or diverging branches. "I'm just interested in the way nature grows and structures," Asawa would later explain, noting the layered or spiraled growth patterns found in organic forms that inspired her practice.[2] This curiosity is evident in Asawa's ink drawing *Redwood 356* (PF.1012 [p. 167]) of 1960, in which the artist took as her subject a cross section of a giant redwood tree, meticulously detailing its concentric growth rings.[3] The passage of time is not only a motif in this "torture exercise," as she described it, but also integral to the artist's broader iterative process. "I enjoyed the repetition" she said of making this work, of "developing from the center out."[4]

Similar in theme to *Redwood 356* are Asawa's tied-wire drawings—made on various paper and metal supports, and even a cotton handkerchief—that date between 1962 and 1999. In 1962, Asawa's friends the photographer Paul Hassel and his wife Virginia returned from a trip to Death Valley with a gift for Ruth: a dried plant for her to draw.[5] Challenged by rendering the plant's entanglements in two dimensions, Asawa instead reached for wire to better grasp the plant's structural intricacies.[6] And so, her series of organic and geometric tied-wire sculptures emerged, including one from about 1963 illustrated on the next page (S.780), bundled at the center and dividing outward, recalling at once a tree canopy and its webbed root system. Only then did she return to the sheet in order to draw what she had haptically untangled. That Asawa tackled this drawing problem through sculpture, and then on paper, shows a profound fluidity between the two mediums.

As with the tied-wire sculptures, the related drawings stem from different centers— a six-branched core, a five-pointed star, a ten-armed spiral. Each center embodies a choice, which in turn determines the resulting structure. In some of these drawings, Asawa filled the entire sheet with seemingly endless branching growth, restrained only by a self-imposed perimeter (SD.129 [p. 168]). Others feature contained, floating forms that resemble complex, petaled flora such as one from about 1969 (SD.168 [p. 169]). Here, Asawa swapped figure and ground, filling the interstices with minute dots. The bulbed termini in an untitled drawing of about 1963–69 (SD.263 [p. 174]), evoke drops of dew, which Asawa occasionally rendered in resin or with beads in her related sculptures.

Asawa soon extended her tied-wire drawings to more rigid supports; in a large drawing on tin from the late 1960s (SD.254 [p. 170]), Asawa effectively drew with light, creating contours

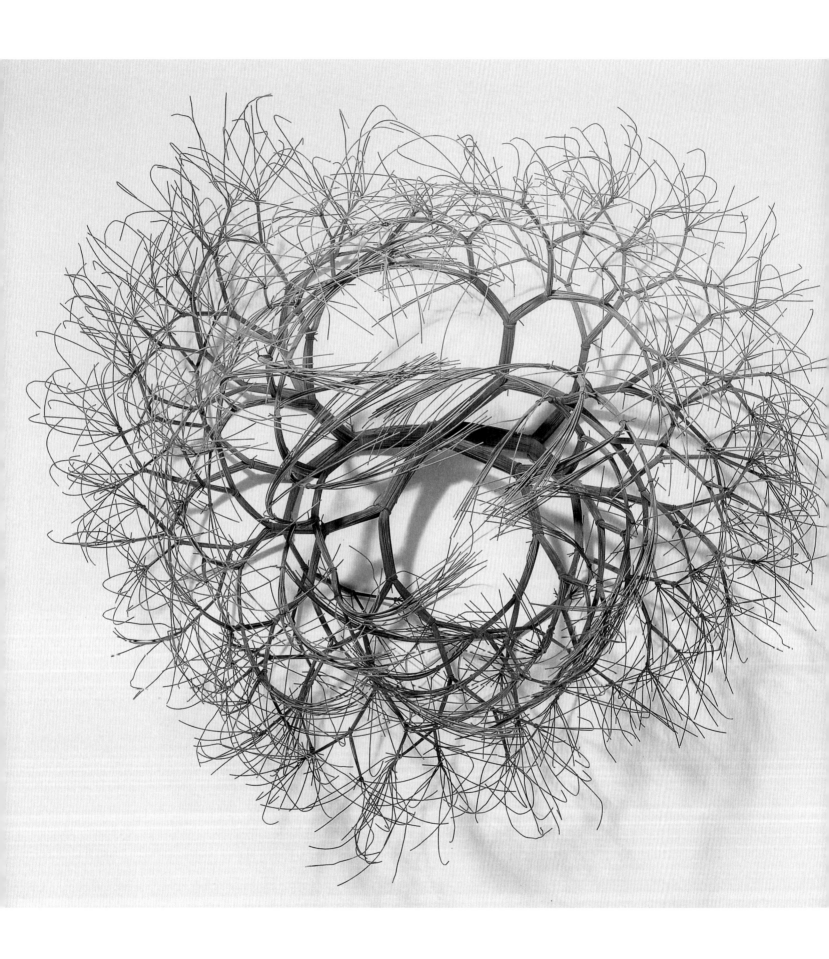

Untitled (S.780, Wall-Mounted, Double-Sided, Center-Tied, Six-Branched Form Based on Nature), c. 1963
Galvanized wire, 27 × 30 × 15 in. (68.6 × 76.2 × 38.1 cm)
Fuller Craft Museum, Gift of the Joan Pearson Watkins Trust, 2014.19.1

through small, repeated punctures.[7] Commissions for bronze plaques in 1979 pushed Asawa further into new materials.[8] For these works, she first drew designs in relief on thin sheets of copper foil, which were then cast. Recognizing the aesthetic merits of the drawings in metal, Asawa then pursued independent compositions on copper foil. Again, looking to patterns of expansion found in nature, the artist drew on both sides of the metal sheet using a stylus to depict the spiral disc and diverging-ray florets of a sunflower (CF.02 [p. 171]).[9]

Together these works based in growth patterns demonstrate Asawa's concern for connectedness and consequence—how starting from a particular center has radiating implications. A poignant metaphor for the relationship between self and community, these intricate networks fanning out from a center align with Asawa's social activism. It is therefore fitting that a tied-wire drawing became the subject of one of Asawa's public artworks: a 1969 collaboratively-produced mosaic aptly titled *Growth* adorns the exterior of Bethany Center Senior Housing in San Francisco, conveying a message of creative expansion and continued development to the center's aging residents and visitors.

— KM

1 Ruth Asawa, "Black Mountain College," in *Buckminster Fuller: Anthology for the New Millennium*, ed. Thomas T.K. Zung (New York: St. Martin's Press, 2001), 204.

2 Ruth Asawa, interview with P3 Gallery, 1989, Ruth Asawa Papers, box 127, folder 5.

3 Ruth Asawa had likely encountered felled redwoods at her family's property in Guerneville. Asawa-Lanier family, conversation with the author, August 31, 2022.

4 Asawa in *Ruth Asawa: Of Forms and Growth,* film by Robert Snyder (Santa Barbara, CA: Masters & Masterworks, 1978). Tree rings also appear in Asawa's sketchbooks, including SB.024 and SB.200.

5 Marilyn Chase, *Everything She Touched: The Life of Ruth Asawa* (San Francisco: Chronicle Books, 2020), 98–99.

6 Ruth Asawa, biography written for Guggenheim Fellowship application, 1971, Ruth Asawa Papers, box 129, folder 7.

7 This perforated line recalls works Asawa made on carbon paper in the early 1950s (SF.067, SF.068, SF.089). Vivian Tong, email message to the author, August 23, 2022.

8 One of these bronze plaques was commissioned by the paper company Crown-Zellerbach. Photocopy of pamphlet in Michael Brown Papers (M2675), Stanford University Library, box 1, folder 8.

9 A hand-drawn, daily schedule dated August 8, 1980, reads "drew on copper sunflower" from 11 pm to midnight. Ruth Asawa Papers, box 184, folder 2.

Headlights (MI.137), 1961
Ink on Japanese paper on board, 16¼ × 23½ in. (41.3 × 59.7 cm)
Collection of halley k harrisburg and Michael Rosenfeld, New York

Redwood 356 (PF.1012), 1960
Ink on Japanese paper, 25 × 25 in. (63.5 × 63.5 cm)
Private collection

Untitled (SD.129, Tied-Wire Sculpture Drawing with Five-Pointed Star in Center), c. 1973
Ink on Japanese paper, 15¾ × 15½ in. (40 × 39.4 cm)
Private collection

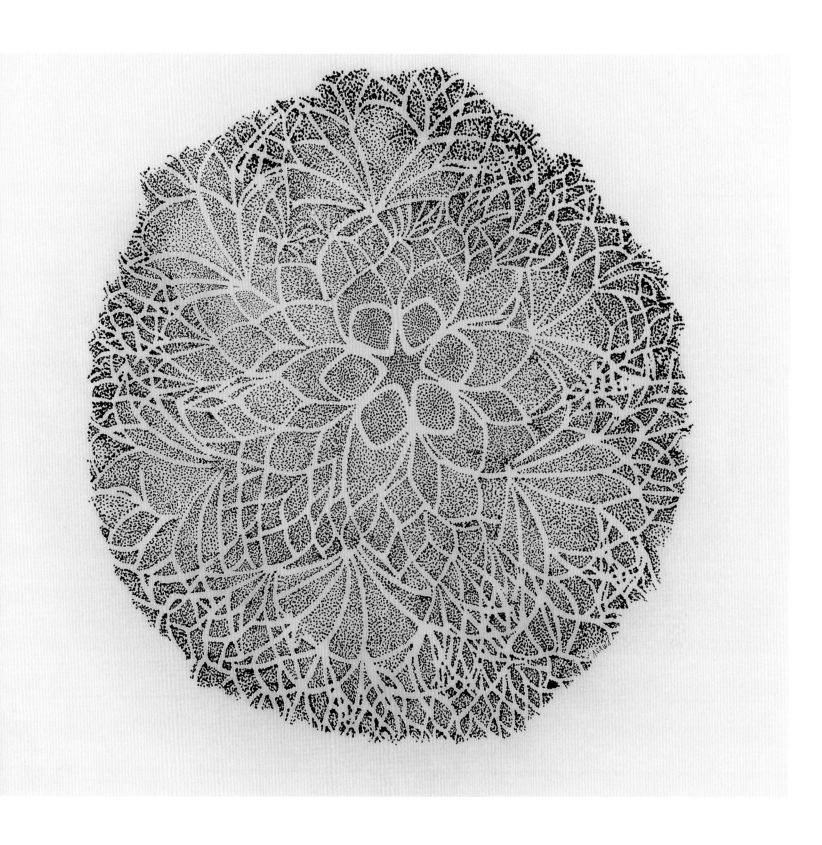

Untitled (SD.168, Tied-Wire Sculpture Drawing with Six-Pointed Star in Center), c. 1969
Ink on Japanese paper, 18 × 18⅛ in. (45.7 × 46 cm)

Fuller Craft Museum, Gift of the Joan Pearson Watkins Trust, 2014.19.4

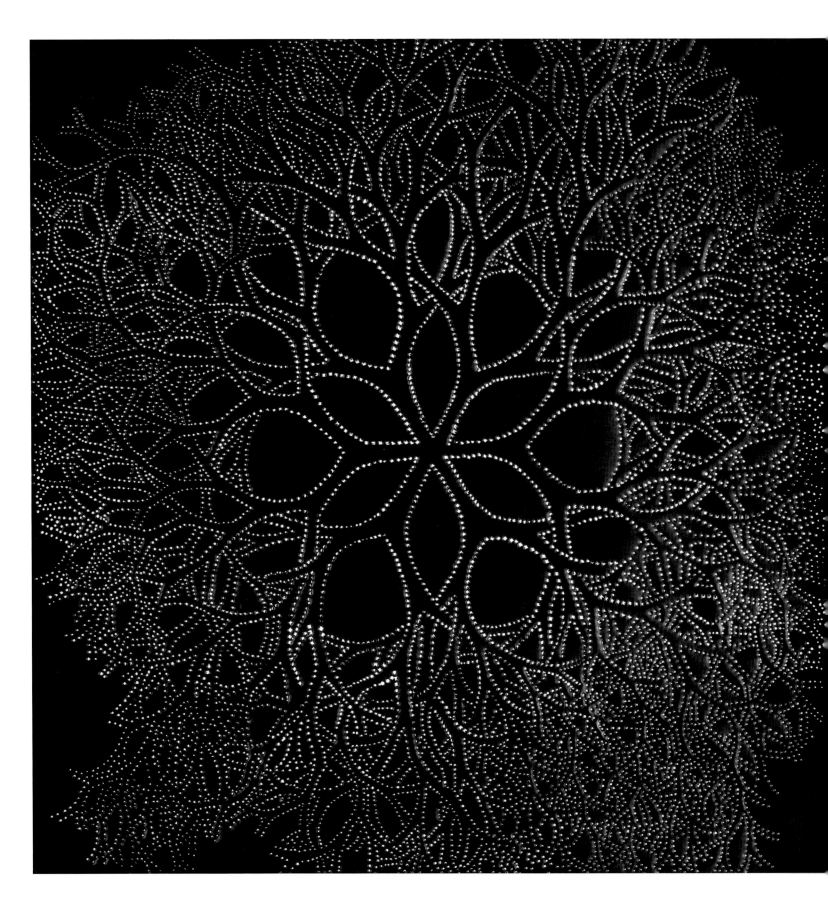

Untitled (SD.254, Tied-Wire Sculpture Drawing with Six Petals in Center), c. late 1960s
Tin, 32¾ × 32¾ × ¼ in. (83.2 × 83.2 × 0.6 cm)
Private collection

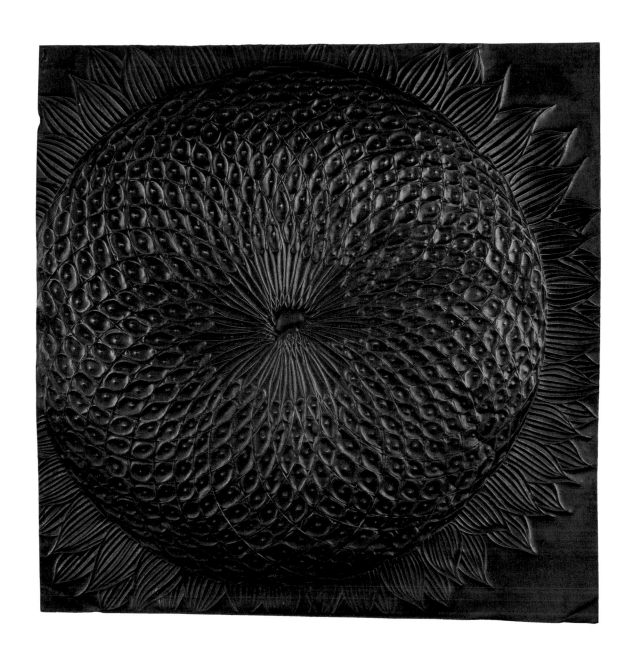

Untitled (CF.02, Sunflower), c. 1980
Copper sheet, 10¼ × 10¼ × ¼ in. (26 × 26 × 0.6 cm)
Private collection

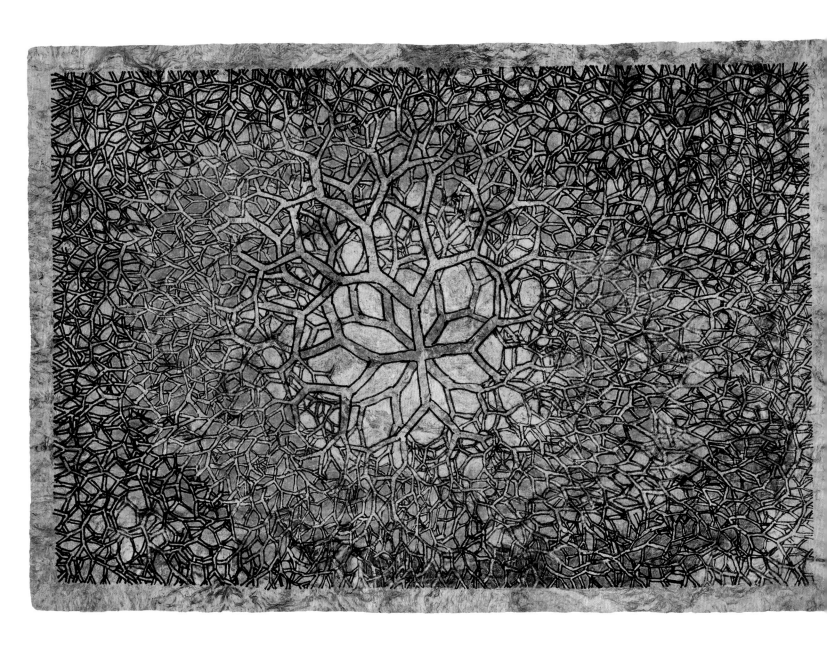

Untitled (SD.126, Tied-Wire Sculpture Drawing with Eight Branches), c. 1980s
Ink and wax crayon on amate paper, 16¾ × 24½ in. (42.5 × 62.2 cm)
Achenbach Foundation for Graphic Arts, Fine Arts Museums of San Francisco,
Gift of the RAL, Inc., 2007.28.76

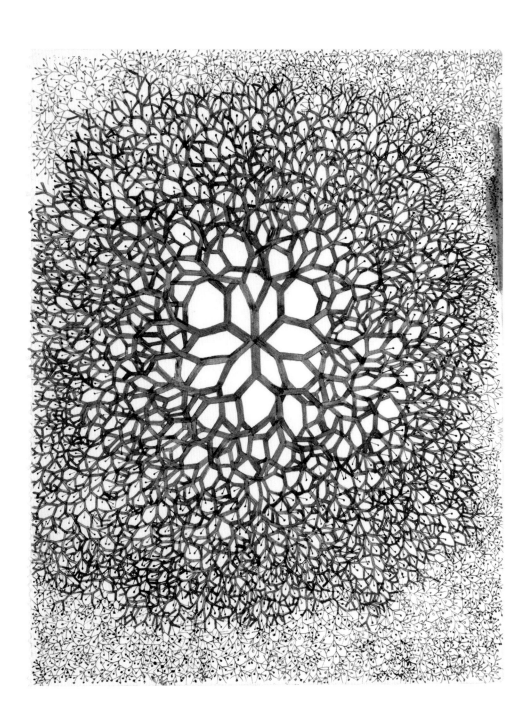

Untitled (SD.012, Tied-Wire Sculpture Drawing with Six-Branch Center and Drops at the Ends), c. 1970s
Ink on paper, 14 × 10¾ in. (35.6 × 27.3 cm)
Private collection

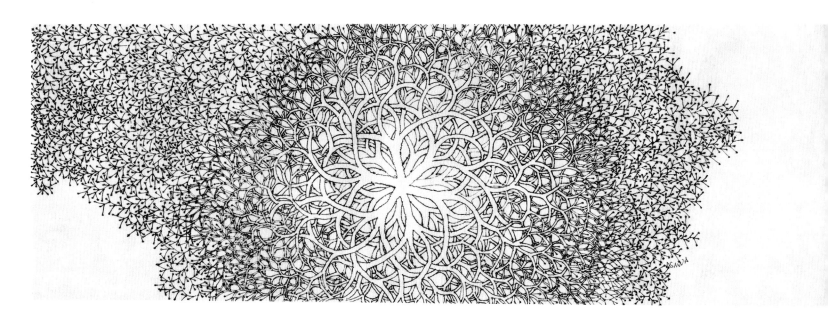

Untitled (SD.263, Tied-Wire Sculpture Drawing with Six-Branch Center and
Drops at the Ends), c. 1963–69
Ink on Japanese paper, 6 × 17¾ in. (15.2 × 45.1 cm)
Achenbach Foundation for Graphic Arts, Fine Arts Museums of San Francisco,
Gift of Mr. and Mrs. Edgar Sinton, Hillsborough, 1969.24

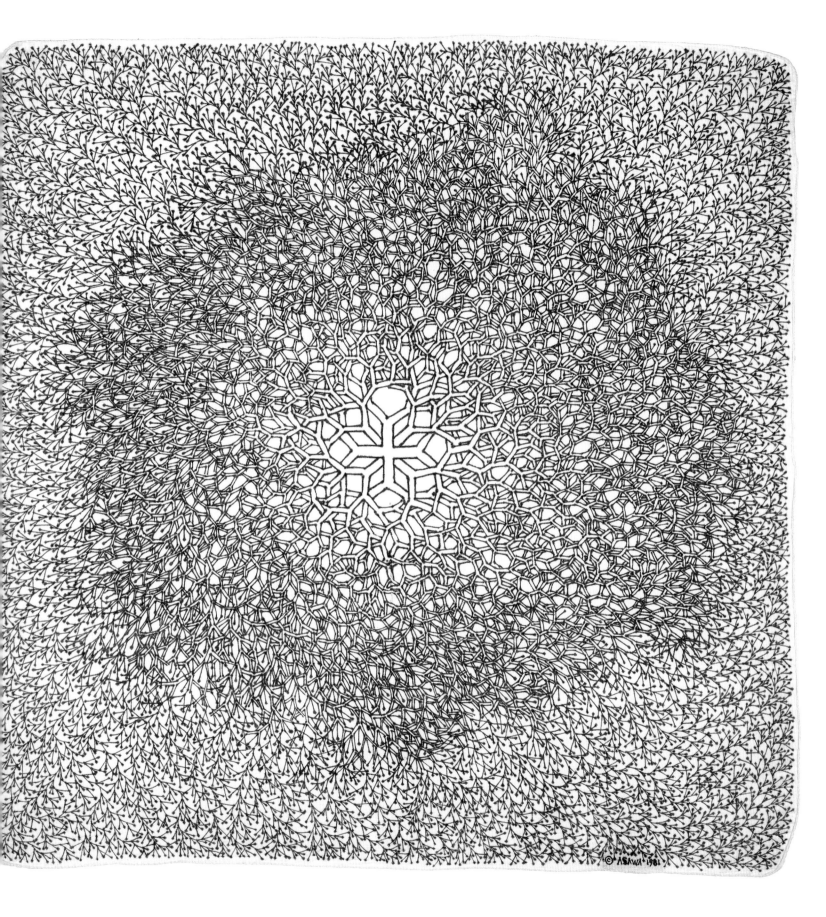

Untitled (SD.164, Tied-Wire Sculpture Drawing with Eight Branches that End in Drops), 1981
Ink on cotton handkerchief, 21 × 21 in. (53.3 × 53.3 cm)
Private collection

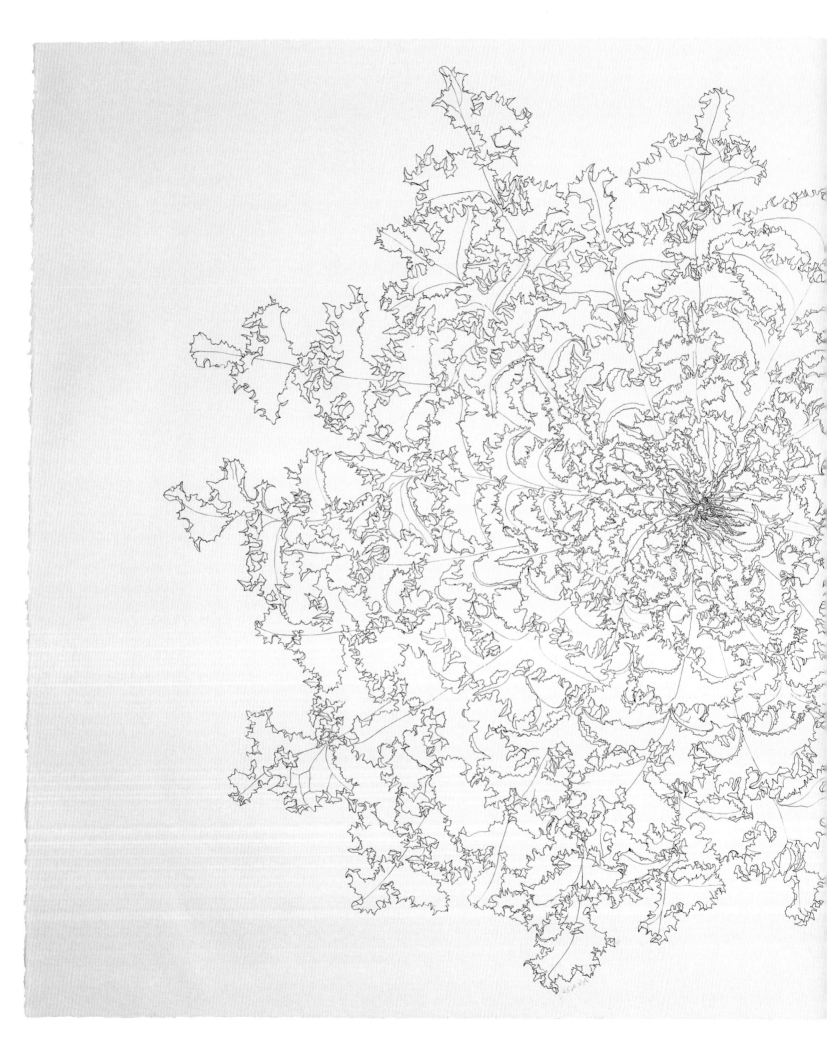

Untitled (PF.295, Endive), c. early 1990s
Ink on paper, 29½ × 41¾ in. (74.9 × 106.1 cm)
Private collection

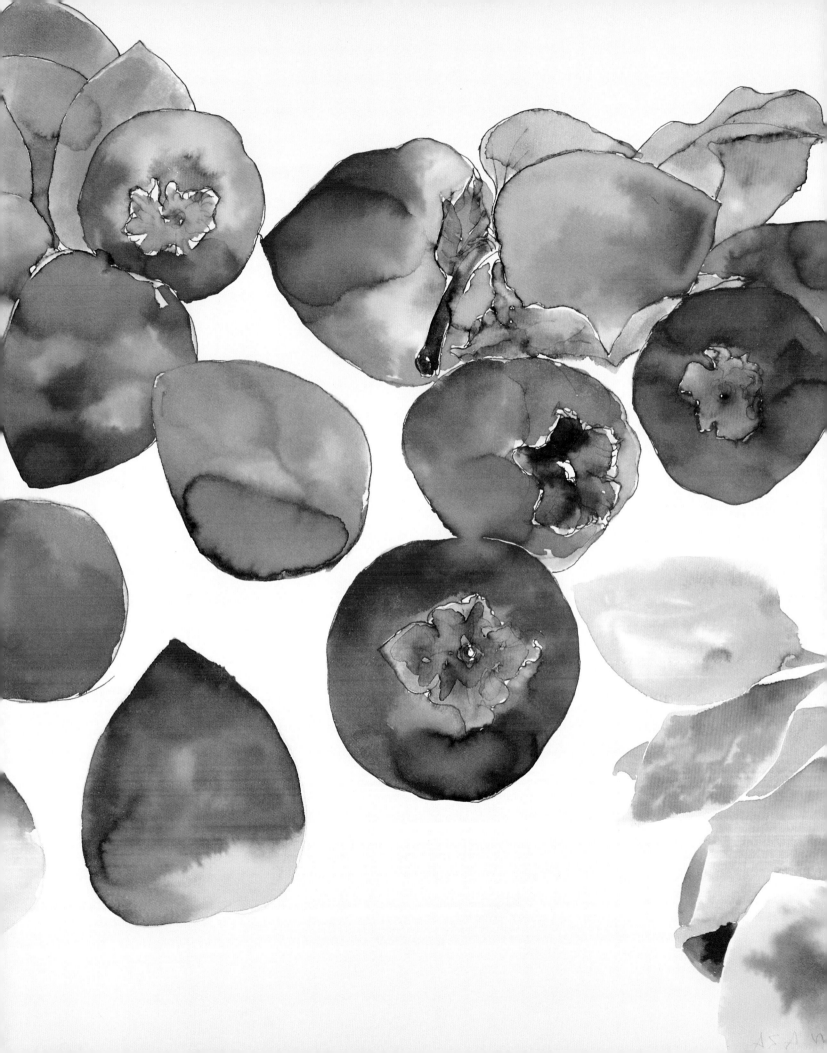

CURIOSITY AND CONTROL

Ruth Asawa once stated: "My favorite time is when I'm doing watercolors."[1] She first held a brush when she was about eight years old during her calligraphy lessons at the local Japanese language school, and would later recall the joy of learning to use the art form's tools—grinding the stick of sumi on a wet inkstone to produce a pool of ink—and practicing the attentive gestures calligraphy required: a succession of swift strokes, pauses, and lifts, each movement dependent on the one that preceded it.[2] Asawa credited her calligraphy lessons with stimulating her later interest in watercolor painting, which she learned from skilled painters during her grade school years and while incarcerated at the Santa Anita Racetrack and Rohwer Relocation Center (see Kim Conaty's essay in this volume).

This early training primed her for the technical challenges she encountered in Josef Albers's painting classes at Black Mountain College. His lessons on color relationships and transparency surface in the watercolors Asawa produced during her time at the school. An untitled drawing of trees (BMC.148 [p. 183]), for example, demonstrates Albers's instruction that students use almost "no form to create form."[3] Her strategic application of paint in slender columns of orange and black suggests rather than explicitly depicts a grove of trees brimming with fall color; blank paper is used to pick out spots of sunlight along the trunks, while a few strokes of near-translucent wash create the illusion of a forest receding into the distance. The composition is a testament to Albers's frequent directive: "Do less, get more."[4]

In the mid-1950s, Asawa resumed her childhood studies in calligraphy, taking lessons with Hodo Tobase, a Buddhist priest at the Soto Mission of San Francisco. Her experiences with calligraphy provided an unexpected complement to Albers's drawing and painting philosophy; both placed special emphasis on the figure-ground relationship and required Asawa to think ahead as she placed marks on the page. Her reflections on calligraphy could easily describe Albers's meander exercises: "You're not watching what your brush is doing, but you're watching the spaces around it. You're watching what it isn't doing, so that you're taking care of both the negative space and the positive space."[5] In fact, she would execute a variation on the meander— generally done in pencil or pen—with brush and black ink in *Untitled* (WC.202 [p. 188]). Rather than traveling in a straight path across the page (as in BMC.124 [p. 150] or SF.031 [p. 151]), here the lines take circuitous routes, curling back on themselves until they fill the entire sheet.

Working with brushed ink in San Francisco, Asawa did not try to make the aqueous medium conform to her chosen subject matter; instead, she studied how it pooled and spread, how different papers absorbed or repelled water, and the various ways pigment could be moved across the page with her brush. She then looked

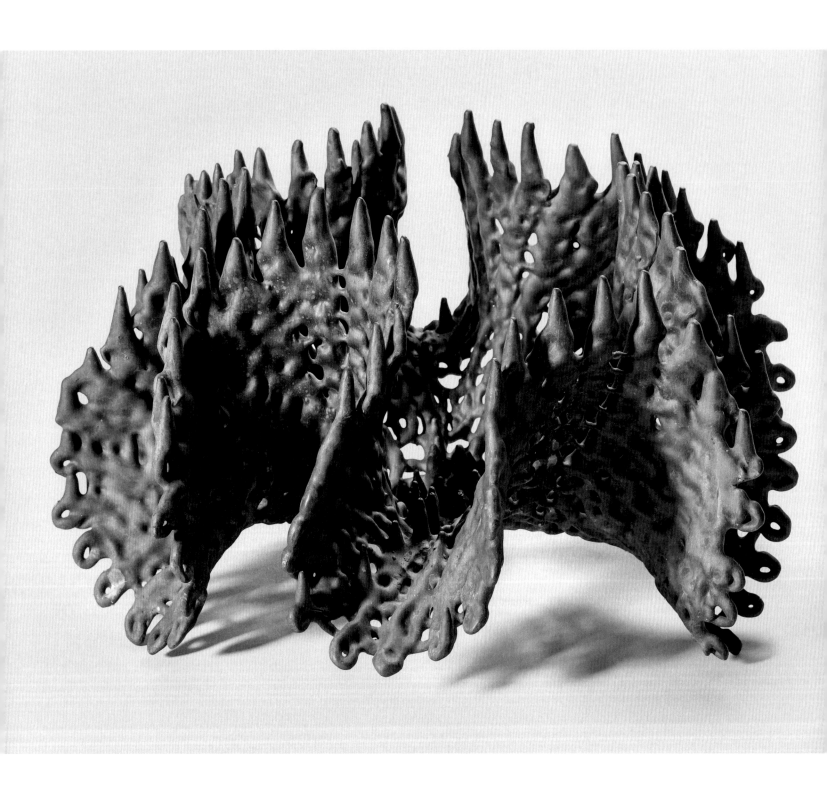

Untitled (S.003, Freestanding Reversible Undulating Form), 1998
Bronze, 10 × 16⅔ × 16⅔ in. (25.4 × 42.3 × 42.3 cm)
Private collection

to her immediate surroundings for forms that resonated with these material explorations. Such is the case with her series of Plane Tree drawings begun in 1958[6]—semi-abstract renderings of the pruned London plane trees found in Golden Gate Park (see Edouard Kopp's essay in this volume). She applied the same techniques and materials to a wider array of subjects in the early-to-mid-1960s: pooled pigment becomes peeling bark in a painting of a eucalyptus grove (PF.1016 [p. 186]), while alternating passages of dark ink, thin wash, and blank paper evoke the rippling sheen of water (PT.062 [p. 189]).

At this time, she frequently worked on coated paper (with a luminous surface Albers referred to as "glowy"[7]), which encouraged the paint to run and gather as opposed to being absorbed evenly into the surface. The mesmerizing effect of a fluid medium stilled in its tracks reappears in Asawa's cast looped-wire sculptures like the one on the page opposite (S.003 [p. 180]). Wax dripping from the ends of the wire formed minute stalactites, which became permanently suspended when cast in bronze, and, when the sculpture was upended, seem to defy gravity. The effect appealed to Asawa for its spontaneous appearance: "It looks like I didn't even touch it, like I didn't even have my hands on it. It looks like coral; like it just grew like that."[8] She had discovered the process in the mid-1960s while seeking the best material to represent the scales and fins of the mermaids' tails in her Ghirardelli Square fountain commission, *Andrea*, and would continue to cast similar small wire sculptures into the 1990s.

Asawa's brushed ink drawings from the later 1960s and 1970s show her gravitating toward increasingly spare compositions. She introduced more absorbent Japanese papers in addition to the coated sheets, allowing for more tightly controlled line work. In *Untitled* (PF.686 [pp. 192–93]), for example, thin lines of green ink applied with a pen describe a watermelon's mottled stripes. Given the translucent nature of some of the papers she used, ink occasionally bled through the support entirely, producing the effect of a mirror image on the verso (as in MI.108 [pp. 190–91]). By the 1980s, Asawa was able to afford true watercolor paints and paper, resulting

in a higher level of precision in the finished works (for example, WC.252 [p. 195]).

When Asawa was diagnosed with lupus in early 1985, watercolor presented itself as a restorative medium, offering a way for her to continue making art while she rested. The watercolors she produced had such an impact on her that in 1987 she applied for a Guggenheim Fellowship to continue pursuing the medium. As part of this proposal, Asawa expressed a desire to record the plants and flowers that grew in the family garden. Painted in 1987, *Allie's Iris* (WC.175 [p. 197]) may be representative of this proposed body of work. The luminous watercolor and ink piece is a testament to Asawa's nimble balance of chance and control; the flower's finely rendered stem erupts into violet and lavender petals, where she uses effects like blooms and tidelines to her advantage. Though her Guggenheim application was unsuccessful, it was significant as the first time she applied for the fellowship to pursue a body of works on paper, and underscores the relevance of watercolor to her overall practice. As she explained in the application: "I now look back at this Lupus experience not as an illness but as a reawakening of my interest in painting."[9]

— SH

1 Ruth Asawa, *Art, Competence, and Citywide Cooperation for San Francisco* (Berkeley, CA: Regional Oral History Office, Bancroft Library, University of California, Berkeley, 1980), 132.
2 Ruth Asawa, in Jacqueline Hoefer, "A Working Life," in *The Sculpture of Ruth Asawa: Contours in the Air*, Timothy Anglin Burgard and Daniell Cornell et al., rev. ed. (San Francisco: Fine Arts Museums of San Francisco; Oakland: University of California Press, 2020), 32.
3 Ruth Asawa, interview with Mary E. Harris, December 1971, Ruth Asawa Papers, box 35, folder 3.
4 Ruth Asawa, lecture on Josef Albers, n.d., Ruth Asawa Papers, box 1, folder 4.
5 Asawa, *Art, Competence, and Citywide Cooperation*, 13–14.
6 "Works on Paper: 20th Anniversary Catalog" (New York: Elrick-Manley Fine Art, 2010), unpaginated.
7 Josef Albers, letter to Asawa, June 3, 1966, Ruth Asawa Papers, box 1, folder 5.
8 Ruth Asawa, interview with Katie Simon, June 26, 1995, Ruth Asawa Papers, box 127, folder 7.
9 Ruth Asawa, biography written for Guggenheim Fellowship application, c. 1987, Ruth Asawa Papers, box 129, folder 9.

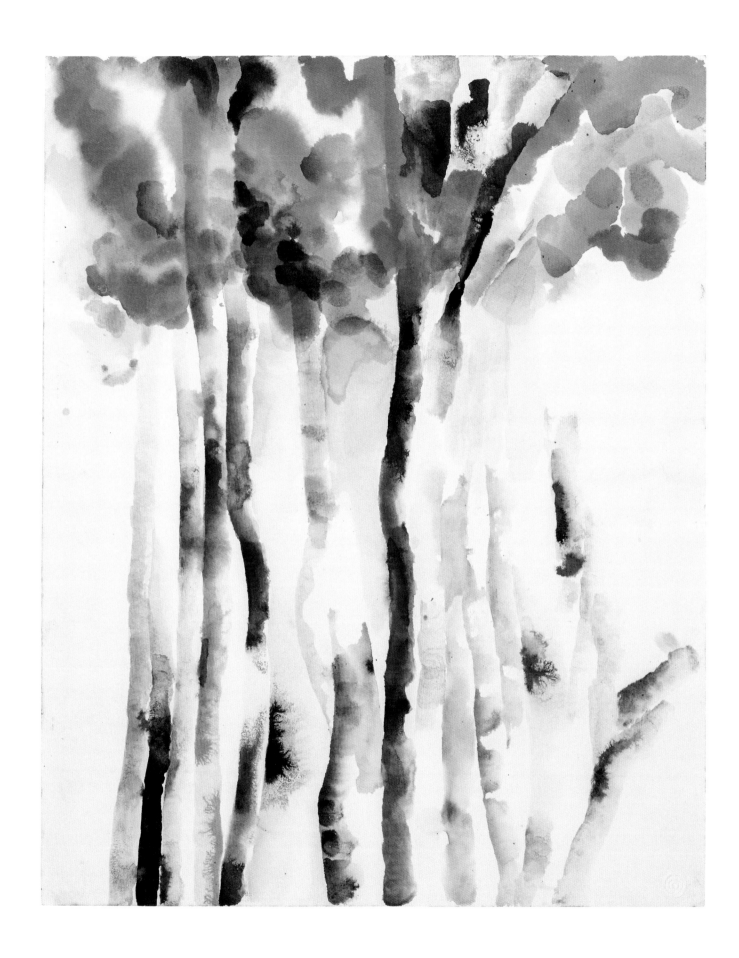

Untitled (BMC.148, Trees), c. 1948–49
Watercolor on paper, 19⅞ × 16 in. (50.5 × 40.6 cm)
Private collection

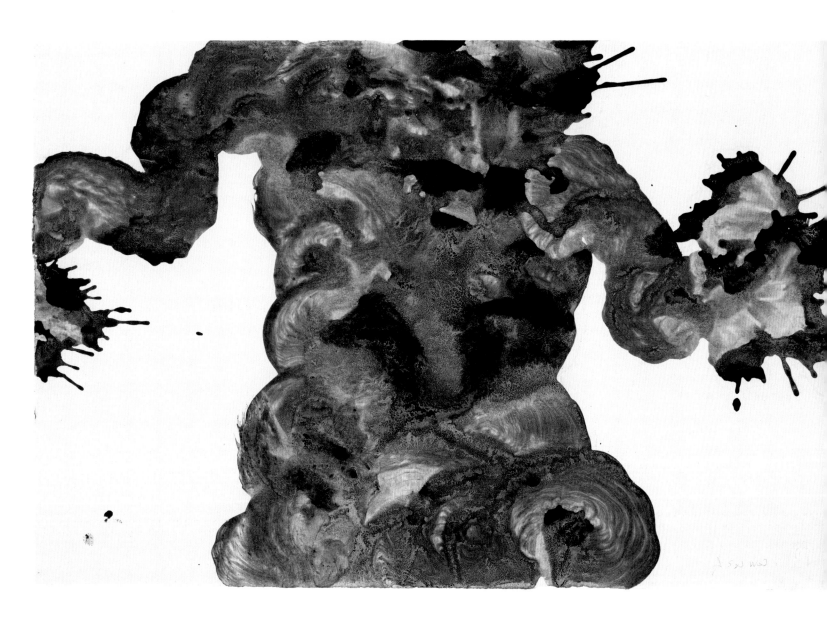

Untitled (PT.106, Plane Tree #12), 1959
Ink on coated paper, 12⅜ × 18⅞ in. (31.4 × 47.9 cm)
Whitney Museum of American Art, New York; purchase with funds from Gregg Seibert, 2016.5

Untitled (PT.064, Plane Tree), c. early 1960s
Ink on coated paper, 37¾ × 25 in. (95.9 × 63.5 cm)
Private collection

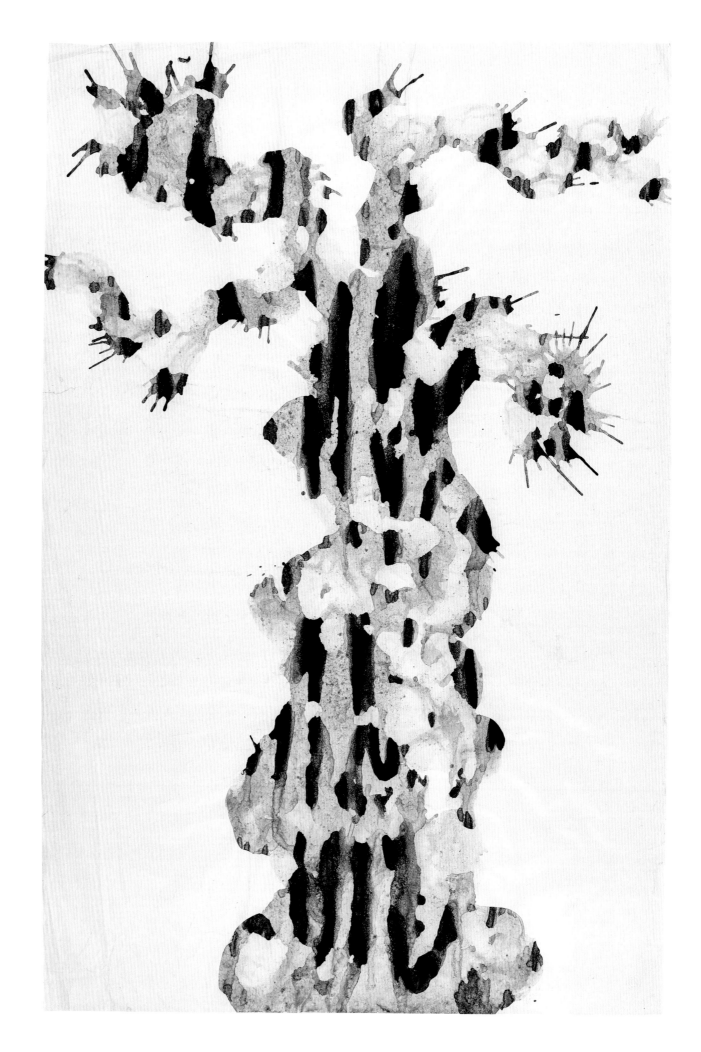

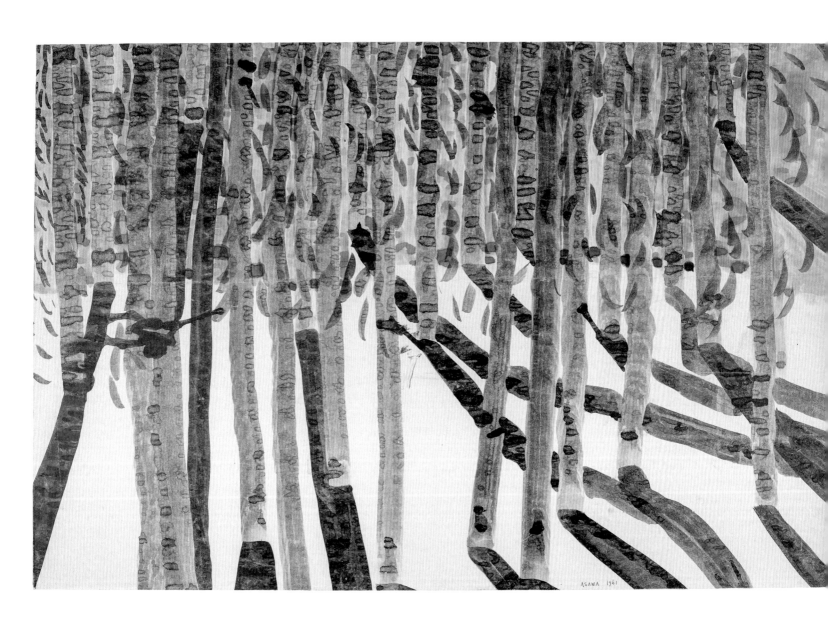

Untitled (PF.1016, Eucalyptus Grove), 1961
Ink on coated paper on board, 23 × 35 in. (58.4 × 88.9 cm)
Private collection

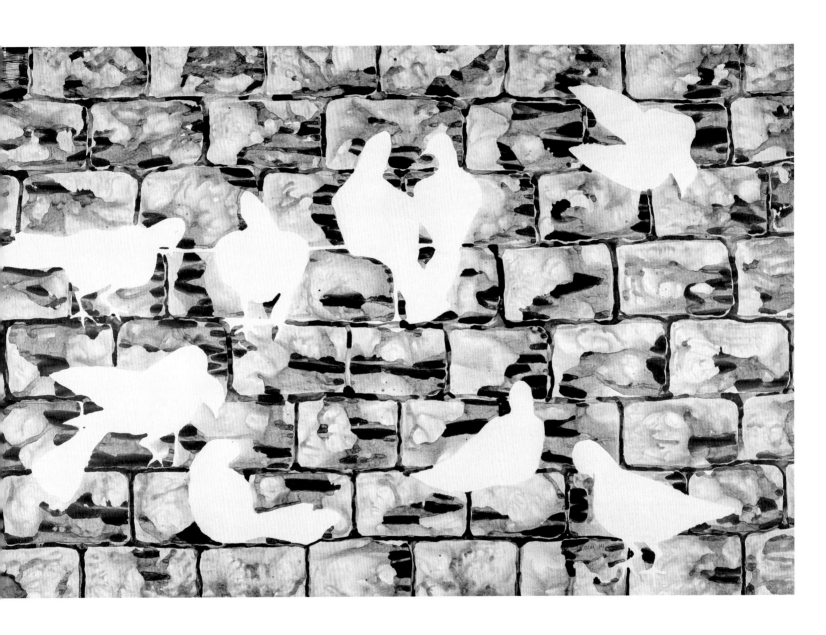

Untitled (AN.077, Pigeons on Brick), 1963
Ink on coated paper, 24½ × 37¼ in. (62.2 × 94.6 cm)
Private collection

Untitled (WC.202, Black and White Organic Pattern), c. 1961
Ink on coated paper, 15½ × 23 in. (39.4 × 58.4 cm)
Private collection

Untitled (PT.062, Blue and Black Ink Wash [Water]), c. early 1960s
Ink on coated paper, 25 × 37¾ in. (63.5 × 95.9 cm)
Private collection

Untitled (MI.108, Shell), c. 1969
Ink, watercolor, and colored pencil on
Japanese paper, 24 × 36 in. (61 × 91.4 cm)
Private collection

Untitled (PF.686, Watermelon), c. 1960s
Ink on Japanese paper,
20 × 30 in. (50.8 × 76.2 cm)
Private collection

Untitled (WC.100, Nasturtiums), c. 1970s–80s
Watercolor on paper, 15 × 22½ in. (38.1 × 57.2 cm)
Private collection

Untitled (WC.252, Persimmons), c. 1970s–80s
Watercolor on paper, 14 × 17 in. (35.6 × 43.2 cm)
Private collection

Untitled (WC.154, Lily Pads), c. 1960s
Ink and watercolor on coated paper, 12½ × 14 in. (31.8 × 35.6 cm)
Private collection

Allie's Iris (WC.175, Purple Iris with Three Blooms), 1987
Ink and watercolor on paper, 17½ × 11½ in. (44.4 × 29.2 cm)
Private collection

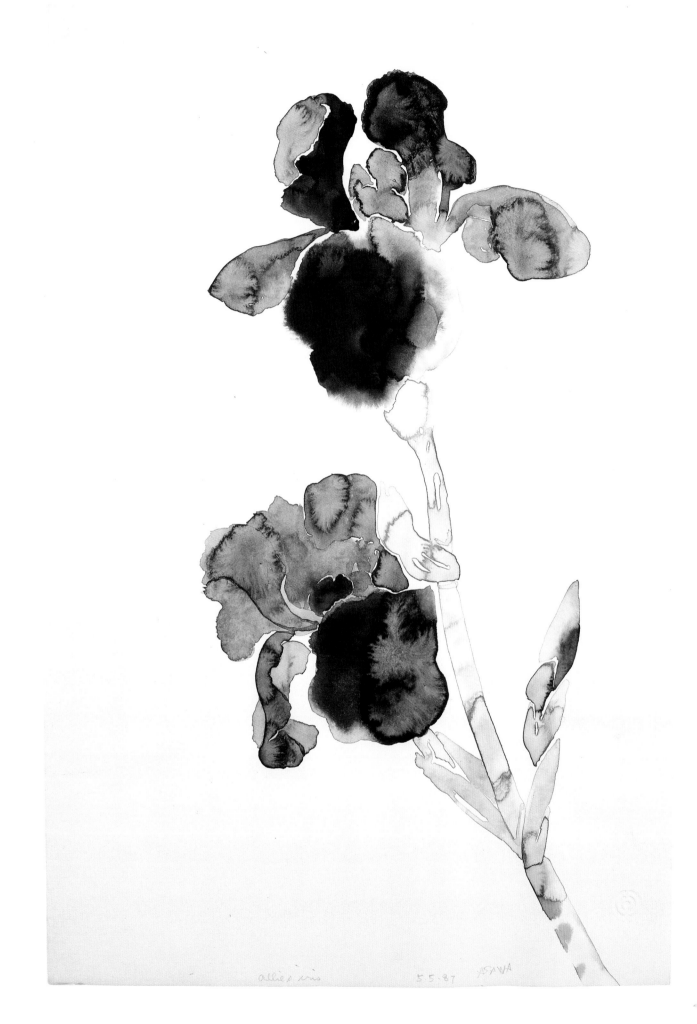

allied iris 5.5.87 ASAWA

LIFE LINES

Ruth Asawa's arrival in San Francisco in 1949 marked the first time she had been without a supportive arts community in many years. Seeking out ways to foster the atmosphere she had so valued at Black Mountain College, she began hosting informal drawing sessions with friends. Some classes were held around her kitchen table, which was, according to Andrea Jepson, scattered with "pens and paper and teacups."[1] Others involved outdoor excursions to public parks throughout the city, where parents could keep a close watch on their children while also sketching from nature: "We'd draw the children and we'd draw the animals," Asawa recalled. "Wherever we went, we took our sketchbooks with us."[2] Over the ensuing years, Asawa's ability to draw in any environment resulted in hundreds of individual works on paper and sketchbooks filled with portraits, object studies, and botanical illustrations. They range from spare contour line renderings in pen or graphite to works that demonstrate her use of dense hatching or brushed ink to create texture and shadow. Considered as a whole, they illustrate what Asawa most valued in life: creative labor, nature and gardening, and her extensive network of family, friends, and Bay Area community.

Wielding keen observational skills and a range of techniques, Asawa employed line to capture not just the form but also the character of her subject matter, from the twists of a nasturtium stem to the soft down of an infant's hair.

Asawa once described a desire not to simply draw a picture of a ceramic vessel, but to somehow graphically convey the particular quality of its glaze, the way it drips and catches the light—in her words, "to try to make it as though it was there."[3] Coincidentally, it was a ceramic artist, Daniel Rhodes, who was so struck by Asawa's alchemical renderings of objects through line that he wrote to her after seeing her drawings at the San Francisco Museum of Art in 1963, admiring how each "seemed to be a distillation of a real experience, and not something produced according to a set formula. . . . [Y]ou have the gift of adapting technique to the experience rather than flaunting it for itself."[4] In her portrait of Jepson, diffuse pools of ink become the abstract pattern on the sitter's blouse (WC.112 [p. 211]); in a drawing of two sleepers (FF.054 [p. 208]), the cockled paper lends itself to the effect of a wrinkled duvet blanket. Asawa's portrait of David Tudor (FF.896 [pp. 206–7]) shows her experimenting with variations in line quality within the same work: loose brushwork suggests the gathers and folds in Tudor's suit jacket, while the delicate line of a pen was reserved for his hands, delineating the lines across his knuckles and the curves of his fingernails. Asawa's choice to focus on the pianist-composer's hands rather than his face demonstrates her understanding of the significance of his art to his identity.

At Black Mountain, instructors like Josef Albers and Buckminster Fuller stressed economy

of means as an artistic approach. When the concept was applied to drawing lessons, students were encouraged to find the lines essential to establish form and allow the viewer's eye to complete the rest of the image.[5] In the figure study *Mervin Lane* (BMC.7 [p. 203]), a sketch of a classmate, Asawa accentuated Lane's defining characteristics while letting the rest of his body fade into blank space. She partially attributed this technique to her early background in cartooning and caricature, in which it is common to exaggerate a specific feature to convey an individual's personality.[6] In Albers's and Fuller's "less is more" philosophy, this drawing style became a form of communication in which Asawa learned to make her line suggest rather than declare outright.

In various artist statements and interviews, Asawa frequently recounted Albers's advice to her when she confided that she wanted to paint flowers: "Make sure that they're Asawa flowers."[7] For more than half a century, she filled sheets of paper and sketchbooks with renderings of petals and foliage. In these botanical images, her choice of drawing instrument and quality of line shift according to the distinctive nature of the plant variety at hand. A thick ink line describes the rubbery, scalelike growth of an arborvitae frond (SB.091 [p. 219]), while a slender nib recorded the filigree of a bouquet of ranunculi (PF.1107 [p. 223]). During her treatment for lupus in early 1985, Asawa's backyard garden in Noe Valley provided both a source of nutrient-rich food and a space of solace, dense with inspiration for her sketchpad. "At last, I will go into my garden and paint the flowers," she wrote to a friend, explaining how her husband, Albert, had selected plants that would be particularly interesting for her to draw: "Kiwi vines, babcock peach, pear, artichokes, cosmos, Mexican sunflower, daisies, nasturtiums, and on and on."[8]

It was rare for this self-effacing artist, who could draw her subjects without ever glancing down at the page, to turn her unwavering gaze onto herself. On one occasion Asawa observed herself by way of her own life mask (LC.012-002 [p. 31]). Using red and black Conté crayons to translate this three-dimensional form into two dimensions (FF.016 [p. 213]), she underscored the reciprocal relationship between her sculptural and drawing practices. In an earlier untitled self-portrait (WC.134), Asawa chose to depict herself in the act of drawing. Nib pen in right hand, head resting in the other, she is completely absorbed in her process. In foregrounding her art, both self-portraits are distillations of Asawa's belief that the essence of life "is in the doing—integrating your life and your work and everything together."[9]

— SH

1 Andrea Jepson, "In Praise of Ruth Asawa," *San Francisco Sunday Examiner & Chronicle*, May 11, 1975, 7.
2 Ruth Asawa, *Art, Competence, and Citywide Cooperation for San Francisco* (Berkeley, CA: Regional Oral History Office, Bancroft Library, University of California, Berkeley, 1980), 66.
3 Ruth Asawa, Presentation for Tamarind Lithography Workshop (recording), August 29, 1965, Tamarind Institute Records (MSS 574 BC), box 31, CD 020, University of New Mexico Center for Southwest Research & Special Collections, City, provided by Nancy Brown-Martinez.
4 Daniel Rhodes, letter to Ruth Asawa, March 10, 1964, Ruth Asawa Papers, box 102, folder 4.
5 Ruth Asawa, interview with Mary E. Harris, December 1971, Ruth Asawa Papers, box 35, folder 3.
6 Asawa, interview with Harris.
7 Ruth Asawa, in "Oral History Interview with Ruth Asawa and Albert Lanier," by Mark Johnson and Paul Karlstrom, June 21–July 5, 2002, Archives of American Art, Smithsonian Institution, unpaginated transcript, https://www.aaa.si.edu/collections/interviews/oral-history-interview-ruth-asawa-and-albert-lanier-12222.
8 Ruth Asawa, letter to William Matson Roth, March 2, 1985, Ruth Asawa Papers, box 127, folder 5.
9 Ruth Asawa, untitled statement on arts education, 1976, Ruth Asawa Papers, box 127, folder 3.

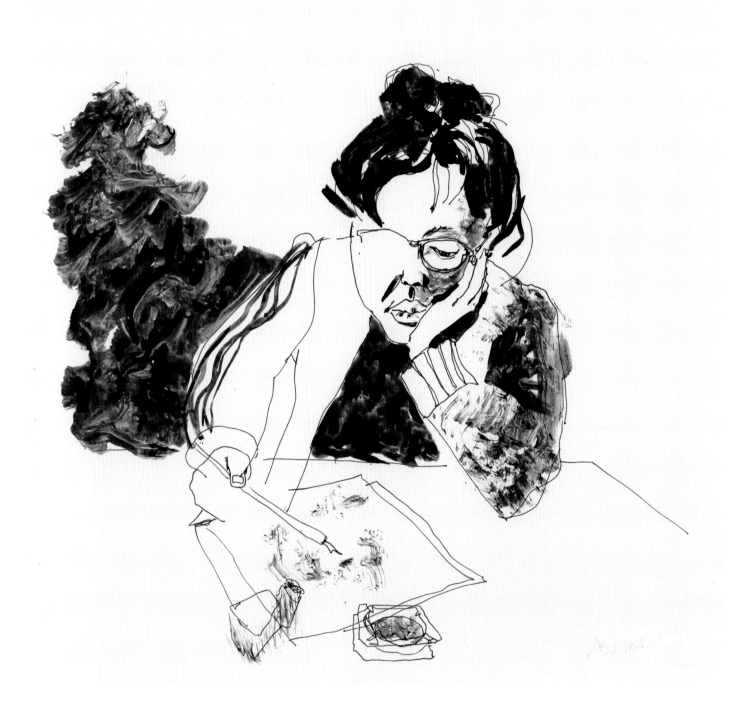

Untitled (WC.134, Self-Portrait), c. 1960s
Ink on paper, 13 × 12⅜ in. (33 × 31.4 cm)
Courtesy of Crystal Bridges Museum of American Art, Bentonville, Arkansas

Mervin Lane (BMC.7), 1947
Ink on paper, 24 × 17 in. (61 × 43.2 cm)
Achenbach Foundation for Graphic Arts, Fine Arts Museums of San Francisco,
Gift of the Artist, 2007.28.55

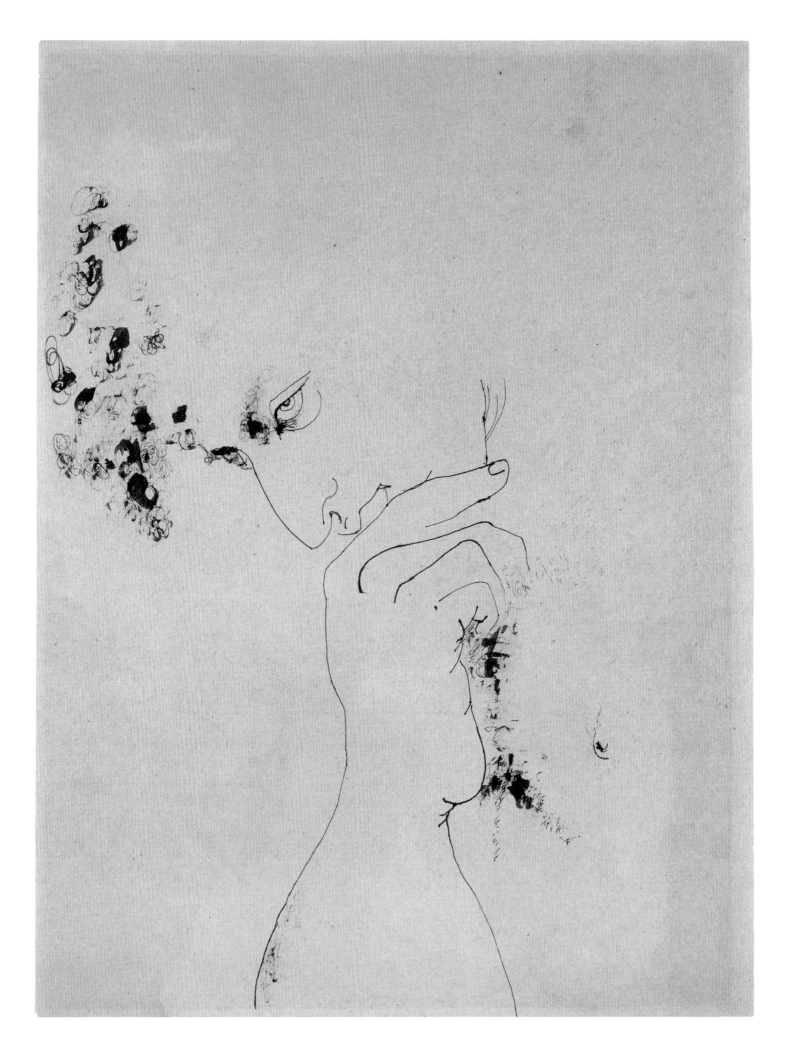

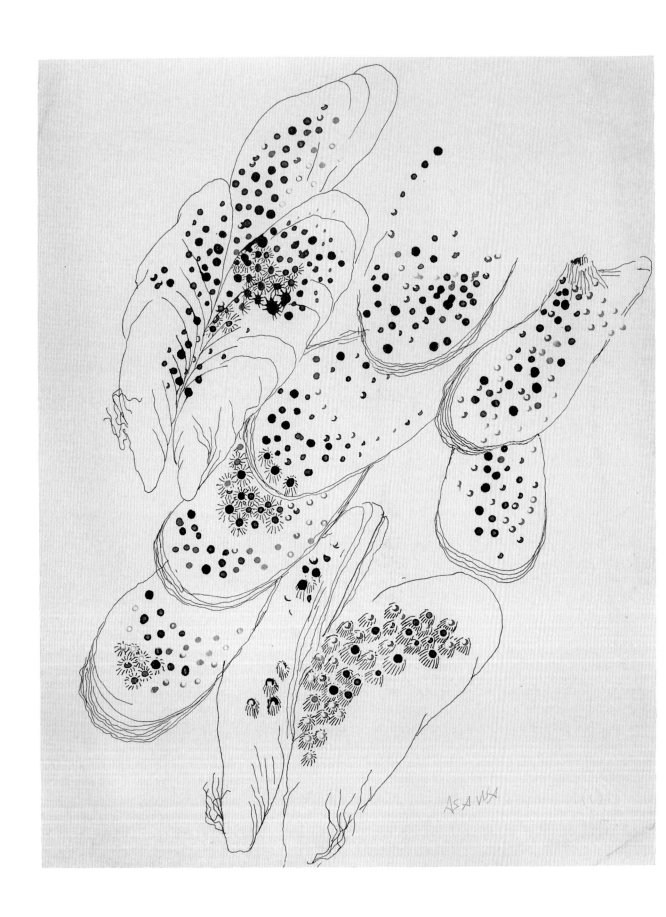

Untitled (AN.003, Mussels), c. late 1960s
Ink on paper, 11 × 8½ in. (27.9 × 21.6 cm)
Private collection

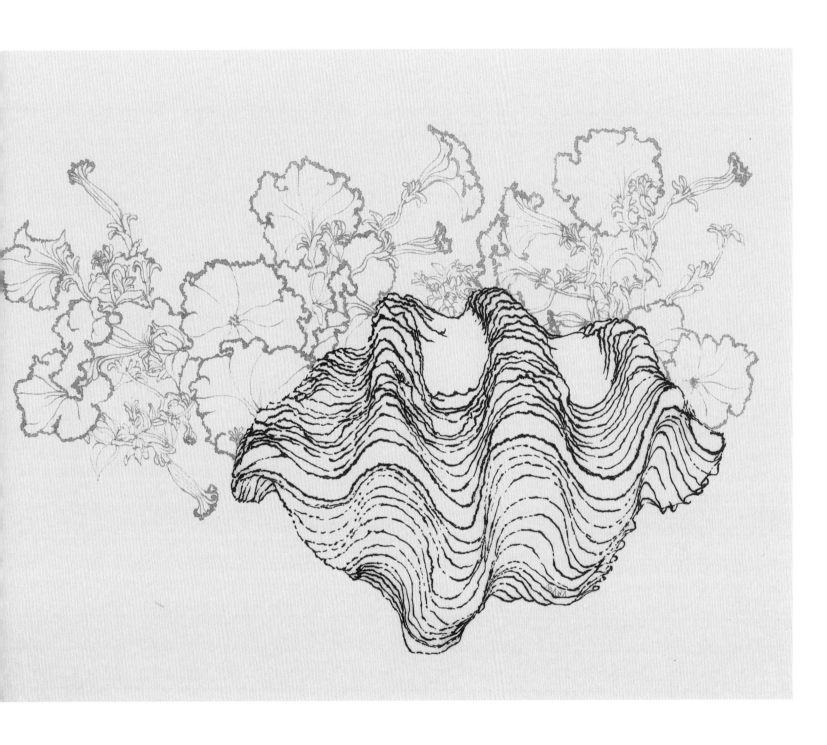

Untitled (MI.146, Clam Shell with Petunias), c. 1969
Ink on Japanese paper, 20⅝ × 23⅞ in. (52.4 × 60.6 cm)
Fuller Craft Museum, Gift of the Joan Pearson Watkins Trust, 2014.19.2

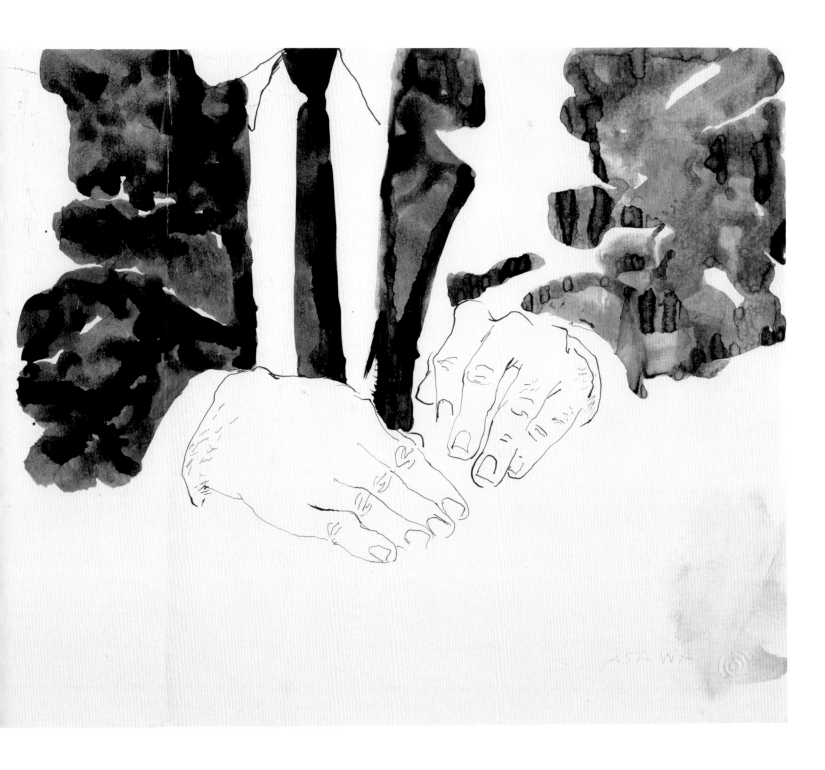

David Tudor's Hands (FF.896), c. 1964
Ink on paper, 12½ × 22⁹⁄₁₆ in. (31.8 × 57.3 cm)
Getty Research Institute, Los Angeles. Gift of Ruth Asawa

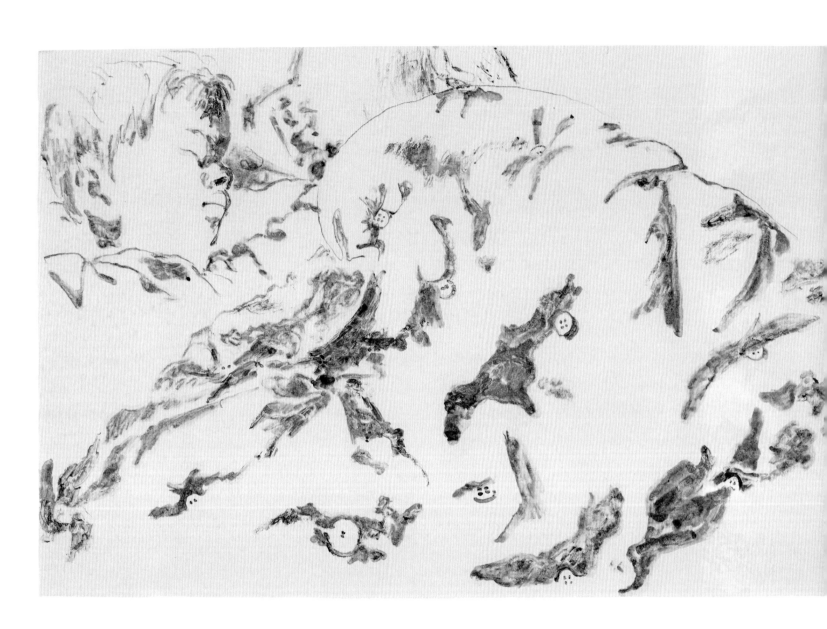

Untitled (FF.054, Albert and Child Sleeping), c. 1964
Ink on coated paper, 12½ × 19 in. (31.8 × 48.3 cm)
Private collection

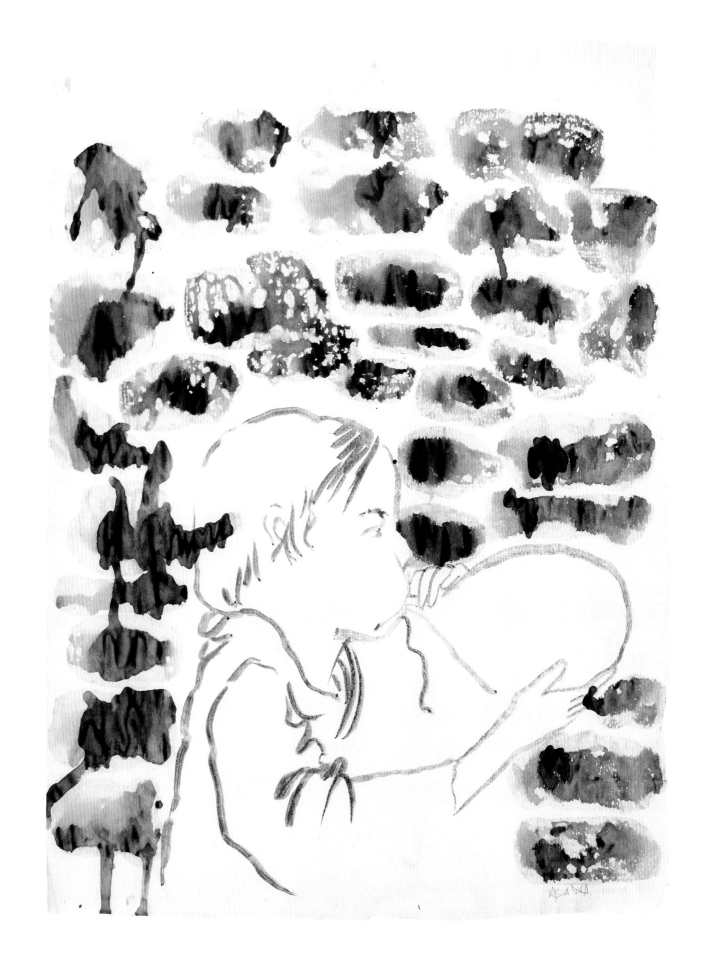

Untitled (FF.434, Aiko Lanier Blowing up Balloon), c. 1955
Ink on tracing paper, 19 × 14 in. (48.3 × 35.6 cm)
Private collection

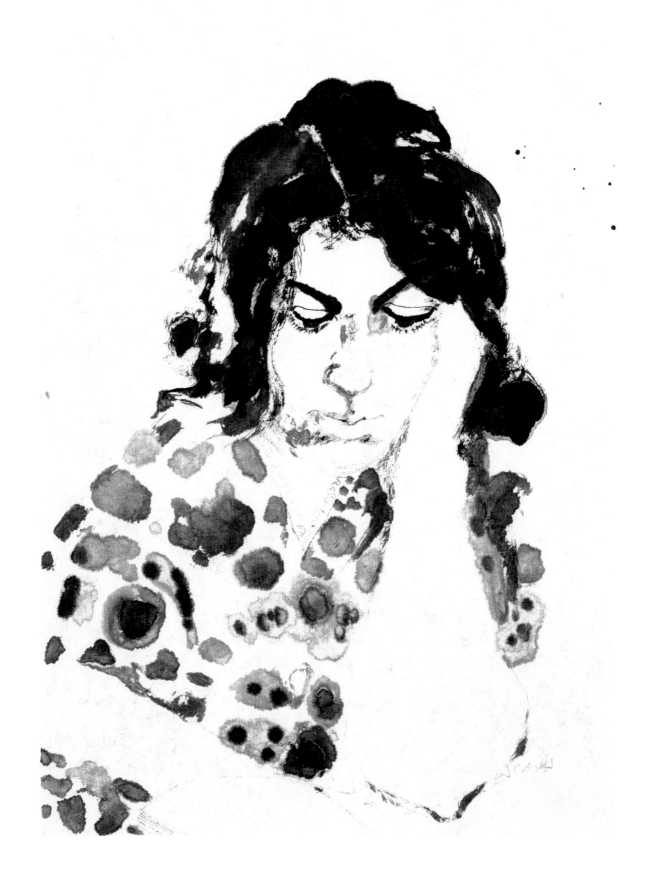

Untitled (WC.112, Andrea Jepson), 1964
Ink on Japanese paper, 18 × 12 in. (45.7 × 30.5 cm)
Achenbach Foundation for Graphic Arts, Fine Arts Museums of San Francisco,
Gift of the Artist, 2010.51.21

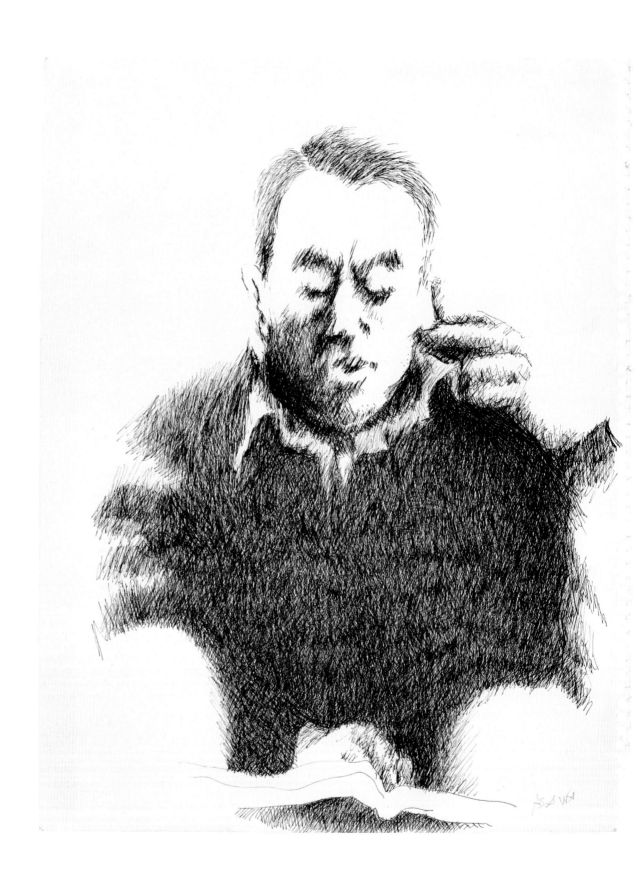

Untitled (FF.116, Albert Lanier), c. 1965
Ink on paper, 14 × 11 in. (35.6 × 27.9 cm)
Private collection

Untitled (FF.016, Life Mask of Ruth Asawa), c. 1968–70s
Conté crayon on Japanese paper, 17½ × 10 in. (44.5 × 25.4 cm)
Private collection

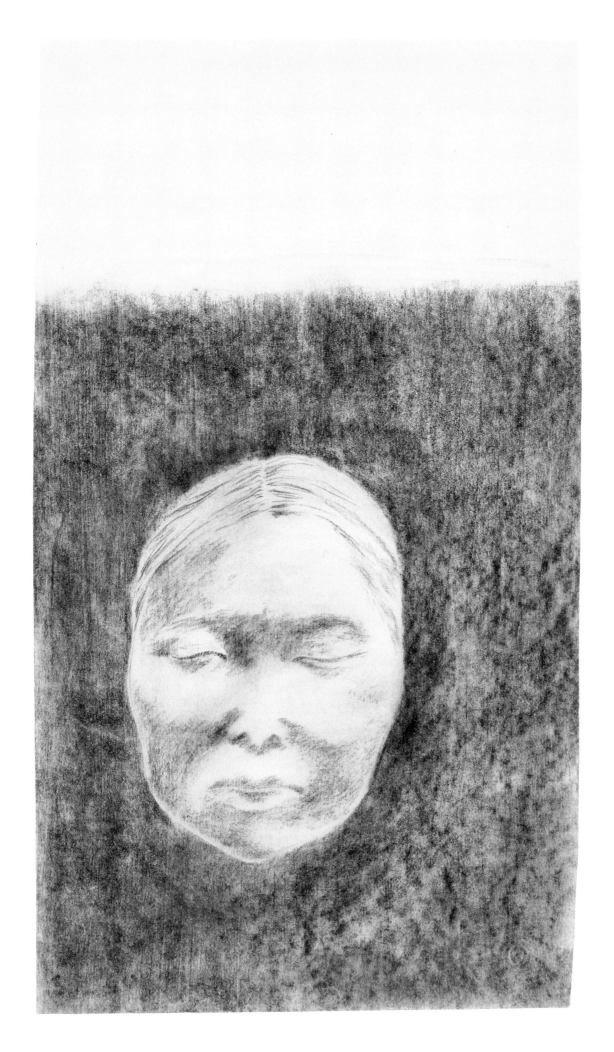

Untitled (PF.099, Nasturtiums), 1994
Ink on Japanese paper, 18 × 24¼ in. (45.7 × 61.6 cm)
Private collection

8.12.9

ISAKA

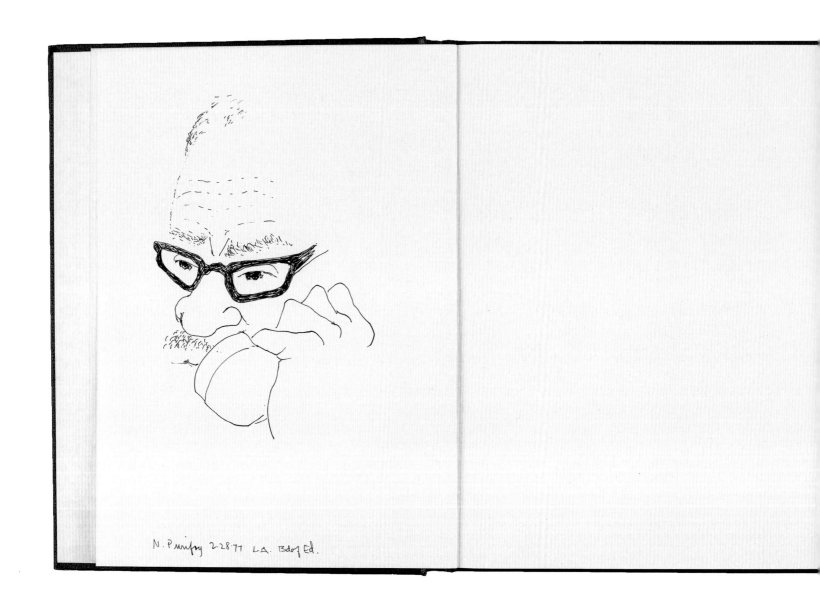

N. Purifoy 2.28.77 LA. Bd of Ed.

N. Purifoy 2.28.77 LA Bd of Ed. (SB.102), 1977
Ink on paper in hardbound sketchbook, 11 × 8½ in. (27.9 × 21.6 cm)
Private collection

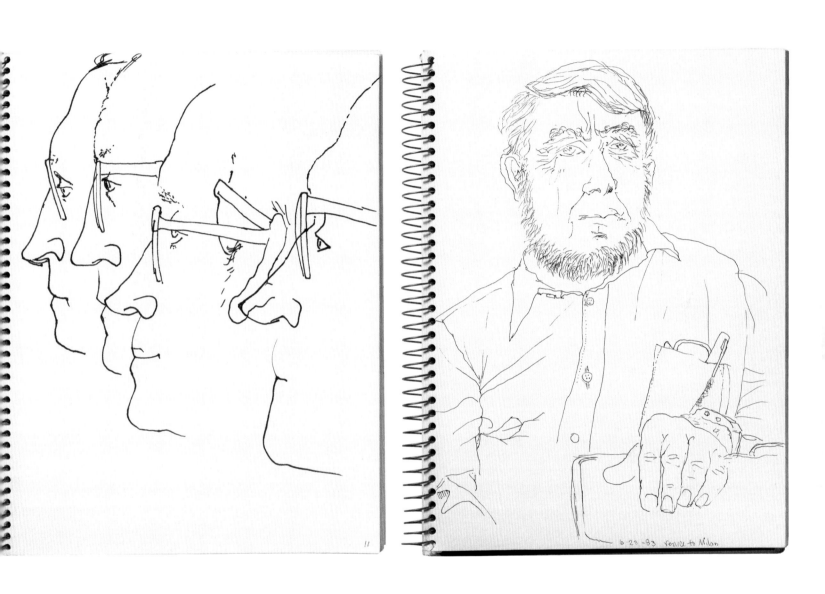

Untitled drawing (SB.076), c. 1974–76
Ink on paper in spiral-bound sketchbook, 11 × 8½ in. (27.9 × 21.6 cm)
Private collection

6.23.83 Venice to Milan (SB.137), 1983
Ink on paper in spiral-bound sketchbook, 11 × 8½ in. (27.9 × 21.6 cm)
Private collection

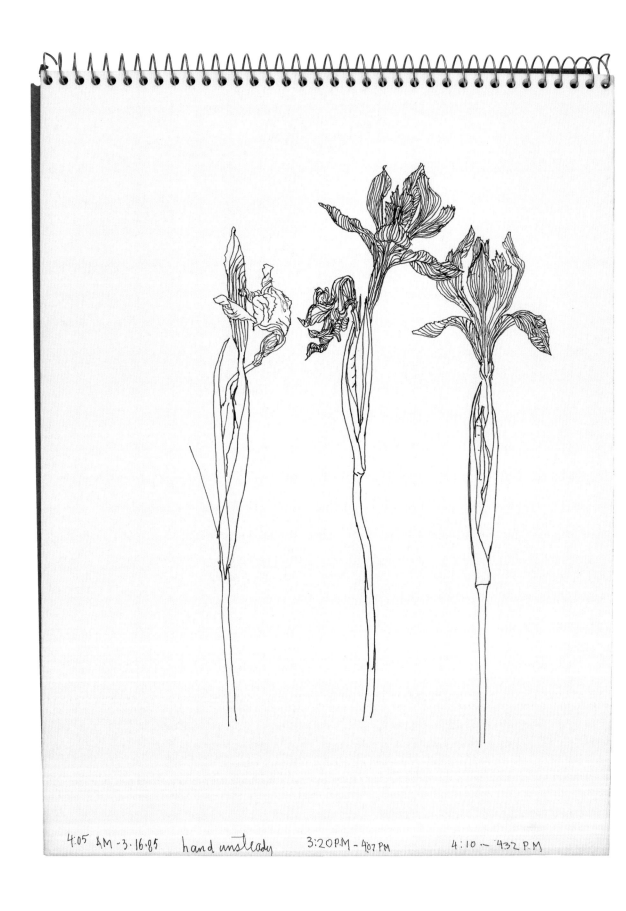

4:05 AM–3.16.85 hand unsteady 3:20PM–4:07PM 4:10–4:32PM (SB.157), 1985
Ink on paper in spiral-bound sketchbook, 12 × 9 in. (30.5 × 22.9 cm)
Private collection

Drawing for *The Japanese Tea Garden Golden Gate Park* pamphlet (SB.091), 1976
Ink on paper in spiral-bound sketchbook, 11 × 8½ in. (27.9 × 21.6 cm)
Private collection

Untitled (PF.825, John Elsesser's Leek), 1976
Ink on Japanese paper, 40 × 18 in. (101.6 × 45.7 cm)
Glenstone Museum, Potomac, Maryland

9.16.77 Gladiolas Paul's; Paul's Gladiolas 9.14.77 (SB.092), 1977
Ink on paper in spiral-bound sketchbook, 14⅛ × 11½ in. (35.9 × 29.2 cm) each
Private collection

Adam's Ranunculus (PF.1107, Bouquet from Adam Lanier with Snail), 1999
Ink on Japanese paper, 24 × 16⅞ in. (61 × 42.9 cm)
Private collection

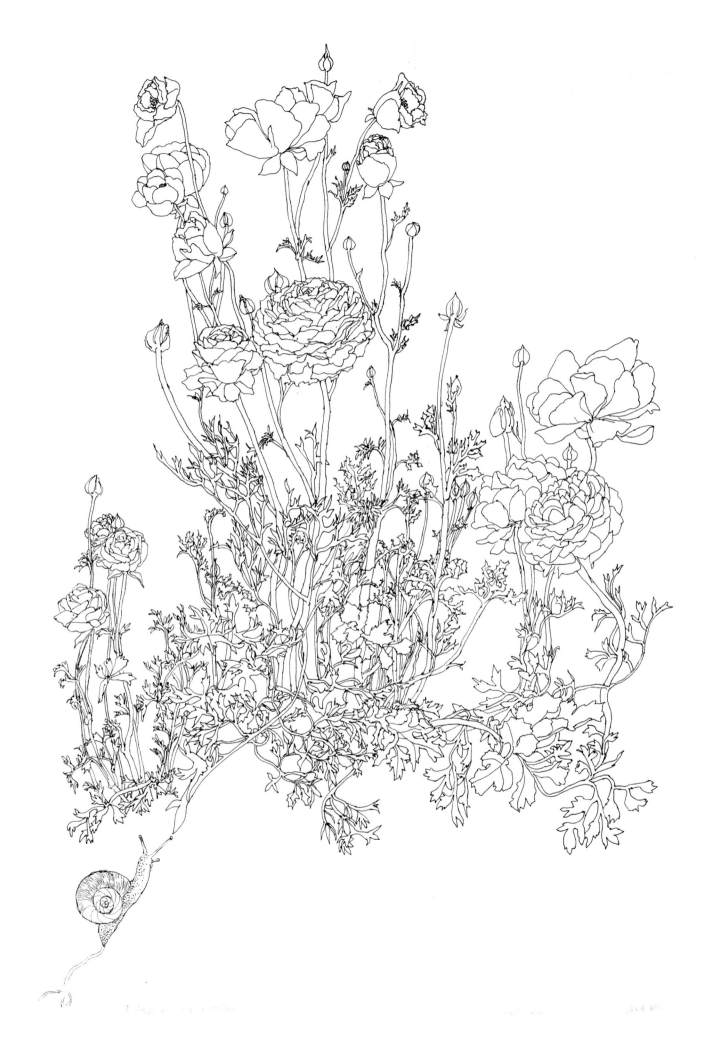

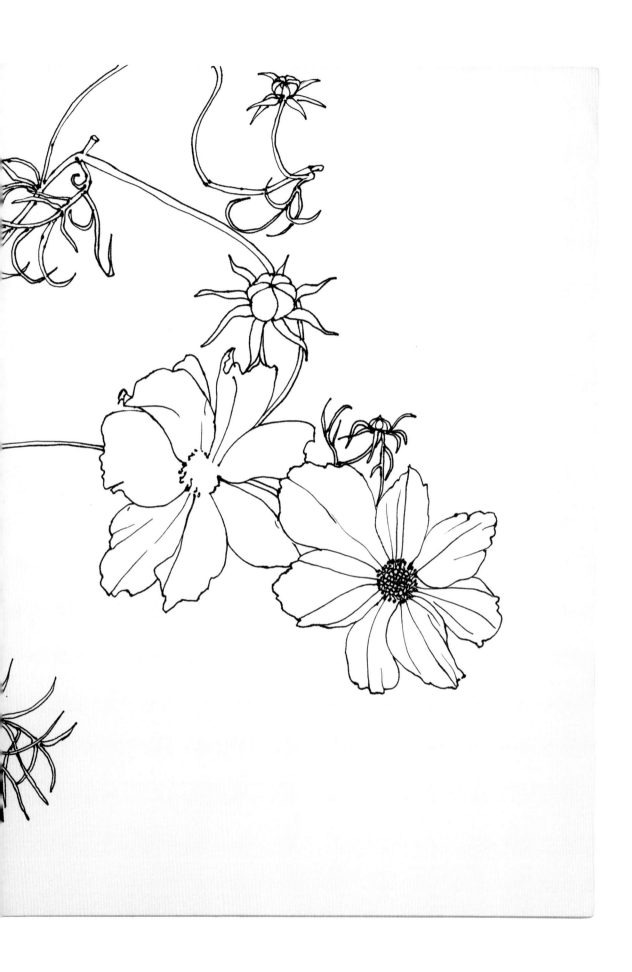

Untitled double-page drawing of cosmos (SB.087), c. 1976–89
Ink on paper in spiral-bound sketchbook, 14⅛ × 22½ in. (35.9 × 57.2 cm)
Private collection

WORKS IN THE EXHIBITION

Untitled (BMC.48, Jello Molds),
c. 1946–49
Ink and graphite on paper
17 × 22 in. (43.2 × 55.9 cm)
Achenbach Foundation for Graphic
Arts, Fine Arts Museums of San
Francisco, Gift of the Artist, 2007.28.57
Whitney only
p. 75

Untitled (BMC.57, Curved Lines),
c. 1946–49
Ink on paper
15¼ × 18 in. (38.7 × 45.7 cm)
Private collection
p. 148

Untitled (BMC.70, *3's* and *S's*),
c. 1946–49
Graphite, ink, and watercolor on paper
17 × 22 in. (43.2 × 55.9 cm)
The Josef and Anni Albers Foundation,
2007.30.32
Whitney only
p. 76

Untitled (BMC.123, Studies of Hands
and Feet), c. 1946–49
Ink on tracing paper
18¾ × 23¾ in. (47.6 × 60.3 cm)
Harvard Art Museums/Busch-Reisinger
Museum, Gift of Josef Albers, BR49.385
Whitney only
pp. 12, 74

Untitled (BMC.125, Squares and
Circles), c. 1946–49
Ink over graphite on tracing paper
17½ × 22¾ in. (44.5 × 57.8 cm)
Harvard Art Museums/Busch-Reisinger
Museum, Gift of Josef Albers, BR49.378
Menil only
p. 129

Untitled (BMC.126, Study in Primary
Colors), c. 1946–49
Collage of cut colored papers mounted
to three colored papers
13⅜ × 11½ in. (34 × 29.2 cm)
Harvard Art Museums/Busch-Reisinger
Museum, Gift of Josef Albers, BR49.416
Menil only
p. 71

Untitled (BMC.127, Meander in Green,
Orange, and Brown), c. 1946–49
Collage of cut and printed colored
papers mounted to brown coated paper
17¼ × 22⅜ in. (43.8 × 56.8 cm)
Harvard Art Museums/Busch-Reisinger
Museum, Gift of Josef Albers, BR49.408
Whitney only
p. 72

Untitled (BMC.132, Color Study of Many
Colored Squares and Triangles),
c. 1946–49
Oil on paper
16 × 9½ in. (40.6 × 24.1 cm)
The Josef and Anni Albers Foundation,
1976.30.4
Whitney only
p. 77

Mervin Lane (BMC.7), 1947
Ink on paper
24 × 17 in. (61 × 43.2 cm)
Achenbach Foundation for Graphic
Arts, Fine Arts Museums of San
Francisco, Gift of the Artist, 2007.28.55
p. 203

Untitled (BMC.59, Meander – Straight
Lines), c. 1948
Ink on paper
7⅞ × 13½ in. (20 × 34.3 cm)
Private collection
p. 149

Untitled (BMC.56, Dancers), c. 1948–49
Oil and gouache on paper
12 × 19 in. (30.5 × 48.3 cm)
Private collection
pp. 68, 84

Untitled (BMC.68, Stem with Leaves),
c. 1948–49
Watercolor on paper
19¾ × 16 in. (50.2 × 40.6 cm)
Achenbach Foundation for Graphic
Arts, Fine Arts Museums of San
Francisco, Gift of Aiko and Laurence
Cuneo, 2007.29.3
p. 87

Untitled (BMC.74, Double Sheet Stamp),
1948
Stamped ink on newsprint
17⅛ × 22 in. (43.5 × 55.9 cm)
Asheville Art Museum, Black Mountain
College Collection, gift of Aiko &
Laurence Cuneo, 2010.33.02.60
p. 91

Untitled (BMC.75, Double Sheet
Clusters), c. 1948–49
Stamped ink on newsprint
17¼ × 22 in. (43.8 × 55.9 cm)
Achenbach Foundation for Graphic
Arts, Fine Arts Museums of San
Francisco, Gift of the Artist, 2007.28.60
p. 93

Untitled (BMC.78, BMC Sunburst),
c. 1948–49
Stamped ink on newsprint
17 × 22 in. (43.2 × 55.9 cm)
The Josef and Anni Albers Foundation,
2007.30.44
p. 92

Untitled (BMC.84, Dogwood Leaves),
c. 1948–49
Oil and watercolor on paper
7 × 12 in. (17.8 × 30.5 cm)
The Josef and Anni Albers Foundation,
2007.30.6
p. 82

Untitled (BMC.86, Dogwood Leaf),
c. 1948–49
Oil and watercolor on tracing paper
10½ × 8 in. (26.7 × 20.3 cm)
The Josef and Anni Albers Foundation,
2007.30.10
Whitney only
p. 83

Untitled (BMC.91, In and Out), c. 1948–49
Oil on board
8¼ × 14¼ in. (21 × 36.2 cm)
Achenbach Foundation for Graphic
Arts, Fine Arts Museums of San
Francisco, Gift of Aiko and Laurence
Cuneo, 2007.29.4
Whitney only
p. 127

Untitled drawing of Albert Lanier sleeping (SB.024), c. early 1960s
Felt-tipped pen and graphite on paper in spiral-bound sketchbook
10 × 17¼ in. (25.4 × 43.8 cm) open; 10 × 8½ × ¾ in. (25.4 × 21.6 × 1.9 cm) closed
Private collection
p. 62

Untitled (FF.1211, Paul Lanier on Patterned Blanket), 1961
Felt-tipped pen on paper on board
31 × 21 in. (78.7 × 53.3 cm)
Private collection
pp. 144, 159

Headlights (MI.137), 1961
Ink on Japanese paper on board
16¼ × 23½ in. (41.3 × 59.7 cm)
Collection of halley k harrisburg and Michael Rosenfeld, New York
Whitney only
p. 166

Untitled (PF.1016, Eucalyptus Grove), 1961
Ink on coated paper on board
23 × 35 in. (58.4 × 88.9 cm)
Private collection
p. 186

Untitled (WC.202, Black and White Organic Pattern), c. 1961
Ink on coated paper
15½ × 23 in. (39.4 × 58.4 cm)
Private collection
Menil only
p. 188

Untitled (AN.077, Pigeons on Brick), 1963
Ink on coated paper
24½ × 37¼ in. (62.2 × 94.6 cm)
Private collection
p. 187

Untitled (MI.053, Houses and Hills), 1963
Felt-tipped pen on bitumen waterproof paper
14¼ × 18 in. (36.2 × 45.7 cm)
Private collection
p. 154

Untitled (S.780, Wall-Mounted, Double-Sided, Center-Tied, Six-Branched Form Based on Nature), c. 1963
Galvanized wire
27 × 30 × 15 in. (68.6 × 76.2 × 38.1 cm)
Fuller Craft Museum, Gift of the Joan Pearson Watkins Trust, 2014.19.1
p. 164

Untitled (SD.263, Tied-Wire Sculpture Drawing with Six-Branch Center and Drops at the Ends), c. 1963–69
Ink on Japanese paper
6 × 17¾ in. (15.2 × 45.1 cm)
Achenbach Foundation for Graphic Arts, Fine Arts Museums of San Francisco, Gift of Mr. and Mrs. Edgar Sinton, Hillsborough, 1969.24
p. 174

Untitled (WC.112, Andrea Jepson), 1964
Ink on Japanese paper
18 × 12 in. (45.7 × 30.5 cm)
Achenbach Foundation for Graphic Arts, Fine Arts Museums of San Francisco, Gift of the Artist, 2010.51.21
p. 211

Untitled (FF.054, Albert and Child Sleeping), c. 1964
Ink on coated paper
12½ × 19 in. (31.8 × 48.3 cm)
Private collection
p. 208

David Tudor's Hands (FF.896), c. 1964
Ink on paper
12½ × 25 in. (31.8 × 63.5 cm)
Getty Research Institute, Los Angeles. Gift of Ruth Asawa
pp. 206–7

Untitled (FF.116, Albert Lanier), c. 1965
Ink on paper
14 × 11 in. (35.6 × 27.9 cm)
Private collection
p. 212

Untitled (AN.003, Mussels), c. late 1960s
Ink on paper
11 × 8½ in. (27.9 × 21.6 cm)
Private collection
p. 204

Untitled (SD.254, Tied-Wire Sculpture Drawing with Six Petals in Center), c. late 1960s
Tin
32¾ × 32¾ × ¼ in (83.2 × 83.2 × 0.6 cm)
Private collection
p. 170

Untitled (FF.016, Life Mask of Ruth Asawa), c. 1968–70s
Conté crayon on Japanese paper
17½ × 10 in. (44.5 × 25.4 cm)
Private collection
pp. 30, 213

Untitled (MI.108, Shell), c. 1969
Ink, watercolor, and colored pencil on Japanese paper
24 × 36 in. (61 × 91.4 cm)
Private collection
Whitney only
pp. 190–91

Untitled (MI.146, Clam Shell with Petunias), c. 1969
Ink on Japanese paper
20⅝ × 23⅞ in. (52.4 × 60.6 cm)
Fuller Craft Museum, Gift of the Joan Pearson Watkins Trust, 2014.19.2
p. 205

Untitled (SD.168, Tied-Wire Sculpture Drawing with Six-Pointed Star in Center), c. 1969
Ink on Japanese paper
18 × 18⅛ in. (45.7 × 46 cm)
Fuller Craft Museum, Gift of the Joan Pearson Watkins Trust, 2014.19.4
p. 169

Various paperfold models, c. 1970s
Gelatin silver print
8 × 10 in. (20.3 × 25.4 cm)
Photograph by Laurence Cuneo
Courtesy of the Department of Special Collections, Stanford University Libraries
p. 47

Untitled (SD.012, Tied-Wire Sculpture Drawing with Six-Branch Center and Drops at the Ends), c. 1970s
Ink on paper
14 × 10¾ in. (35.56 × 27.31 cm)
Private collection
Menil only
p. 173

Untitled (WC.100, Nasturtiums), c. 1970s–80s
Watercolor on paper
15 × 22½ in. (38.1 × 57.2 cm)
Private collection
pp. 60, 194

Untitled (WC.252, Persimmons), c. 1970s–80s
Watercolor on paper
14 × 17 in. (35.6 × 43.2 cm)
Private collection
pp. 178, 195

Untitled drawing (SB.059), 1971
Graphite on paper in spiral-bound sketchbook
14 × 11 in. (35.6 × 27.9 cm) open; 14 × 12 × 1 in. (35.6 × 30.5 × 2.5 cm) closed
Private collection
p. 64

Untitled drawing (SB.070), 1973
Graphite on paper in spiral-bound sketchbook
12 × 9 in. (30.5 × 22.9 cm) open; 12 × 10 × 1½ in. (30.5 × 25.4 × 3.8 cm) closed
Private collection
p. 64

Untitled (SD.129, Tied-Wire Sculpture Drawing with Five-Pointed Star in Center), c. 1973
Ink on Japanese paper
15¾ × 15½ in. (40 × 39.4 cm)
Private collection
p. 168

Untitled drawing (SB.076), c. 1974–76
Ink on paper in spiral-bound sketchbook
11 × 8½ in. (27.9 × 21.6 cm) open; 11 × 9⅛ × ⅞ in. (29.9 × 23.2 × 2.2 cm) closed
Private collection
Whitney only
p. 217

Addie Laurie Lanier and Aiko Cuneo discussing a paperfold model for San Francisco Japantown's *Origami Fountains* (PC.006), 1975
Gelatin silver print
10 × 8 in. (25.4 × 20.3 cm)
Photograph by Laurence Cuneo
Courtesy of the Department of Special Collections, Stanford University Libraries
Whitney only
p. 46

Untitled (FF.1231, Imogen Cunningham with Beads), 1975
Ink on paper
12 × 9 in. (30.5 × 22.9 cm)
Private collection
p. 33

Ruth Asawa folding paper, c. 1975
Digital print from color transparency
10 × 8 in. (25.4 × 20.3 cm)
Photograph by Laurence Cuneo
Courtesy of the Department of Special Collections, Stanford University Libraries
Whitney only
p. 45

Ruth Asawa holding a paperfold, c. 1975
Gelatin silver print
10 × 8 in. (25.4 × 20.3 cm)
Photograph by Laurence Cuneo
Courtesy of the Department of Special Collections, Stanford University Libraries
p. 45

Untitled (PF.825, John Elsesser's Leek), 1976
Ink on Japanese paper
40 × 18 in. (101.6 × 45.7 cm)
Glenstone Museum, Potomac, Maryland
Whitney only
p. 221

Drawing for *The Japanese Tea Garden Golden Gate Park* pamphlet (SB.091), 1976
Ink on paper in spiral-bound sketchbook
11 × 8½ in. (27.9 × 21.6 cm) open; 11 × 9½ × 1¼ in. (27.9 × 24.1 × 3.2 cm) closed
Private collection
p. 219

Untitled double-page drawing of cosmos (SB.087), c. 1976–89
Ink on paper in spiral-bound sketchbook
14⅛ × 22½ in. (35.9 × 57.2 cm) open; 14⅛ × 11½ × 1¼ in. (35.9 × 29.2 × 3.2 cm) closed
Private collection
pp. 224–25

9.16.77 Gladiolas Paul's; Paul's Gladiolas 9.14.77 (SB.092), 1977
Ink on paper in spiral-bound sketchbook
14⅛ × 22⅜ in. (35.9 × 56.8 cm) open; 14⅛ × 11½ × 1¼ in. (35.9 × 29.2 × 3.2 cm) closed
Private collection
p. 222

Suzanne Jackson, 2.11.77 (SB.100), 1977
Ink on paper in hardbound sketchbook
11 × 8½ in. (27.9 × 21.6 cm) open; 11½ ×
9 × ¾ in. (29.2 × 22.9 × 1.9 cm) closed
Private collection
p. 33

N. Purifoy 2.28.77 LA Bd of Ed. (SB.102),
1977
Ink on paper in hardbound sketchbook
11 × 8½ in. (27.9 × 21.6 cm) open; 11½ ×
9 × ¾ in. (29.2 × 22.9 × 1.9 cm) closed
Private collection
p. 216

Untitled (SD.126, Tied-Wire Sculpture
Drawing with Eight Branches), c. 1980s
Ink and wax crayon on amate paper
16¾ × 24½ in. (42.5 × 62.2 cm)
Achenbach Foundation for Graphic Arts,
Fine Arts Museums of San Francisco,
Gift of the RAL, Inc., 2007.28.76
p. 172

Untitled (CF.02, Sunflower), c. 1980
Copper sheet
10¼ × 10¼ × ¼ in. (26 × 26 × 0.6 cm)
Private collection
Menil only
p. 171

Untitled (CF.11, Sculpture, Continuous
Form within a Form), c. 1980
Copper sheet
16 × 8 × ¼ in. (40.6 × 20.3 × 0.6 cm)
Private collection
p. 115

Untitled (CF.13, Sculpture, Continuous
Form within a Form), c. 1980
Copper sheet
7 × 12 × ¼ in. (17.8 × 30.5 × 0.6 cm)
Private collection
p. 114

Untitled (WC.133, Continuous Form
within a Form), after c. 1980
Watercolor on paper
15½ × 21½ in. (39.4 × 54.6 cm)
Private collection
pp. 102, 108

Untitled (SD.164, Tied-Wire Sculpture
Drawing with Eight Branches that End
in Drops), 1981
Ink on cotton handkerchief
21 × 21 in. (53.3 × 53.3 cm)
Private collection
Menil only
pp. 162, 175

6.23.83 Venice to Milan (SB.137), 1983
Ink on paper in spiral-bound sketchbook
11 × 8½ in. (27.9 × 21.6 cm) open; 11 × 9 ×
1¼ in. (27.9 × 22.9 × 3.2 cm) closed
Private collection
p. 217

*4:05 AM–3.16.85 hand unsteady
3:20PM–4:07PM 4:10–4:32PM*
(SB.157), 1985
Ink on paper in spiral-bound sketchbook
12 × 9 in. (30.5 × 22.9 cm) open;
12¼ × 9 in. (31.1 × 22.9 cm) closed
Private collection
Whitney only
p. 218

Untitled (LP.009, Fish), 1987
Ink on Japanese paper
22 × 40 in. (55.9 × 101.6 cm)
Private collection
pp. 100–101

Allie's Iris (WC.175, Purple Iris with
Three Blooms), 1987
Ink and watercolor on paper
17½ × 11½ in. (44.4 × 29.2 cm)
Private collection
Whitney only
p. 197

Dancers rehearsing with large paper-
folds for *Breathing*, performed at
School of the Arts, San Francisco, 1989
Gelatin silver print
6¼ × 9¼ in. (15.9 × 23.5 cm)
Photograph by Tom Wachs
Courtesy of the Department of Special
Collections, Stanford University
Libraries
p. 46

Stills from *Breathing*, School of the Arts,
San Francisco, 1989
Digitized video recording, 14:50 min.
Courtesy of the Department of Special
Collections, Stanford University
Libraries
pp. 142, 143

Untitled (Leaf from the Sacramento
Delta), c. early 1990s
Ink on Japanese paper
42¾ × 25¾ in. (108.5 × 65.3 cm)
Courtesy of the Department of Special
Collections, Stanford University
Libraries
pp. 54, 99

Untitled (LP.001, Large Leaf), c. early
1990s
Ink on Japanese paper
17¾ × 17 in. (45.1 × 43.2 cm)
Private collection
p. 98

Untitled (PF.295, Endive), c. early 1990s
Ink on paper
29½ × 41¾ in. (74.93 × 106.05 cm)
Private collection
pp. 10, 176–77

Untitled (PF.099, Nasturtiums), 1994
Ink on Japanese paper
18 × 24¼ in. (45.72 × 61.6 cm)
Private collection
pp. 60, 214–15

Herb Rankins' Redwood 6.17.95
(SB.200), 1995
Ink on paper in spiral-bound sketchbook
17 × 14⅛ in. (43.2 × 35.9 cm) open; 17½ ×
14⅛ × ½ in. (44.5 × 35.9 × 1.3 cm) closed
Private collection
p. 34

*Hudson's Wildflowers for Mother's Day,
5.14.95* (SB.200), 1995
Ink on paper in spiral-bound sketchbook
17 × 14⅛ in. (43.2 × 35.9 cm) open; 7½ ×
14⅛ × ½ in. (44.5 × 35.9 × 1.3 cm) closed
Private collection
Whitney only

Untitled (S.003, Freestanding Reversible
Undulating Form), 1998
Bronze
10 × 16⅔ × 16⅔ in.
(25.4 × 42.33 × 42.33 cm)
Private collection
p. 180

Adam's Ranunculus (PF.1107, Bouquet
from Adam Lanier with Snail), 1999
Ink on Japanese paper
24 × 16⅞ in. (61 × 42.9 cm)
Private collection
pp. 198, 223

CREDITS

Published in conjunction with the exhibition
Ruth Asawa Through Line
Co-organized by the Whitney Museum of American
Art, New York, and the Menil Collection, Houston
Co-curated by Kim Conaty and Edouard Kopp
Whitney Museum of American Art
September 16, 2023–January 15, 2024
The Menil Collection
March 22–July 21, 2024

Generous support for *Ruth Asawa Through Line*
is provided by The Andy Warhol Foundation for
the Visual Arts and the Henry Luce Foundation.

Significant support is provided by Christie's.

In Houston, additional support comes from
The Brown Foundation, Inc./Nancy Abendshein;
Clare Casademont and Michael Metz; Barbara and
Michael Gamson; Dillon Kyle and Sam Lasseter;
Franci Neely; Susanne and William E. Pritchard III;
Ann and Mathew Wolf Drawing Exhibition Fund;
Nina and Michael Zilkha; and the City of Houston
through Houston Arts Alliance. Support for this exhi-
bition catalogue is provided by the Menil Collection
Publishing Fund; and Furthermore: a program of
the J.M. Kaplan Fund.

In New York, the exhibition is sponsored by Delta.
Generous support is provided by Judy Hart Angelo
and David Bolger. Major support is provided by the
Abrams Foundation; the Ellsworth Kelly Foundation
in honor of the Ellsworth Kelly Centennial; the
John R. Eckel, Jr. Foundation; and the Jon and Mary
Shirley Foundation. Significant support is provided
by The Lipman Family Foundation, Nancy and
Fred Poses, and an anonymous donor. Additional
support is provided by Ann Ames and Sheree and
Jerry Friedman.

Front and back covers: Detail of *Untitled* (SF.030,
Blue Triangles on Brown), see p. 153
Front endsheet: Detail of *Redwood 356 (PF.1012)*,
see p. 167
Back endsheet: Detail of *Untitled* (BMC.128, Study in
Repeated Vertical Angular Lines [Triangles]), see p.128
p. 2: Detail of *Untitled* (AB.004, Waves), see p. 157

Published by
The Menil Collection
1511 Branard Street
Houston, Texas 77006
menil.org
and
Whitney Museum of American Art
99 Gansevoort Street
New York, New York 10014
whitney.org

Distributed by
Yale University Press
302 Temple Street
P.O. Box 209040
New Haven, Connecticut
06520–9040
www.yalebooks.com/art

ISBN 978-0-300-27328-1
Library of Congress Control Number: 2023938246

Produced by the Publishing Department
of the Menil Collection
Joseph N. Newland, director
Editor: Joseph N. Newland
Copyeditor: Betsy Stepina Zinn
Design: Julia Ma and Miko McGinty,
Miko McGinty, Inc.
Typesetter: Tina Henderson, Miko McGinty, Inc.
Typefaces: Visuelt and Circular
Paper: GardaPat Kiara
Separations and printing: Trifolio, Verona, Italy

Printed and bound in Italy